Decorative Ornaments and Alphabets of the Renaissance

Decorative Ornaments and Alphabets of the Renaissance

1,020 Copyright-Free Motifs from Printed Sources

HENRY LEWIS JOHNSON

DOVER PUBLICATIONS, INC., NEW YORK

Published in Canada by General Publishing Company, Ltd., 30 Lesmill Road, Don Mills, Toronto, Ontario.

Published in the United Kingdom by Constable and Company, Ltd., 3 The Lanchesters, 162–164 Fulham Palace Road, London W6 9ER.

This Dover edition, first published in 1991, is a republication of *Historic Design in Printing*, originally published by The Graphic Arts Company, Boston, in 1923. The 39 pages originally printed in two colors appear in black and white in this edition, and the frontispiece has been omitted. A number of obvious typographical errors have been tacitly corrected.

DOVER *Pictorial Archive* SERIES

Library of Congress Cataloging-in-Publication Data

Johnson, Henry Lewis.
 [Historic design in printing]
 Decorative ornaments and alphabets of the Renaissance : 1,020 copyright-free motifs from printed sources / Henry Lewis Johnson.
 p. cm. — (Dover pictorial archive series)
 Reprint. Originally published: Boston : Graphic Arts Co., 1923.
 ISBN 0-486-26605-2
 1. Type ornaments. 2. Printing—Specimens. 3. Printers' or-
naments. 4. Decoration and ornament, Renaissance. I. Title.
II. Series.
Z250.3.J64 1991
686.2'24—dc20 90-47002
 CIP

Manufactured in the United States of America
Dover Publications, Inc., 31 East 2nd Street, Mineola, N.Y. 11501

CONTENTS

Historic Design in Printing

REPRODUCTIONS OF BOOK COVERS,
BORDERS, INITIALS, DECORATIONS,
PRINTERS' MARKS AND DEVICES COM-
PRISING REFERENCE MATERIAL FOR THE
DESIGNER, PRINTER, ADVERTISER
AND PUBLISHER

WITH INTRODUCTION AND NOTATIONS
BY

HENRY LEWIS JOHNSON

BOSTON
The Graphic Arts Company
1923

[original
title page]

Designed by Geoffroy Tory for the Hours of Simon de Colines, 1520

PREFACE

ONLY those who are collectors or connoisseurs can appreciate the pleasurable task represented by garnering the many forms of design and ornament presented herein. At the beginning of my experience in printing in the office of a Boston printer of exceptional abilities, Carl H. Heintzemann, I learned to know the thrill of gratification from a page of fine typography and especially so when it carried some design or color. Mr. Heintzemann, more than any other printer of my early acquaintance, brought to his work a knowledge and practice of principles of composition, design, and color, derived from an appreciation of best Italian, French and German printing. He was a master printer, both as a designer and technician, and from him I learned to have a regard for both phases, in contrast to the then more prevalent effort for mechanical rigidity.

In applying myself to the design of printing for many years, I found my success to be frequently in the use of borders, decorations or devices which gave color in a general sense to the page. Later in originating and editing two periodicals, first The Printing Art and then The Graphic Arts, I greatly extended my collection and use of design in printing.

As a part of my instruction in courses which I have in printing at Boston University, I require students to give particular attention to early printing for its distinction in typography and its masterpieces in design. The reference material is so widely scattered and mainly limited to individual copies, that it is difficult for students to attain an adequate knowledge of this historic foundation for good work. This compilation is partly to make available for students the forms and styles of design in the Renaissance of printing of the fifteenth and sixteenth centuries, and still more to offer authoritative examples in a reasonably comprehensive range as motives for the designer, printer, advertiser, and publisher. The increasing use of devices, trade marks, borders, and decorations creates a wide interest which can be met only by going back to the greatest sources which are afforded by the Renaissance.

It has been possible to photo-engrave many prints of the fifteenth and sixteenth centuries in clear, fine details; others show the defects of early printing as no attempt has been made to redraw the originals.

Neither does this work undertake to define styles, elements or uses of the materials. Any prescription of motives and forms of design without typography would merely lead to work having unrelated elements.

This work is offered with the most serious conviction from study and experience that the expression of feeling and personality through design is the greatest opportunity in the craftsmanship of printing. Charles Eliot Norton's forecast "Printing will become one of the first great arts of this country" finds much confirmation in the sincerity and attainments of an increasing number of those who design and produce printing.

Following the stimulus of the William Morris period of the revival of conventional design, we have had a pictorial era in book covers and in general printing. Now there is a popularity of black and white pattern effects in borders and decorations, which can well be extended again to formal designs in covers and to combinations with many forms of typography. The wealth of Renaissance designs, in panels, vignettes, and initials can be drawn upon for motives which combine most admirably with the rigidity of types. Such effects in printing are today a necessary offset to the grayed out pages in which half-tones and light types so largely predominate.

It is hoped that this compilation, which at best is only representative of a great period, will serve to turn attention to the study of the work of the early masters of printing. Without the influence of this study much printing of today is impoverished and inadequate to its opportunities.

<div align="right">

HENRY LEWIS JOHNSON

</div>

Boston, Massachusetts
 September, 1923

Decorative Ornaments and Alphabets of the Renaissance

HISTORIC DESIGN IN PRINTING

RAPHIC ARTS of today offer great opportunities to the designer, to the printer, and to those who use printing. It is difficult to conceive of anyone active in the professions, arts, industries or commerce who does not use printing, either supplied to him, as in the case of books for the teacher, or produced for his specific purposes, instanced by catalogues for the manufacturer. It follows therefore that not only those who actually design and produce printing, but also the rank and file of humanity, have a direct concern with the manner of printing which best serves them.

To reach quickly the basic reason for design in printing, compare printing with architecture, "the mother of the arts." Buildings might all be flat surfaces of stone, brick, or wood, with merely openings for passage and light. Yet no structure of any account is without finish, defining doors, windows and construction. The simplest printing involves design in form, and when it has a purpose of appeal or influence, it requires some elements of design to be appropriate or significant in expression. Otherwise, it is a flat surface, without individuality. There are many appropriately printed books and routine forms absolutely bare of decorative design, but by far the greater portion are enhanced by designs, either the simplest mark on a title page, a cover design, borders or initials.

Design is a large factor in style in printing. "Style is the man" can well be paraphrased— "Style is the printer." Lethaby's definition: "Art is design in workmanship" means an intelligence for doing work best in appearance as well as in utility.

Design in printing dates from the inception of the art. The first printing was mainly pictorial and decorative, from engraved blocks. When type printing began, it was supplemented by designs to rival manuscript decorations. Then Ratdolt, in 1475, engraved and printed borders and initials which marked the advent of engraved design in printing as it now concerns us. The forms of design in printing of this time do not differ from these used in the earliest work. Interlacings, patterns and cartouch forms for covers, borders, initials, headbands, tailpieces and trade mark devices for type pages are identical now with the earliest usage. What then are the significance and importance of this compilation of historic design in printing?

Pen and ink design, supplemented by photo-engraving, forms a natural adjunct to type printing because of the similarity in the definition of lines. The engraved lines and type lines can be alike or in suitable relation in color.

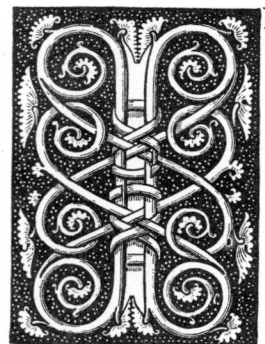NNUMERABLE photo-engraving establishments, with their art departments, designing on a quantity basis, individual designers, mostly without the resources or specific training in historic design, and the very few master designers, are now producing design for printing on a scale never before approached.

Some design in the advertising pages of the popular periodicals is beautiful in composition and of high technical rank but it must be said that whatever is good follows historic styles.

Too much work is produced by the "born" designer, and by others without reference resources, while the specious claims of originality, something new, and unique are common self-introductions for un-classifiable or nondescript work. It may be pretty, well rendered, and "original" but that is as far as it goes. No one wants a doctor or lawyer who is not well founded on precedents, and why should a novice in design expect to lift himself by his own bootstraps?

Several authorities quoted in the display pages warn against the effort for originality—without a foundation upon the best that has been done. Outside of a few cities having large libraries, the designer has only a meager opportunity to study early printing first hand but the printing periodicals point the way by examples and discussions of early work so that all who aspire to advancement can know something of the traditions.

The great difficulty lies in the too prevalent practice of following with avidity the hetrogenious design in present day printing. The designer who adopts this method for his motives can produce only variants without much likelihood of making any advancement.

The great artists of the fifteenth and sixteenth centuries gave to printing of that period a wealth of design. The study of this is the foundation for architectural construction, symbolism, foliage, interlacing and arabesques.

Many of the early title-pages are masterpieces in architectural motives and also are an authoritative source of decoration in mouldings and frets, supplemented by every form of foliage, fruits, fishes, garlands, cornucopias, vases, pilasters and human figures.

Page borders of these centuries display master craftsmanship in flat decoration and in geometric design. Book bindings are unsurpassed in strictly ornamental form and detail. Almost every conceivable kind of decorative motive and the most beautiful letters are to be found in the alphabets of initials designed by the greatest artists of the period.

Although the prints of early wood engravings are usually imperfect because of the crudities of press work, they still provide examples of technique in line and shading. These renderings of forms and details are more appropriate in combinations with types than the stipple and crosshatching of intaglio plates. Early prints by the latter process have remarkable perfection of form and elaboration in design but they are more useful for motives than for technique.

MOST concise presentation of the Renaissance is by the English librarian and author, R. N. Wornum, from whom we quote at length:

"The term Renaissance is used in a double sense: in a general sense implying the revival of art, and specially signifying a peculiar style of ornament, that is, implying both an epoch and a style. The original idea of the Rinascimento, or rebirth, which is the literal meaning of the term, was purely architectural; the restoration of classical ornament did not immediately follow the restoration of the classical orders, though this was the eventual result; this is an important consideration, for unless we bear constantly in mind that the original revival was simply that of the classical orders of architecture in the place of the middle-age styles, the apparent inconsistencies we shall meet with in the ornamental details of the Renaissance will be liable to confuse us. The Renaissance styles, therefore, are only those styles of ornament which were associated with the gradual revival of the ancient art of Greece and Rome, which was not really accomplished until the sixteenth century, in that finished style the Cinquecento.

The course of ancient and modern art has been much the same; both commenced in the symbolic, and ended in the sensuous. The essence of all middle-age art was symbolism, and the transition from the symbolism to the unalloyed principles of beauty is the great feature of the revival.

Venice, already rich in Byzantine works, appears to have taken the lead also in the dawning of classical art; and the Venetians seem likewise to have contributed more than any others to its most finished development, the Cinquecento. The Venetians and the Italians generally, controlled by no trammels of tradition, added their own beginnings of natural imitations, to Christian or to Pagan elements indiscriminately; the prestige of a thousand years was broken; the classical forms prevailed, and the Quattrocento, the first great style of the Renaissance, was established.

The first of those modern innovations is the transition style, the Trecento; which may be considered a negative style, as its peculiarity consists in its exclusion of certain hitherto common ornamental elements.

The great features of this style are its intricate tracery of interlacings, and delicate scroll-work of conventional foliage, the style being but a slight remove from a combination of the Byzantine and Saracenic, the symbolism of both being equally excluded; the foliage and floriage, however, are not exclusively conventional, and it comprises a fair rendering of the classical orders.

In the Quattrocento, the next style, we have a far more positive revival. Lorenzo Ghiberti may, perhaps, be instanced as its great exponent or representative in ornamental art. Filippo Calendario and Antonio Riccio, called Briosco, contemporary with Ghiberti, are likewise important names of this period.

In this style, also, we have the first appearance of cartouches or scrolled shield-work, which became so very prominent in the sixteenth and seventeenth centuries.

Another feature of this Quattrocento style— or what is more especially the Italian Renaissance, as distinct from the Cinquecento— is the introduction, for the first time, of the grotesque arabesque, after the ancient models of Rome and Pompeii; in fact, the style of decoration is now of a very complicated character, though not confused, for we will have the Trecento interlacings very largly used as borders, and the scroll, from the pretty serpentine character of the previous style, appears with all the fulness of the Roman arabesque, but not yet very prominently introduced.

We speak of the Renaissance as an epoch and as a style, but the only true or literal revival is the Cinquecento; the other varieties contain too many original and extraneous elements to be considered an " historical revival."

The term applied to a library "the treasure house of printing" seems sometimes a misnomer to those who want some particular kind of binding or design. It is often difficult to find the desired reference material. This is necessarily so because the examples are scattered through many early printed books or reproduced in works on art in general in which design in printing has only a minor part. There is a real inspiration in searching because many other phases of artistic endeavor contribute to a general sense of what is good.

The pleasure from the exercise of technical skill and the gratification from a finished product are among the rewards to those who achieve well in design in printing. "Art alone endures," and no one can foresee what far reaching influence his handicraft may have. When it has gone from the press it is like Longfellow's:

> I shot an arrow into the air,
> It fell to earth, I knew not where.

Design in printing is a form of expression which contributes to its immediate influence and usually to its longevity. It is a form of eloquence not limited to any time or place. To have a part in the preparation of printing is within the activities of every man of affairs and the right use of design is a most worthy challenge to personal accomplishment.

Grolieresque binding from Erasmus on the New Testament

HISTORIC DESIGN IN PRINTING

GROUP I—BINDINGS

These superb compositions, consecrated to the bindings of the epoch

ERNEST THOINAN

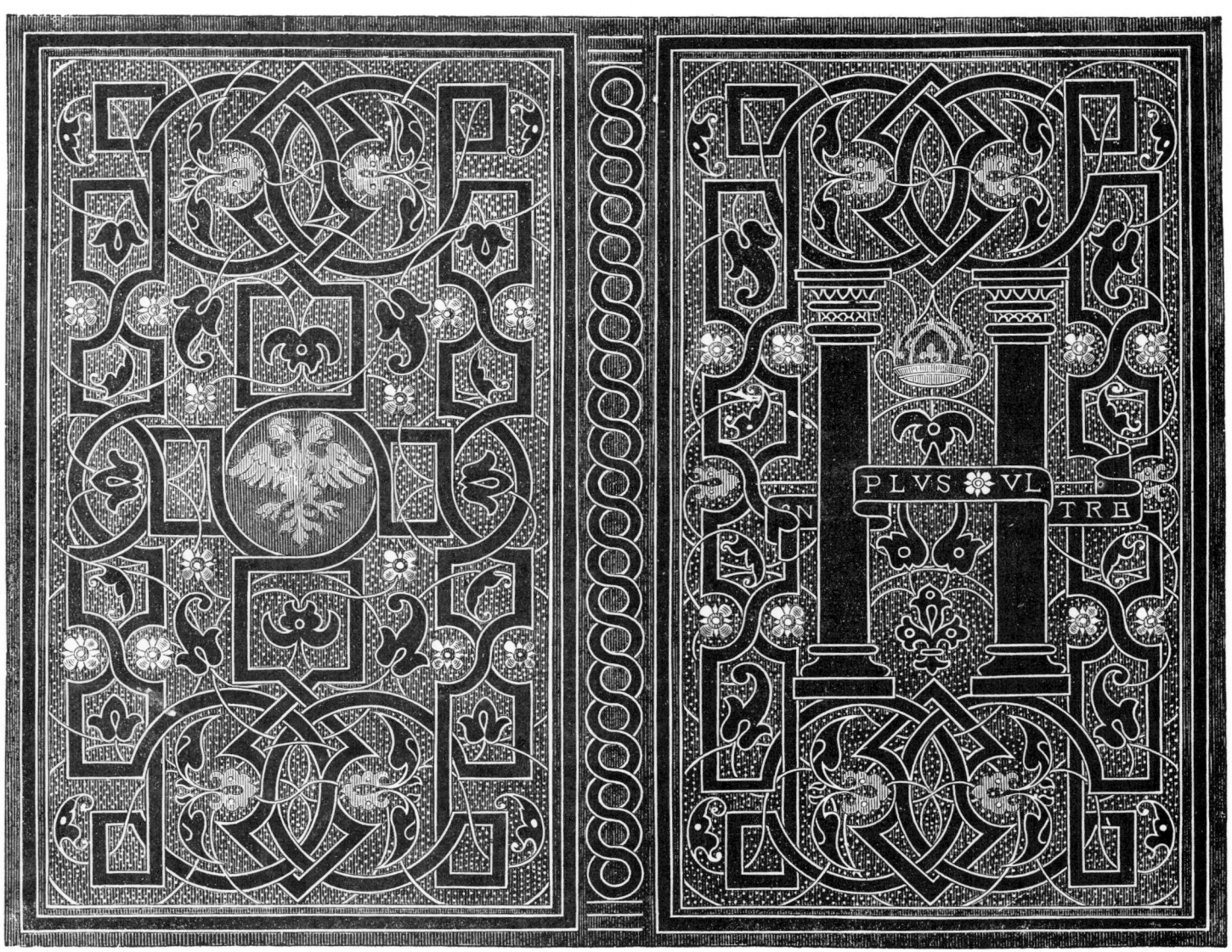

Grolieresque binding of the 16th century, with the arms of Charles V and his device—the
Pillar of Hercules and the motto "Ne Plus Ultra"

JEAN GROLIER

IN the history of bookmaking, no more interesting and brilliant figure is to be found than that of Jean Grolier de Servier, vicomte d'Aguisy, Treasurer-General of France, ambassador to the Court of Rome, and bibliophile. His life forms a complete, epitomized expression of the higher literary feeling of his time. Grolier was born at Lyons in 1476. His family was of Italian descent, originally from Verona; his father, Étienne Grolier, a gentleman of the Court of Louis XII of France, and Treasurer to the King in the Duchy of Milan. At an early age, Grolier was introduced at the French Court by his father, where he soon attracted notice, both by his learning and by his talents as a financier. Under Francis I he held the position of intendant of the army in the Milanese country. He returned to France after the battle of Pavia, and was appointed ambassador to Pope Clement VII in 1534. In this capacity he conducted certain diplomatic negotiations with so much delicacy and skill that he won the personal friendship of the Pontiff, who gave him substantial proof of his favor. During his stay at Rome, Grolier began collecting a library. Upon his return to France he was first appointed Treasurer of the King for the districts of Outre-Seine, and L'Ile-de-France, and afterward Treasurer-

General of Finance, an office which he held until his death, displaying ability and integrity in his administration of the public money, and, not withstanding the malicious accusations which were brought against him, completely triumphing over his enemies. He died at Paris on the 22d of October, 1565, at the age of eighty-six years, and was buried in the Church of St. Germain des Pres, near the great altar.

The interest attached to the name of Grolier in the mind of posterity has far less to do with his distinction and personal merits as a financier than with his passion for books. He loved books as a man of letters, as an artist, and as a dilettante. Both at Paris and in Italy, he had many warm friends among the learned men and the men of letters of his time, to whom he accorded a generous and delicate protection. He was linked also by ties of common interest and sympathy of pursuits with the most famous printers of the epoch. Garuffi, Étienne Niger and Budé dedicated books to him. It was Grolier who caused Budé's treatise "de Asse," to be printed by the Aldines in 1552. An example on vellum of this volume, that which was presented to Grolier and brought 1500 francs in 1816 at the MacCarthy sale, afterwards found its way to England. Dedications to Grolier are seen also at the beginning of a Suetonius printed at Lyons in 1518, of a book by Étienne Niger on Greek literature (Milan, 1517), and of different other works. In many writings of the time, Grolier is spoken of in terms of the highest commendation. Erasmus bestowed great praise upon him. Coelius Rhodigimus, Aldus Manutius, Baptiste Egnazio, and various other persons dedicated works to him. It is Egnazio who relates that Grolier, having invited several learned men to dinner, at the close of the repast set before the guests gloves, in each of which was wrapped a considerable sum in gold.

The historian De Thou compares the famous library of Grolier with that of Asinius Pollio, the most ancient library of Rome. Only such books were included in it as were remarkable for their intrinsic literary value and their beauty of form. The Greek and Latin classics, the works of contemporary philosophers and learned men, historians, geographers, archaeologists, composed a great part of it. By the side of these figures the modern Latin poets, which were read at that time, and the literature of Italy. For this library Grolier selected the best copies procurable of the different works, and frequently caused several copies of a book to be printed especially for him in fine paper. He had the frontispieces and the initials painted in gold, and in colors. The covers bore ornaments in the most exquisite taste, and were gilded with remarkable delicacy. The compartments were painted with various colors, were perfectly well-drawn, and all were designed in different figures. Grolier even went so far as to have new margins carefully added to the leaves which had been left too short in the folding, in order to possess copies with very wide margins. But it is particularly in the bindings which he caused to be made, that Grolier gave the most positive proofs of his admirable good taste. The art with which they were executed was no less remarkable than the beauty of the ornaments which he himself designed.

Most of the books of Grolier's library bore on one side his personal motto, "Portio mea, Domine, sit in terra viventium," and on the other the words, "Io Grolierii et amicorum." This latter inscription has given rise to the theory that Grolier was a bibliophile of an uncommonly generous disposition, and regarded his books as the property of his friends as well as of himself. Another theory, upheld by authenticated facts, is that Grolier, possessing several copies of the same book, all richly bound, was in the habit of reserving the finest copy for himself and distributing the others among his friends.

Being what he was, an evenly balanced, symmetrical individuality, Grolier has left his mark on history as a brilliant, successful man of the world, of broad and generous sympathies, whose business in life was finance and diplomacy, whose recreation was art and letters. He was equally at home in palace, camp, council chamber, treasury, studio and printing room. His list of friends and acquaintances began with kings and popes and ended with artisans and toilers among the people.

He gave to the book, in its most sumptuous form, a lofty and lasting position in the world of letters. To posterity, Grolier represents the spirit of the Renaissance, in all its proud, splendid materialism. His personality stands out in bold relief among the many significant figures of sixteenth century France and Italy, presenting a long busy and useful life; the life of a cultivated gentleman, the influence of which is still felt at the lapse of three centuries and has reached the new world.

CHARLOTTE ADAMS

From JEAN GROLIER—Printed for the Grolier Club, New York, 1907

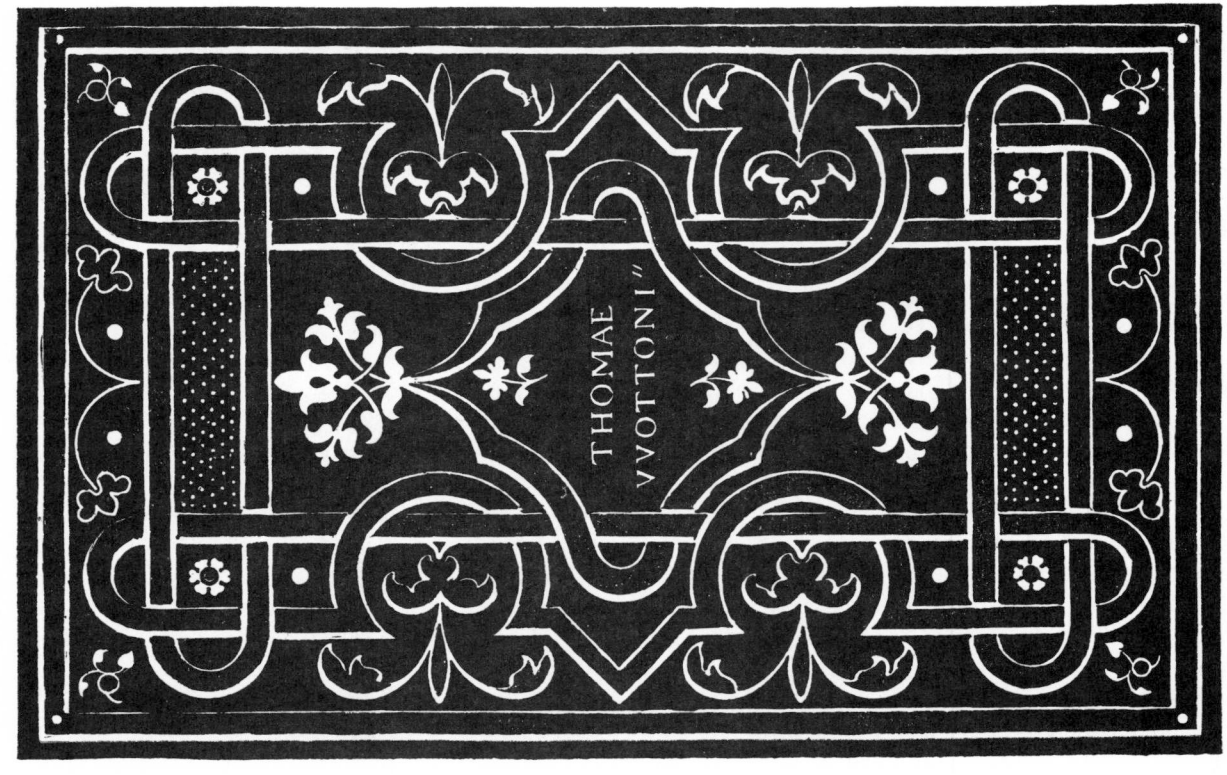

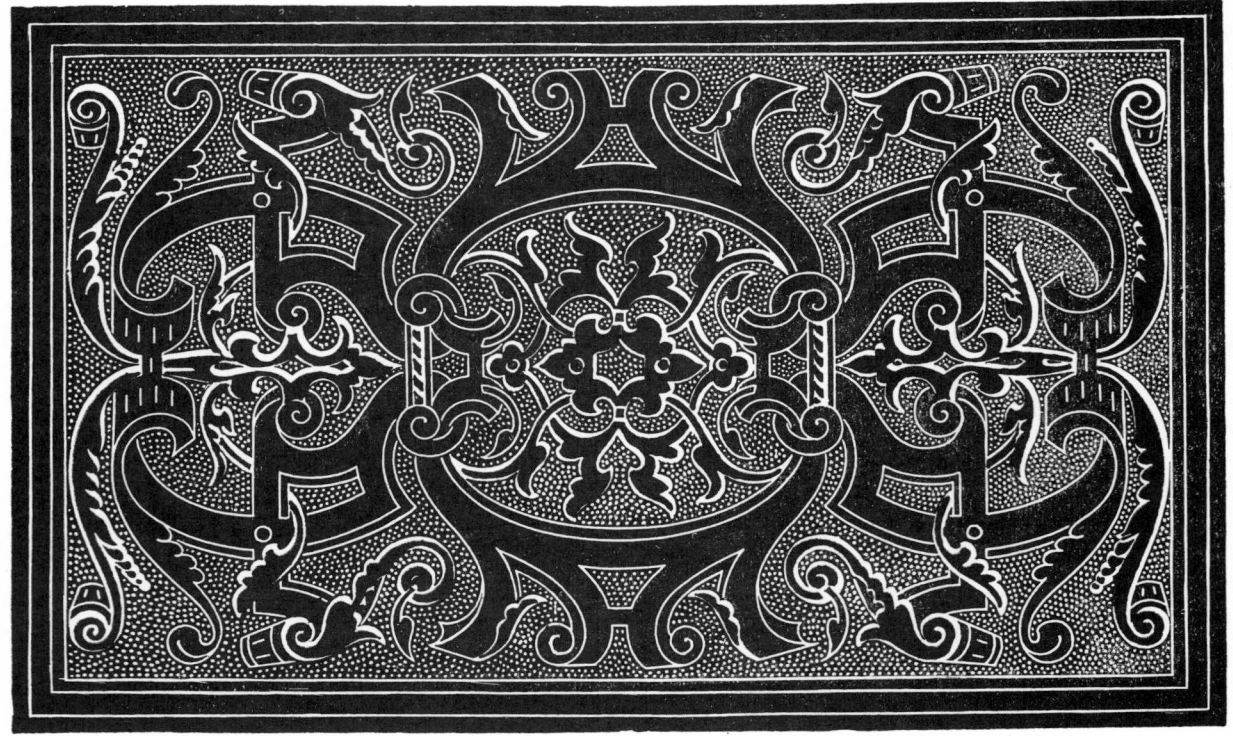

A Grolier binding at the left and a binding of the 16th century for Thomas Wotton, who generally had the covers of his books ornamented in a style similar to those bound for Grolier, whose liberal motto he also adopted, and he is in consequence known as the English Grolier

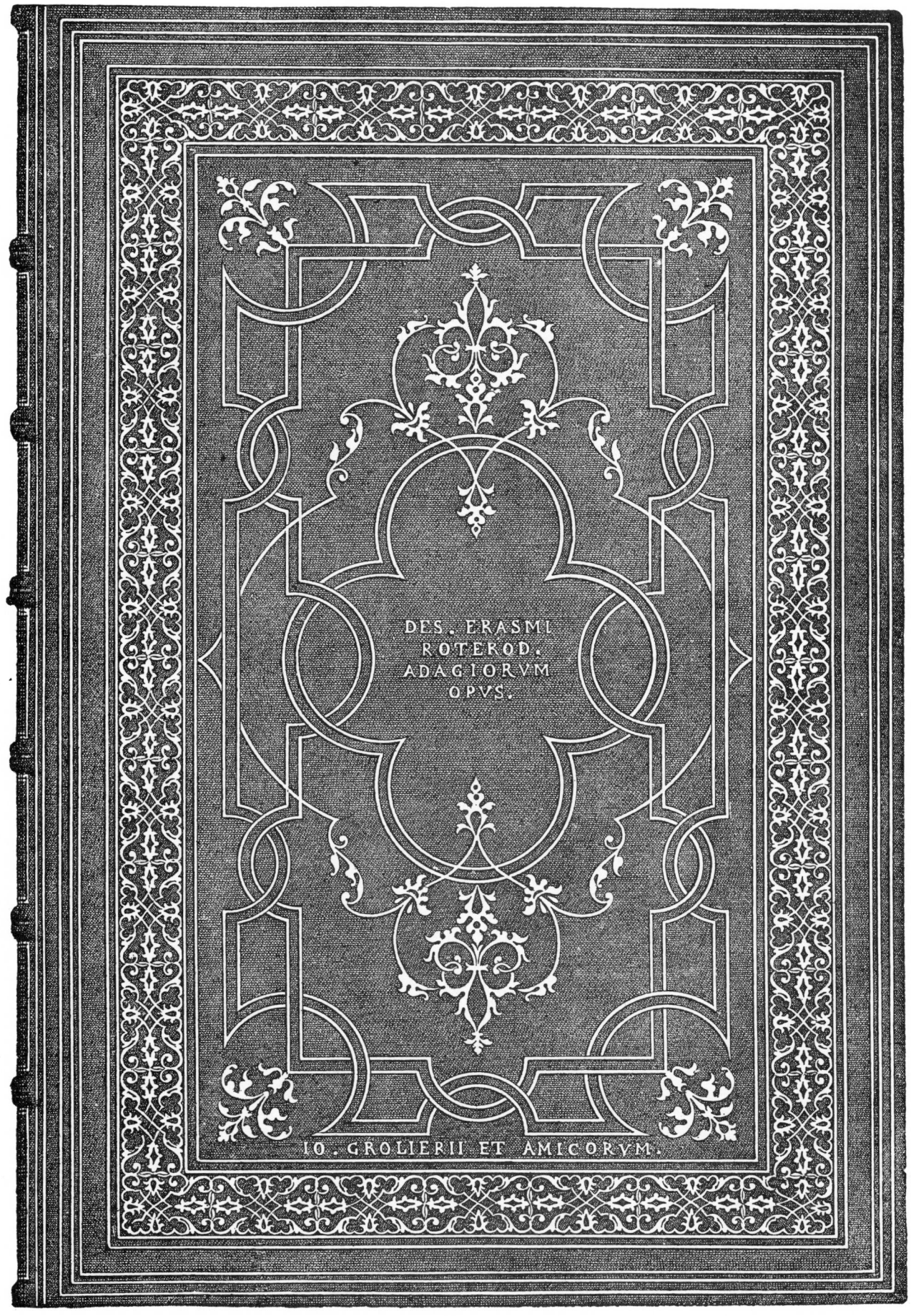

DES. ERASMI
ROTEROD.
ADAGIORVM
OPVS.

IO. GROLIERII ET AMICORVM.

A Grolier binding on dark green sheepskin with ornaments, lines and borders in gold. The
motto at the bottom, "Grolierii et amicorum," was adopted by this
celebrated bibliophile of the 16th century

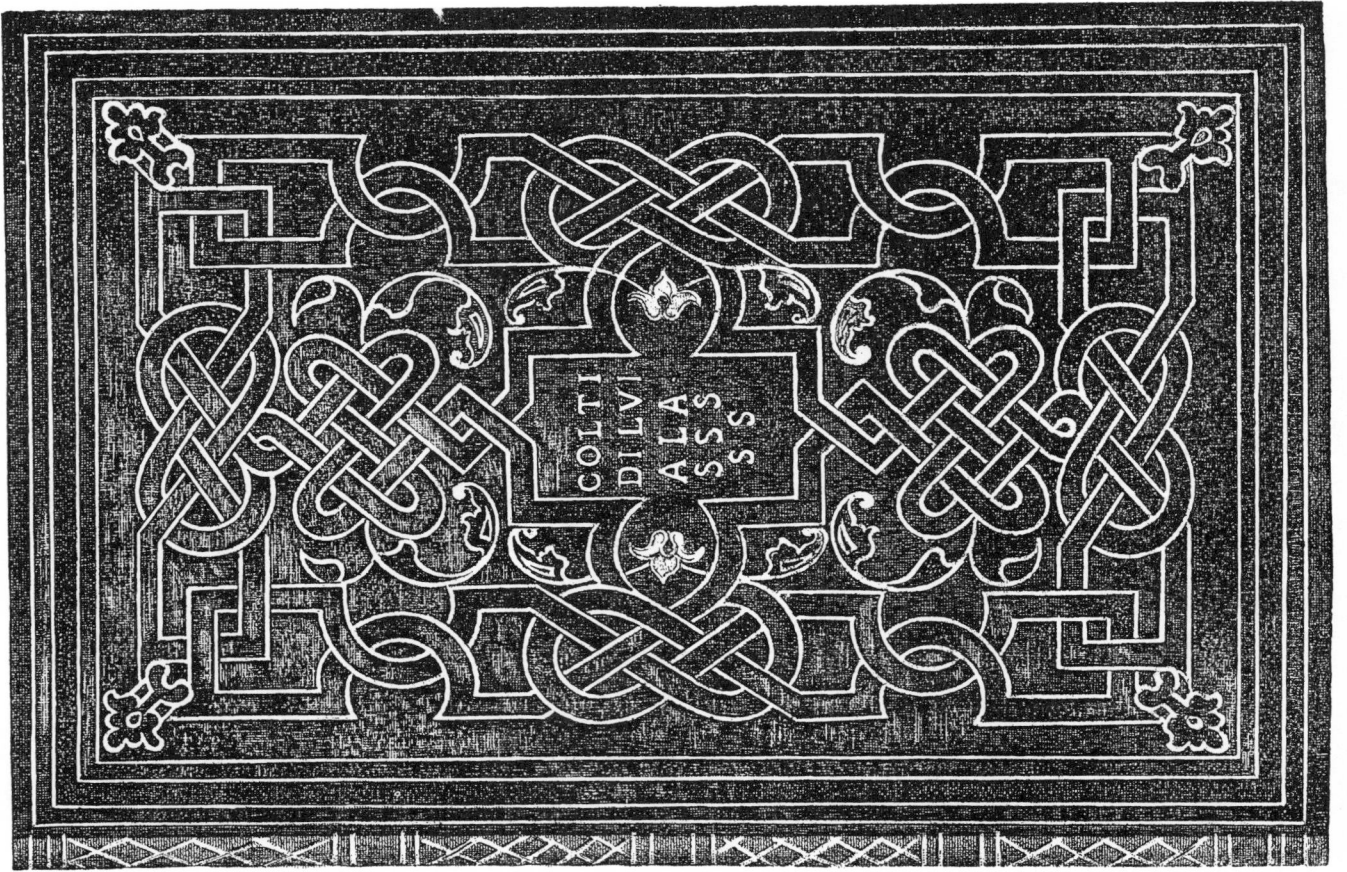

The binding at the left is from a Bible printed in 1526 and appears to have been executed for Grolier. Above is a design in interlacings from a book of 1546, dedicated to Francis I

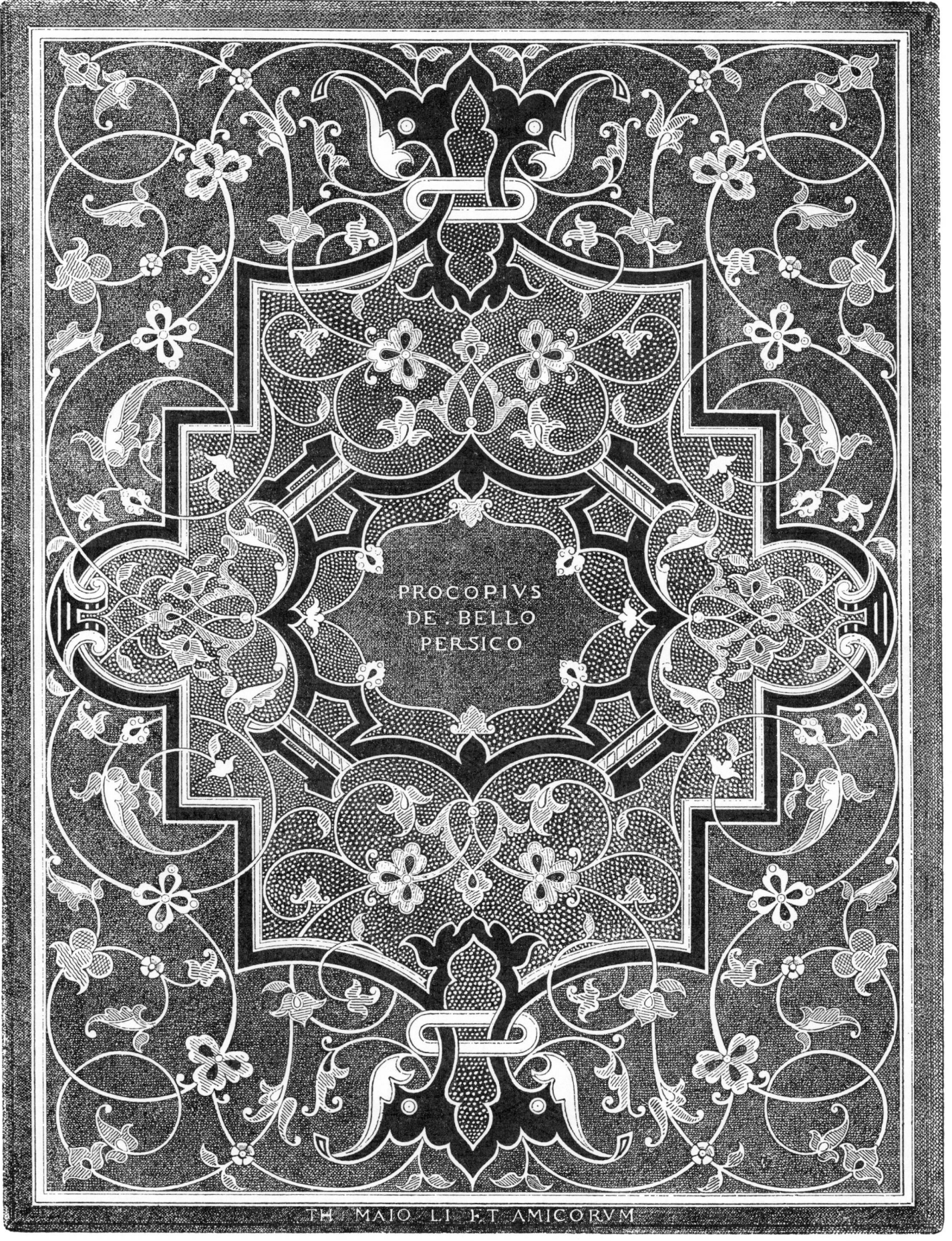

From an Italian binding in gold, silver and black

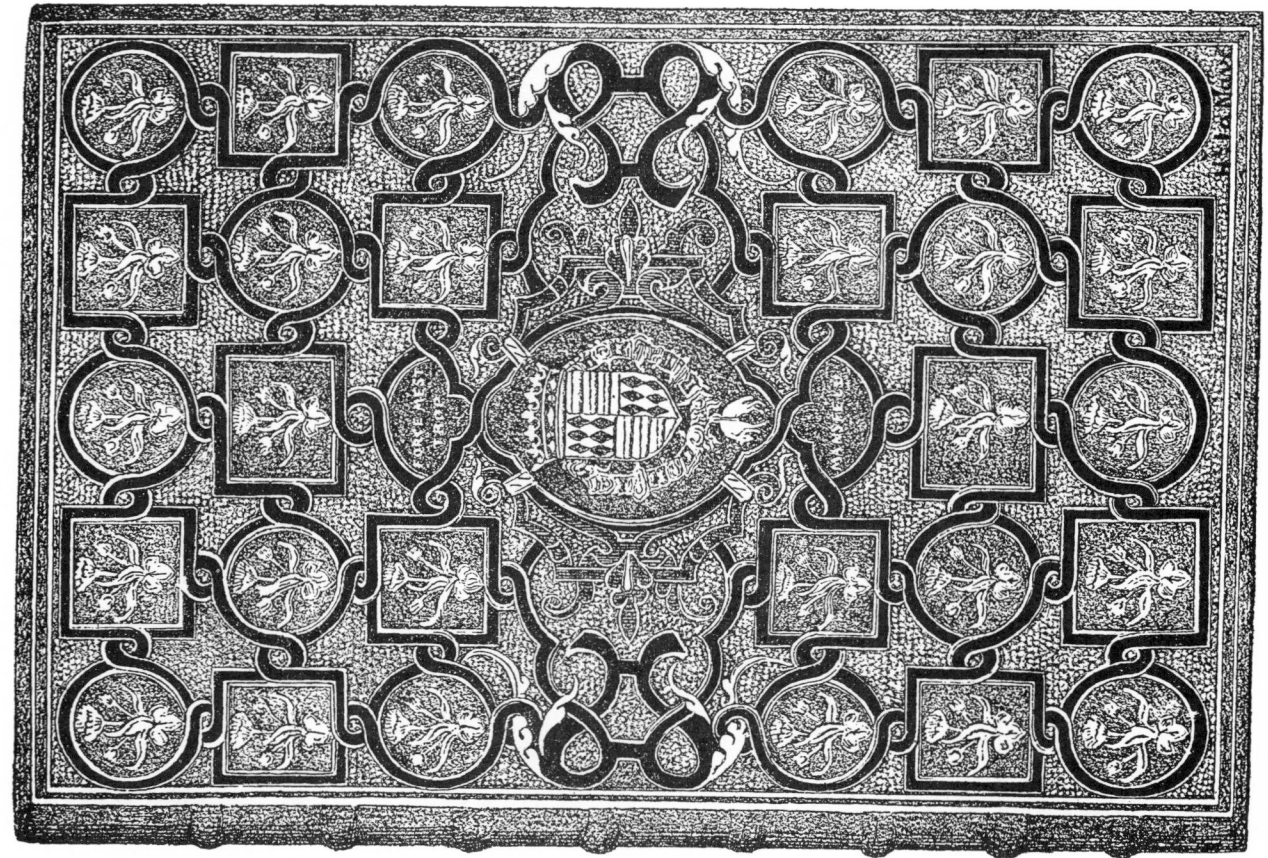

The design at the left has the arms of Charles, Cardinal of Bourbon, in the center, from the Bible printed in Lyons. At the right is an alternating pattern of squares and circles connected by interlacings, dated Lyons, C. Roville, 1554

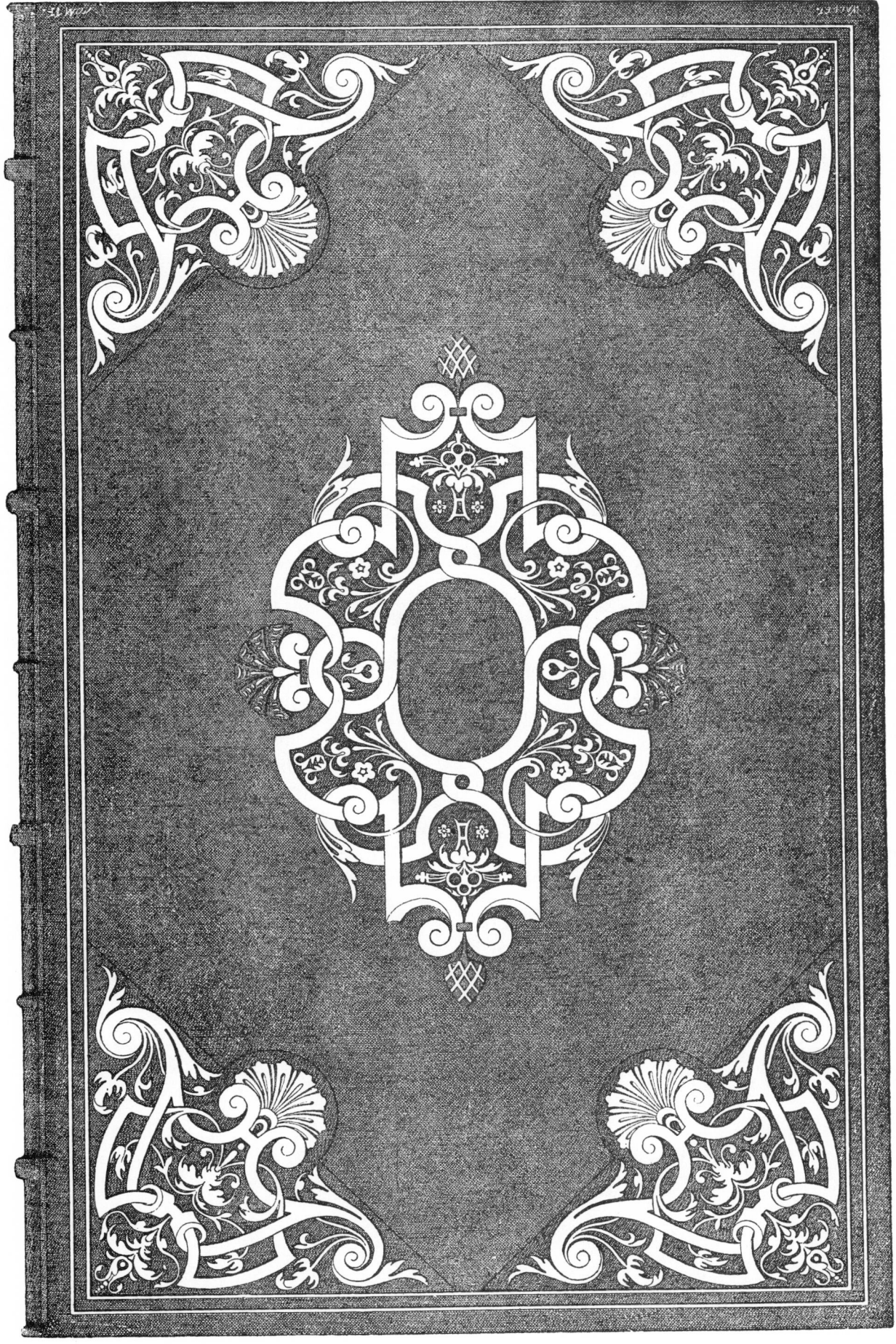

The central motive and the four angle-ties of this binding of the 16th century have a correct and serious style yet not devoid of charm. The book so artistically bound is the Histoire de Marc-Aurele, printed in Paris by the royal printer, Jehan le Royer, 1565

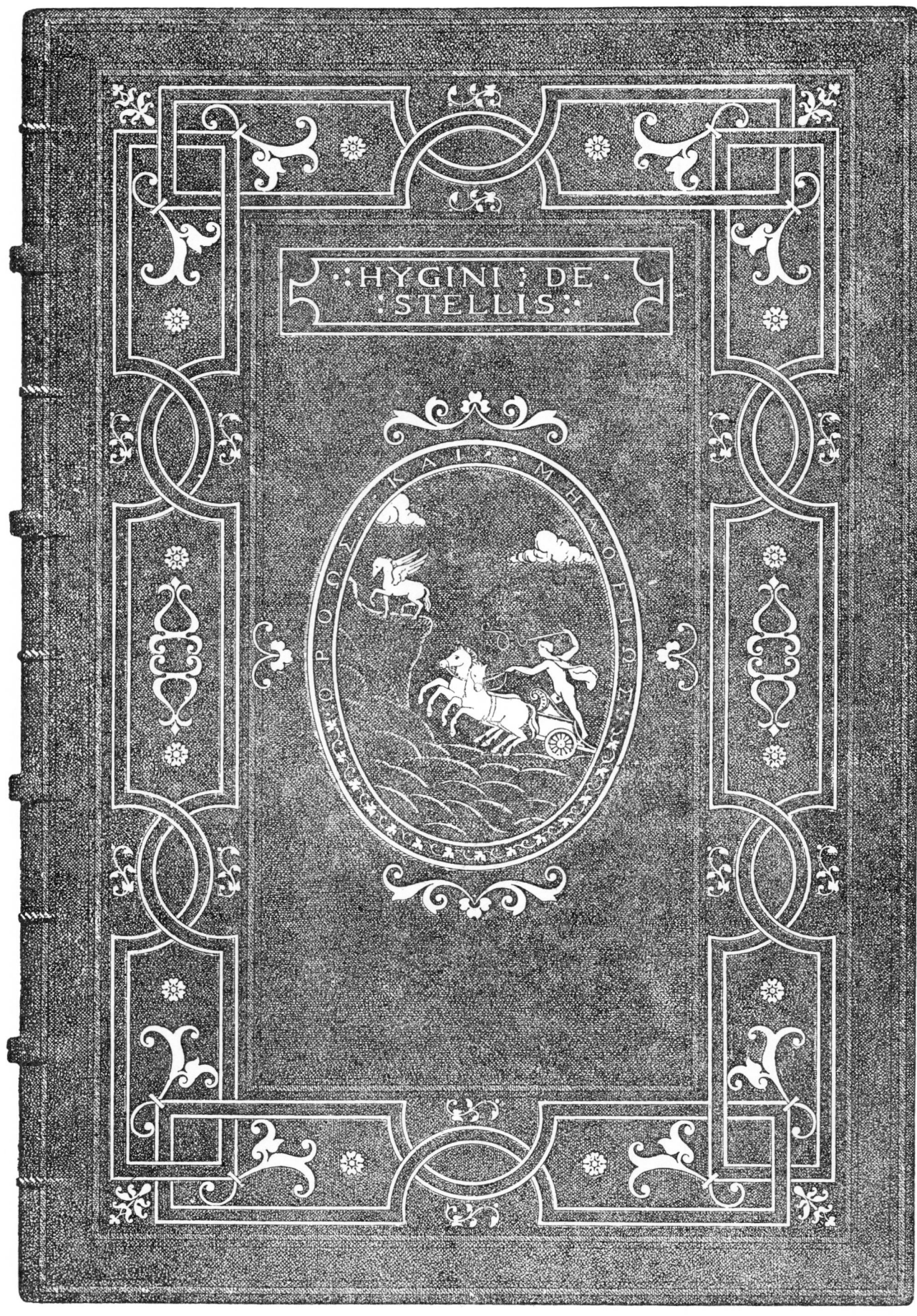

Binding made under the direction of Demetrio Canevari, physician to Pope Urbain VIII

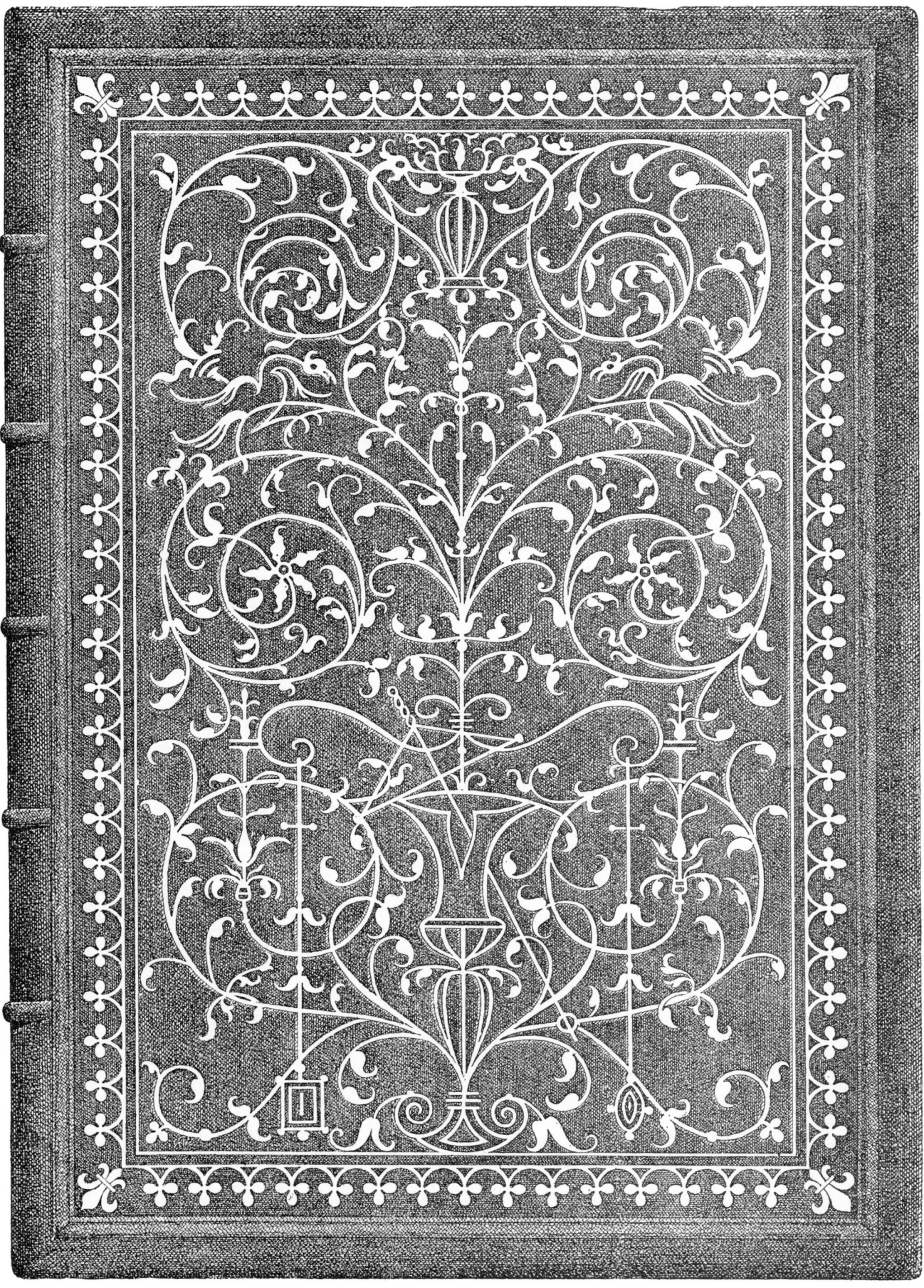

From a binding designed by Geofroy Tory to whom several references are made in this volume. This design includes the Tory mark known as the "broken pot" as a part of the background of airy and graceful ornaments. The original is in gold stamped on sheepskin

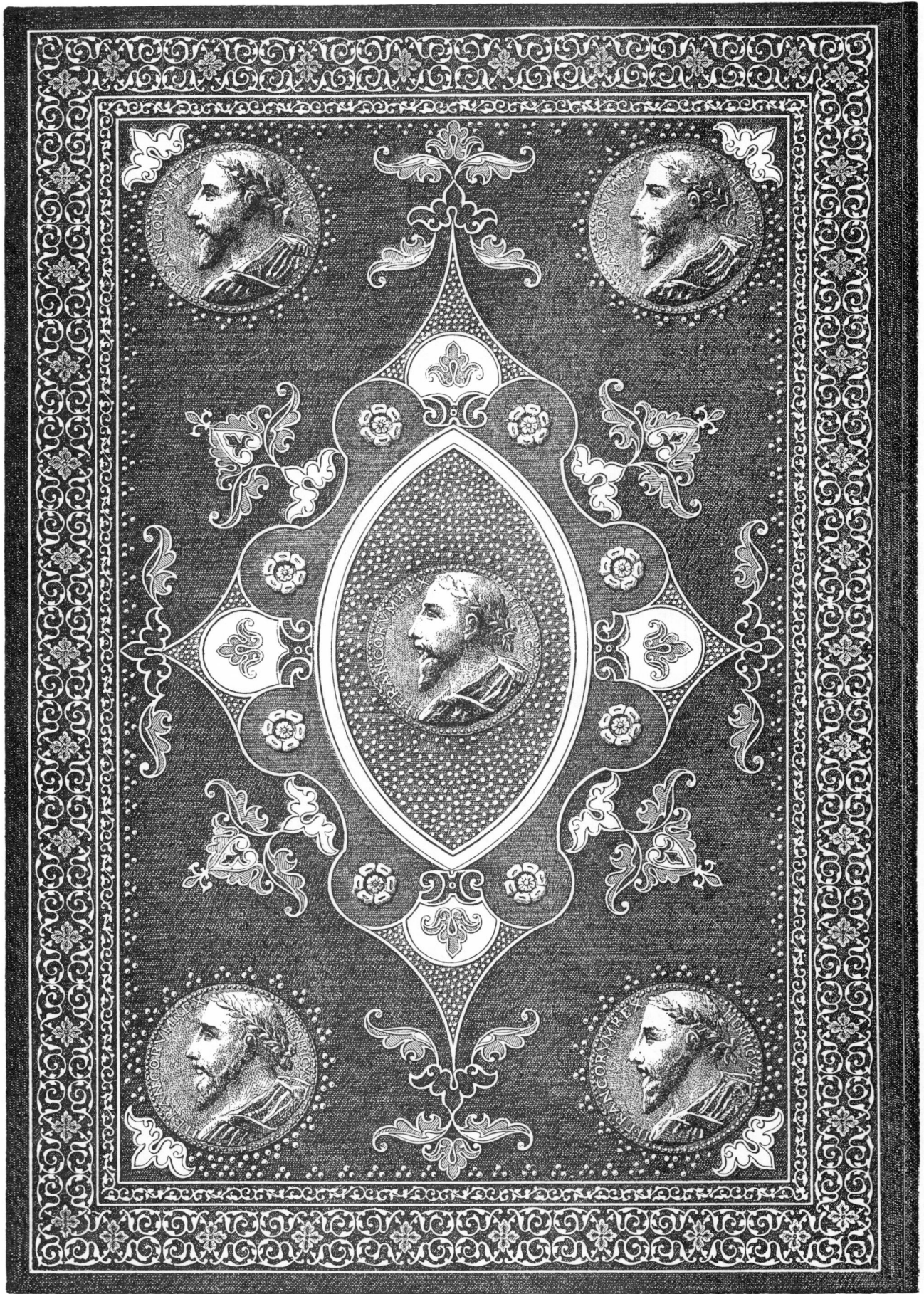

This binding comes from the library of Henry II, showing his medallion portrait five times

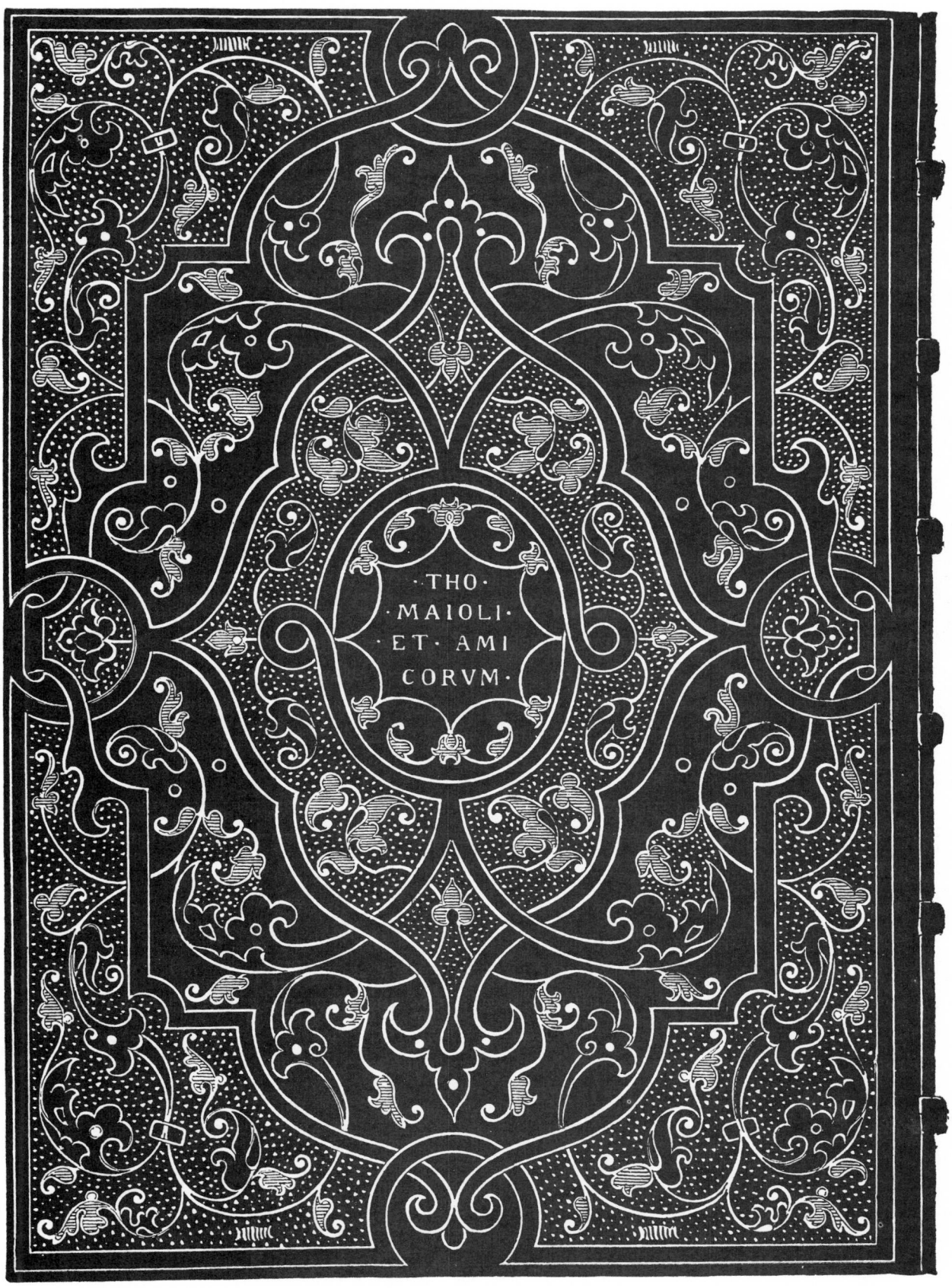

An excellent example of the bindings for Tommaso Maioli, by an unknown master designer
of the early part of the 16th century

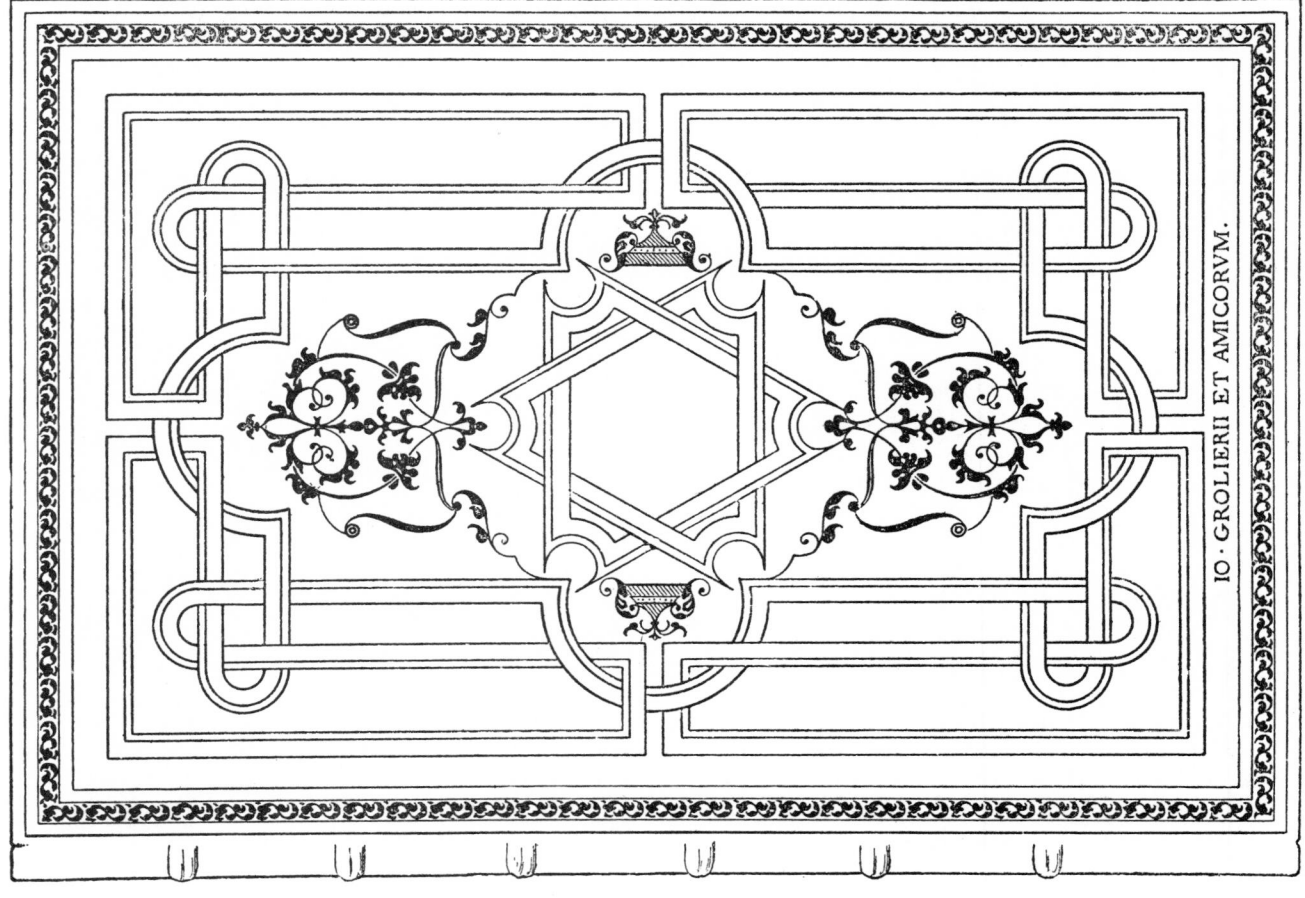

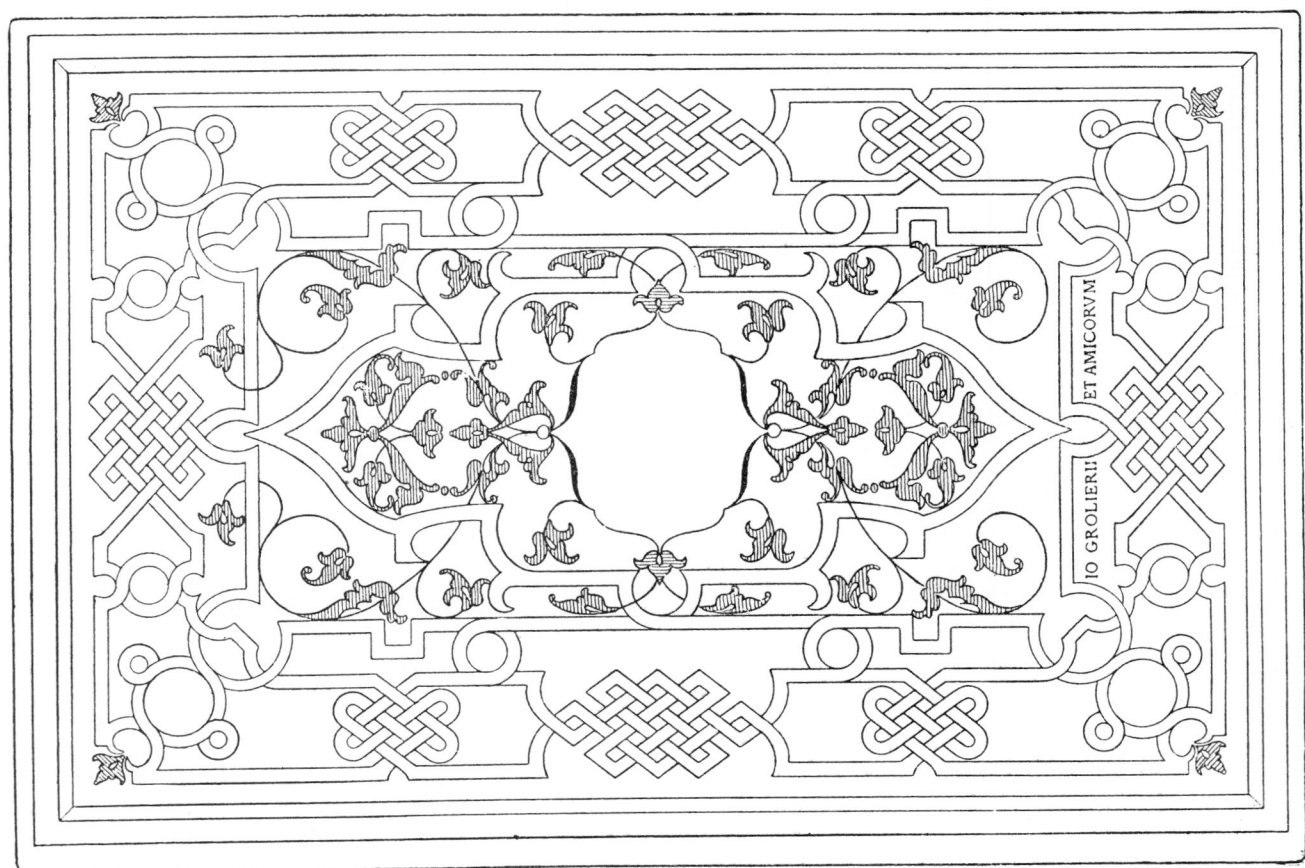

Bindings having diversity in interlacings and in foliated patterns, yet with the Grolier characteristics

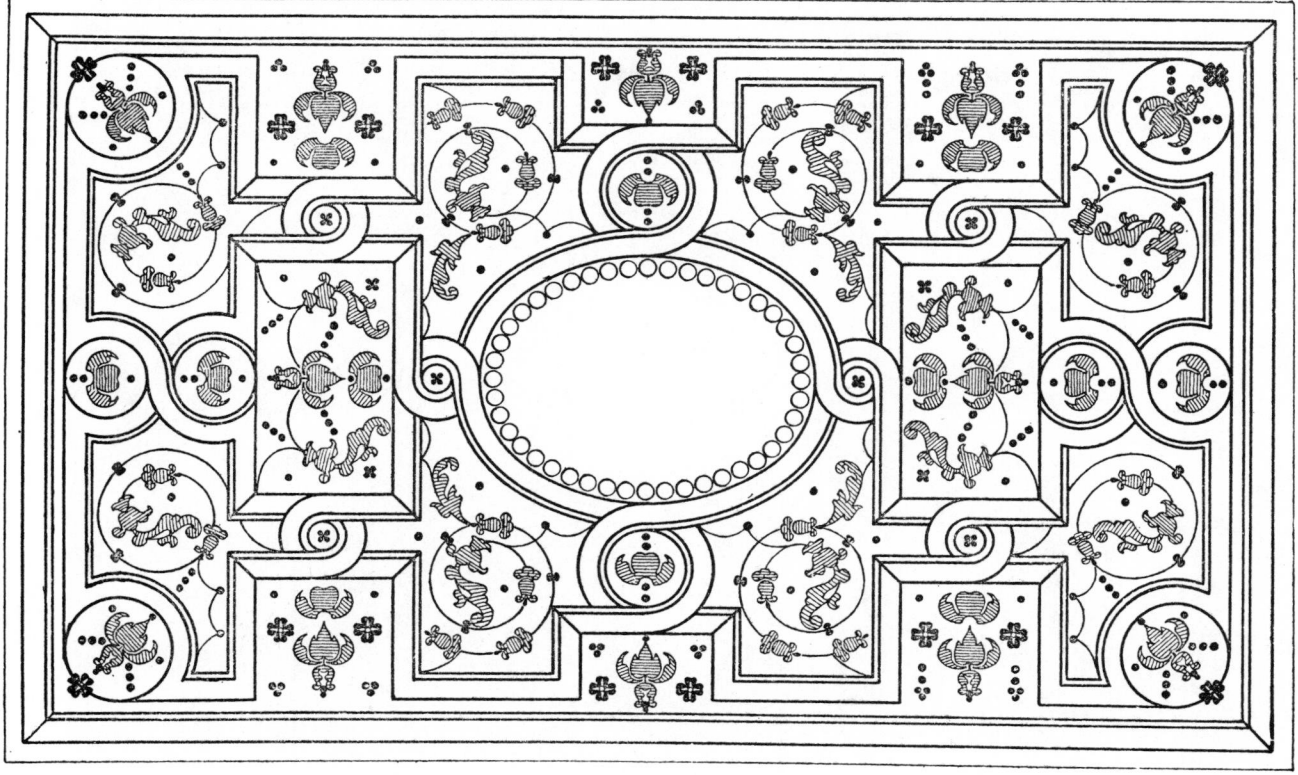

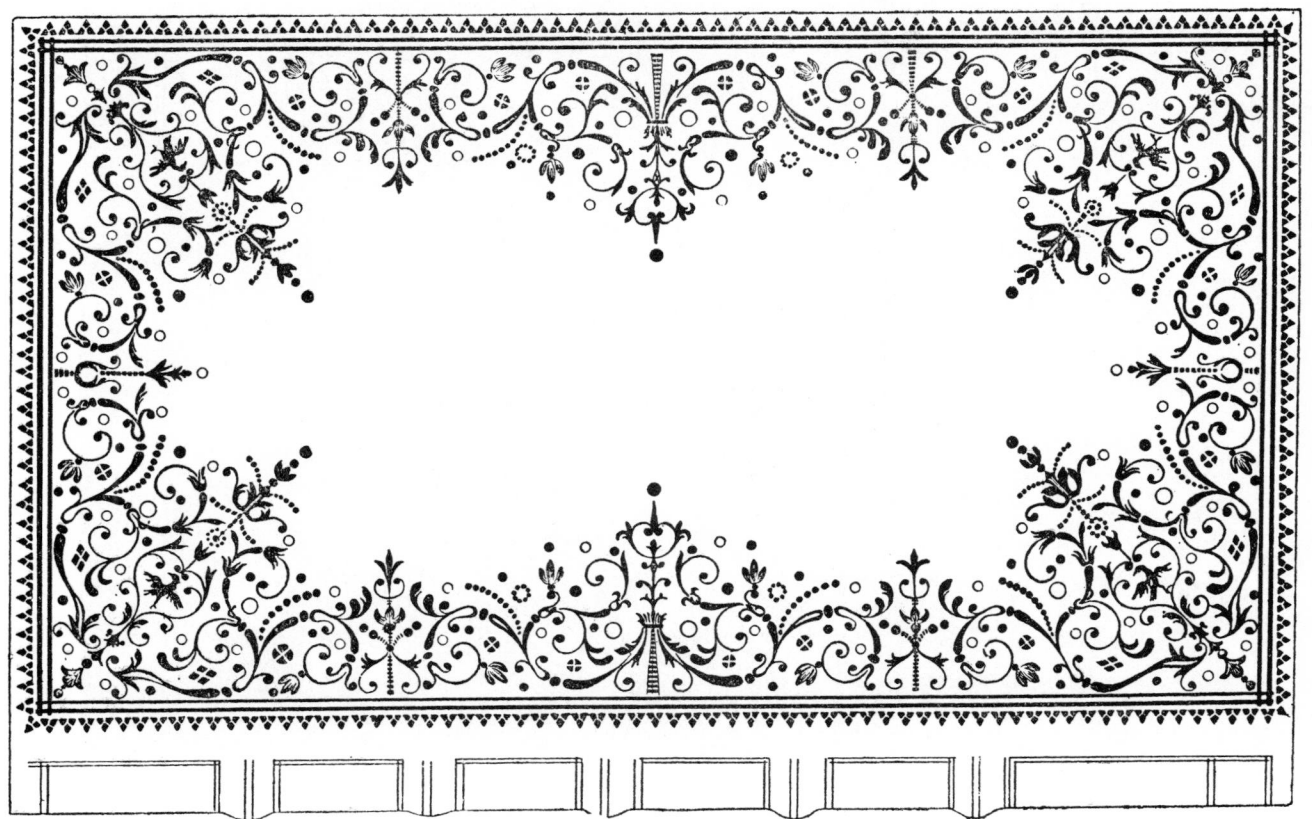

The binding at the left is attributed to Nicolas Denis Derome, the most celebrated of a family of French binders. At the right, a binding of 1580 in a combination of angular and interlacing forms

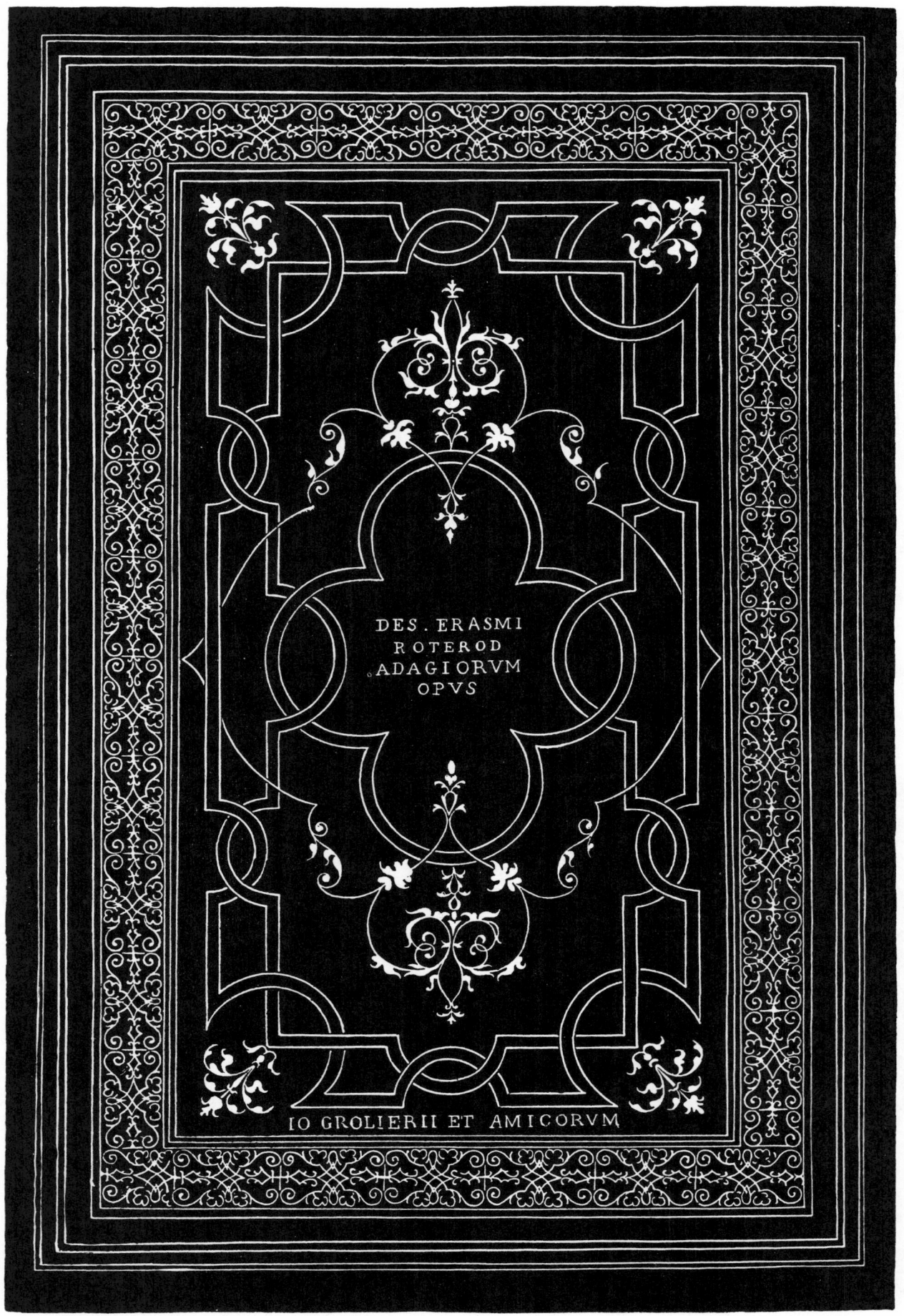

A duplicate reproduction of a Grolier binding to show the contrast of a solid
background as against the stipple in Group I No 5

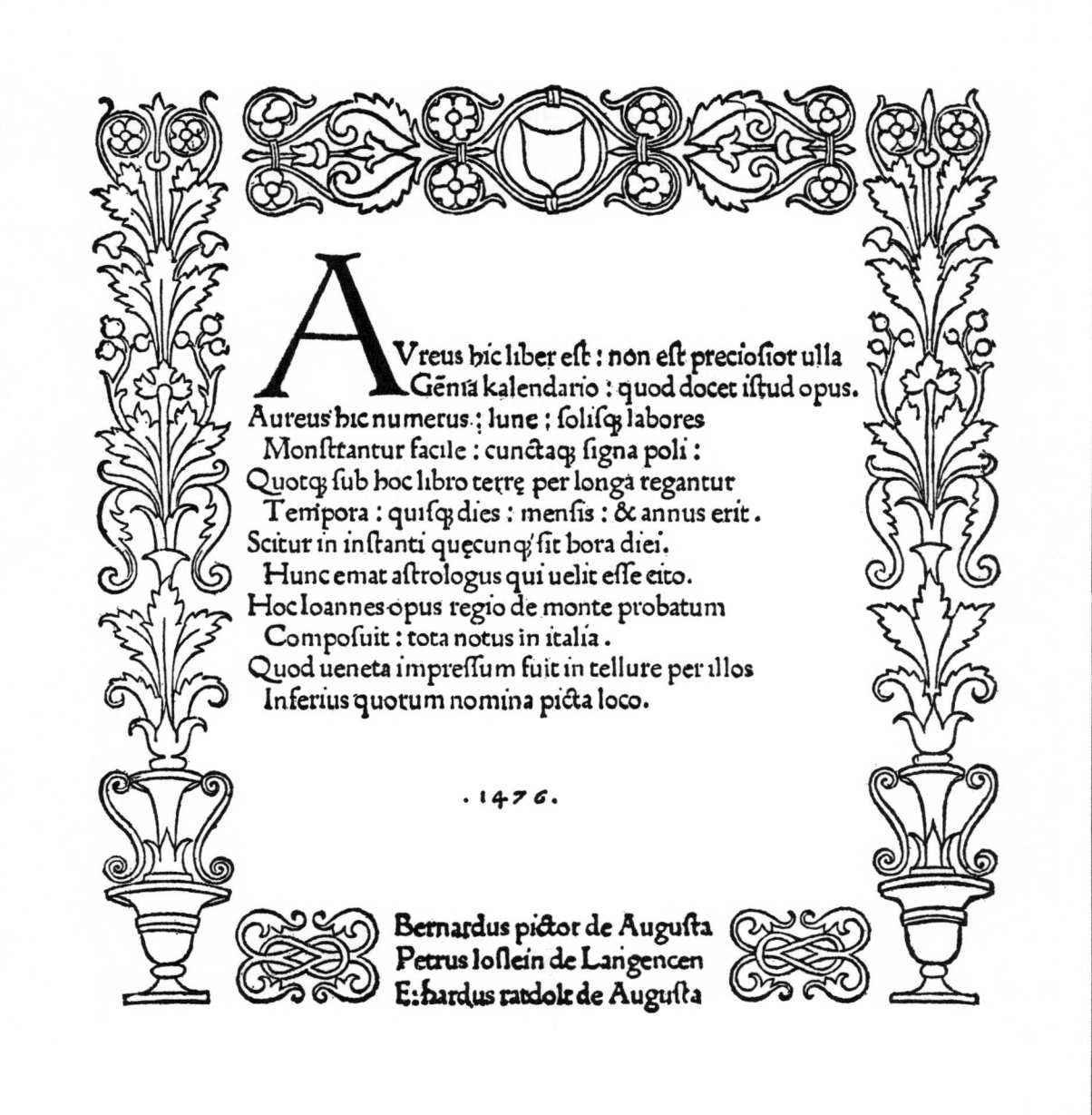

In 1476 there was printed in Venice, simultaneously in Latin, Italian and German, an absolutely perfect and complete title-page, giving the place and date of publication and the names of its printers, with no other peculiarity than the fact that the contents of the book was stated in verse instead of prose. Other title-pages were printed between 1470 and 1490 but they did not become general until as late as 1520

DESIGNS IN EARLY TITLE-PAGES

The early printed books did not have title-pages. The slow development of this feature after the invention of printing is accounted for by the reason that in this respect, as in others, the first printed books were modelled in imitation of the illuminated missals, and it was not deemed necessary in the mediaeval books and manuscripts to have a title-page, the scribe of the olden time merely recording in a note or label fastened to the end of the volume the name and description of his work; so this habit was continued for a long time by the early printers. This note or ending was called a Colophon.

Printers' devices, which were generally of an heraldic character, were commonly seen on the title-pages, some of which were very elaborate and finely designed. The famous printing house of Aldus at Venice had a device of an anchor with a dolphin twined around it, and the motto "Propera tarde" or "Festina lente" (Hasten slowly). It was from the printing press of Aldus in 1499, that the celebrated book called Poliphili Hypnerotomachia, "The Dream of Poliphilus," was issued. It is a finely illustrated book, consisting of classical compositions of figures and processions, many architectural designs, ornamental letters, emblems, and devices, all of which are executed in outline and printed from wood blocks.

A renaissance border, from a woodcut which appeared in an edition of "Herodotus" printed at Venice in 1470, has a rich and delicate design which is extremely effective in white on a black ground, and is artistically appropriate to the decoration of the page, much more so than the later French and German work in borders and title-pages, which was usually of an extremely heavy character.

Shaded designs of an architectural kind, such as friezes, columns, basis, and pediments, with corpulent figure decoration and heavy mouldings, were compositions which in the latter end of the sixteenth and during the seventeenth centuries took the place of the earlier light arabesque scroll-work of the Italian school, which revelled in the beauty of purer outline and in flat treatment of black and white.

JAMES WARD

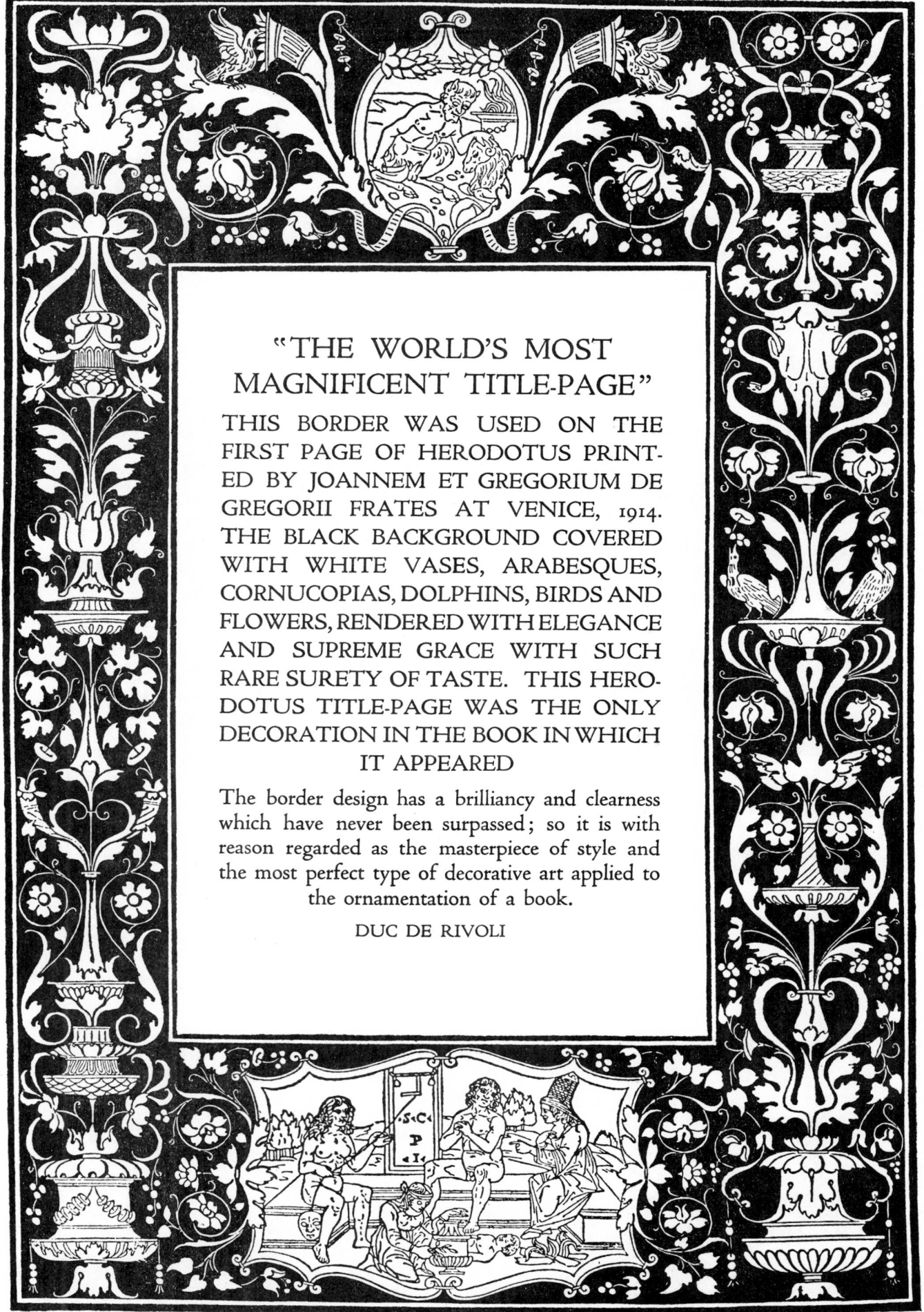

"THE WORLD'S MOST MAGNIFICENT TITLE-PAGE"

THIS BORDER WAS USED ON THE FIRST PAGE OF HERODOTUS PRINTED BY JOANNEM ET GREGORIUM DE GREGORII FRATES AT VENICE, 1914. THE BLACK BACKGROUND COVERED WITH WHITE VASES, ARABESQUES, CORNUCOPIAS, DOLPHINS, BIRDS AND FLOWERS, RENDERED WITH ELEGANCE AND SUPREME GRACE WITH SUCH RARE SURETY OF TASTE. THIS HERODOTUS TITLE-PAGE WAS THE ONLY DECORATION IN THE BOOK IN WHICH IT APPEARED

The border design has a brilliancy and clearness which have never been surpassed; so it is with reason regarded as the masterpiece of style and the most perfect type of decorative art applied to the ornamentation of a book.

DUC DE RIVOLI

Wood engraved title-pages from books printed in Augsburg by Sigmund Grimm and Marx Wirsung, 1518 and 1519

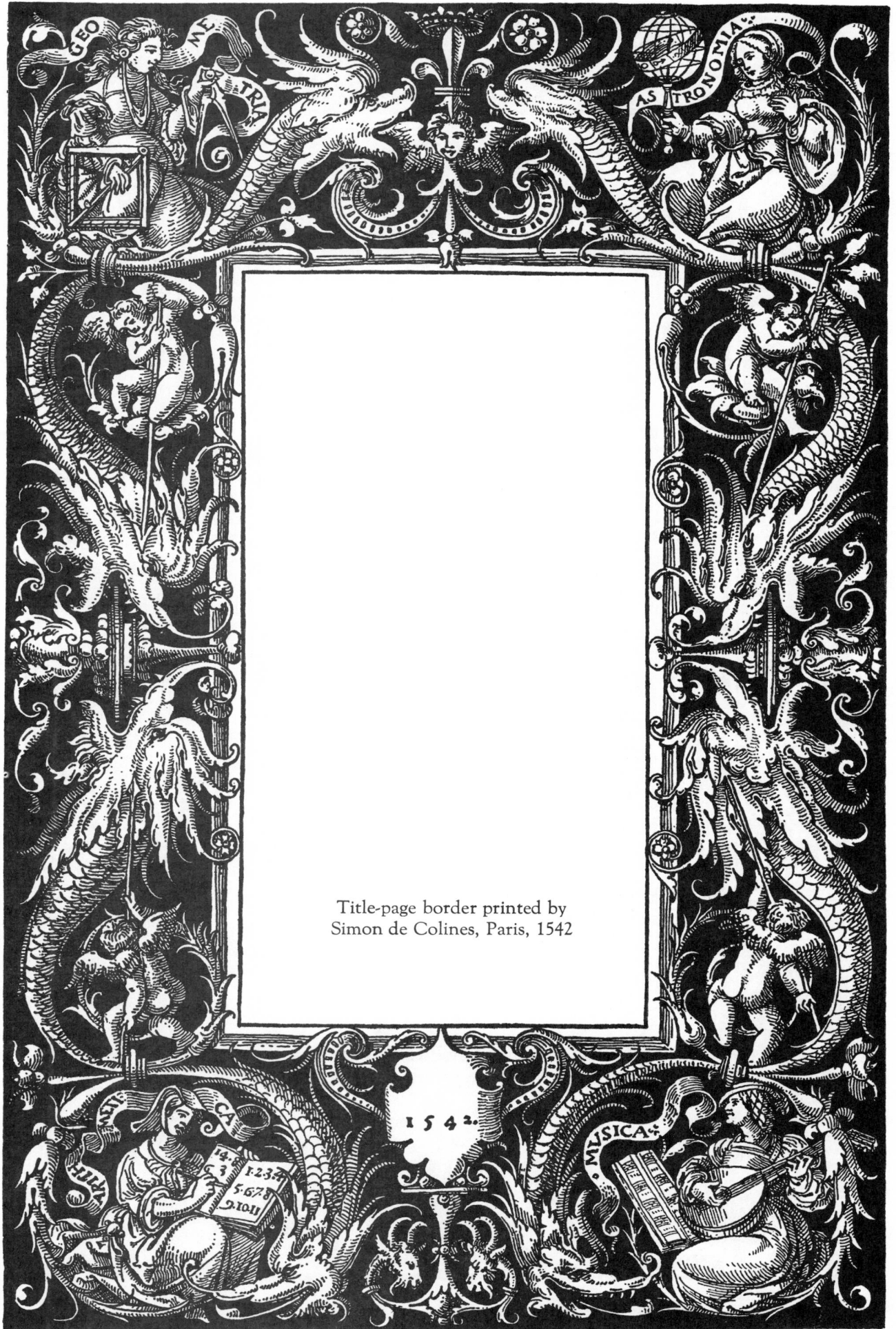

Title-page border printed by
Simon de Colines, Paris, 1542

Design by Florio Vasassore, 1507

℃ Secũda pars operis dñicæ paſſionis & reſurrectio-
nis diē idagat, & iudæoꝝ ſup hoc argumēta confutat.

Tſi multa ſunt argumenta,
quibus iudæi magnám no
bis calumniã ſolent aſtrue
re, & fidem ſperatæ a nobis
reſurrectionis ſtulta garru-
litate deridere, in hac tamē
lucubratiuncula · noſtra ea
duntàxat confutaré aggre-
diemur, quæ dominicæ paſ
ſionis & reſurrectionis materiam concernunt. Solet
nanꝗ obſtinatum illud, & ſeruile iudæorum pecus
in Chriſti ſaluatoris blaſphemiam exire propenſius
& in chriſtianorum calumniam inſultare audentius
& confidentius, quia legis noſtræ munimenta non
pauca ex auita ipſorum religione mutuati ſumus
ea præcipue, quæ agni paſchalis typo, domini paſſio
nem ſignificabant: quo fit ut perperam interpretan
tes legem, & diuini ſacra menti myſterium contami
nantes, multas indies calumnias nobis inferre nõ de
ſiſtant, nunquam cauillandi finem facientes: adeo ꝗ
cõtinuis ſubſánationibus nos laceſſentes, & ſingulas
obſeruationes noſtras deteſtátes perpetuis ipſoꝝ cõ,
tumeliis, atꝗ conuitiis ſimus obnoxii: non ſolum in
paſchæ celebratione obſeruationé noſtram ludibrio
maximoꝗ opprobrio ducentes (de quo ſuperiori lu
cubratiuncula noſtra ſcripſimus) uerũ etiam i dñicæ
paſſionis myſterio ruditatis, & iſcitiæ nos iſimulátes

A. ii

Border and initial engraved on metal, 1513

27

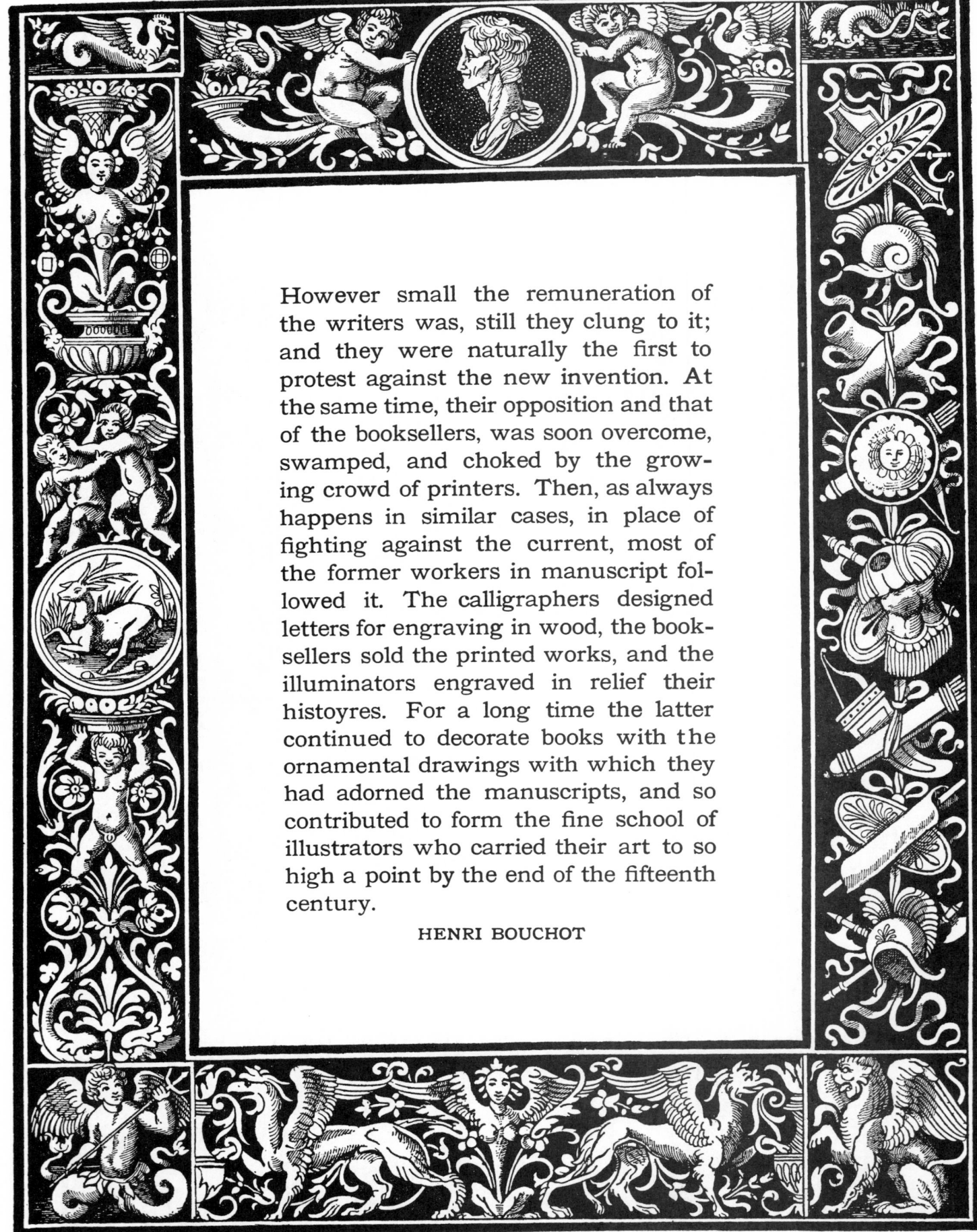

However small the remuneration of the writers was, still they clung to it; and they were naturally the first to protest against the new invention. At the same time, their opposition and that of the booksellers, was soon overcome, swamped, and choked by the growing crowd of printers. Then, as always happens in similar cases, in place of fighting against the current, most of the former workers in manuscript followed it. The calligraphers designed letters for engraving in wood, the booksellers sold the printed works, and the illuminators engraved in relief their histoyres. For a long time the latter continued to decorate books with the ornamental drawings with which they had adorned the manuscripts, and so contributed to form the fine school of illustrators who carried their art to so high a point by the end of the fifteenth century.

HENRI BOUCHOT

Title-page border from a rare folio published in Rome by Jocopo Mazocchi in 1521. This design has been described as illustrating well the printing of the early Italian Schools which had for their object the production with the plainest means the greatest possible sum of effect

An unusual type of early title-page border, the freedom of the outline and the solid black
being in contrast to the more usual strictly rectangular forms

These two reproductions are from intaglio engravings in the series of portraits of illustrious persons begun by Theodorus de Bry who was born in Liége in 1528. He was a print and book seller in Frankfort and he engraved a large number of plates. He was assisted by his son, John, who added greatly to the series of engravings of similar character. As a peculiarity some insect was used in the decorations of nearly every engraving

This portrait and the one adjoining are shown because they are representative of the great sources of decoration in intaglio engravings. As the line treatment is different from that used in relief, such work is not suited to study in technique by those designing for reproduction in photo-engraving. There are many architectural works and series of portraits which contain elaborate frames and rich ornamentation

This wreath, having the appearance of a new design, is an example
of the motives to be found in the frames, borders and trade mark
devices in the Golden Age of printing. In the center of the wreath
was the Tree of Knowledge used as a device by Jean Richer, a
publisher in Paris, 1572-1602

ALL design is a dealing with certain problems in the light of a body of
observation and experience. As to general arrangement, we are mostly
agreed that the first consideration should be utility and as to construction,
that it should be governed by stability. Beyond this, there is no agreement as
to elements and no recognized basis of criticism other than that of archaeological
correctness — judgment by authority.

W. R. LETHABY

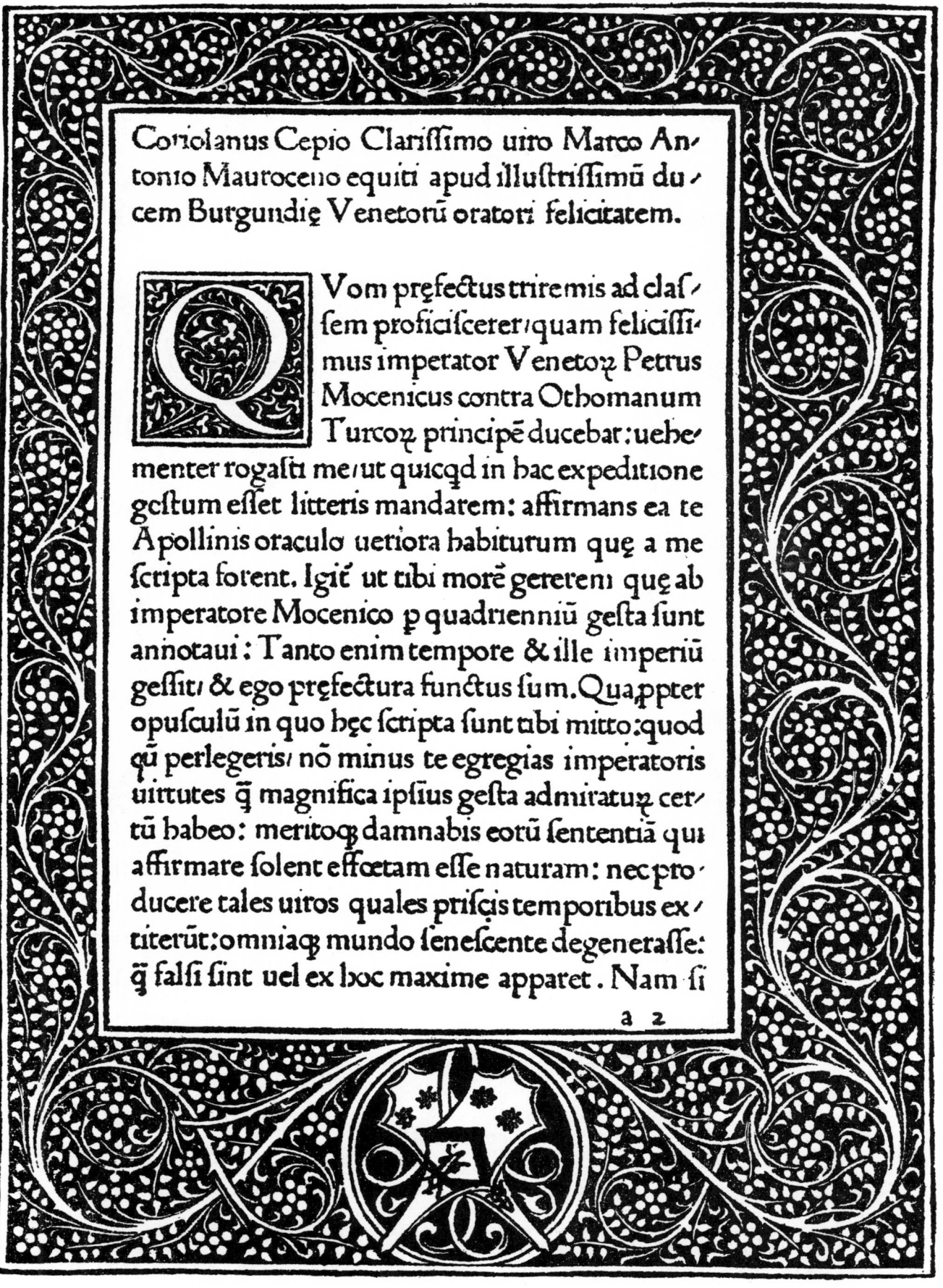

Coriolanus Cepio Clariffimo uiro Marco An-
tonio Mauroceno equiti apud illuftriffimū du-
cem Burgundiẹ Venetorū oratori felicitatem.

Vom prẹfectus triremis ad claf-
fem proficifceret/quam feliciffi-
mus impetator Venetoȥ Petrus
Mocenicus contra Othomanum
Turcoȥ principẽ ducebat:uehe-
menter rogafti me/ut quicqd in hac expeditione
geftum effet litteris mandarem: affirmans ea te
Apollinis oraculo uetiora habiturum quẹ a me
fcripta forent. Igit ut tibi morẽ gererem quẹ ab
imperatore Mocenico p quadrienniū gefta funt
annotaui: Tanto enim tempore & ille imperiū
geffit/ & ego prẹfectura functus fum.Quaȝppter
opufculū in quo hẹc fcripta funt tibi mitto:quod
qū perlegeris/ nõ minus te egregias imperatoris
uirtutes q̃ magnifica ipfius gefta admiratuȥ cer-
tū habeo: meritoȣ damnabis eotū fententiā qui
affirmare folent effœtam effe naturam: nec pro-
ducere tales uiros quales prifcis temporibus ex-
titerūt:omniaȣ mundo fenefcente degeneraffe:
q̃ falfi fint uel ex hoc maxime apparet. Nam fi

a 2

Several of the books printed by Erhart Ratdolt carry the name of Bernardus Pictor. The latter was a painter
and made the border designs and some of the initials used by Ratdolt

33

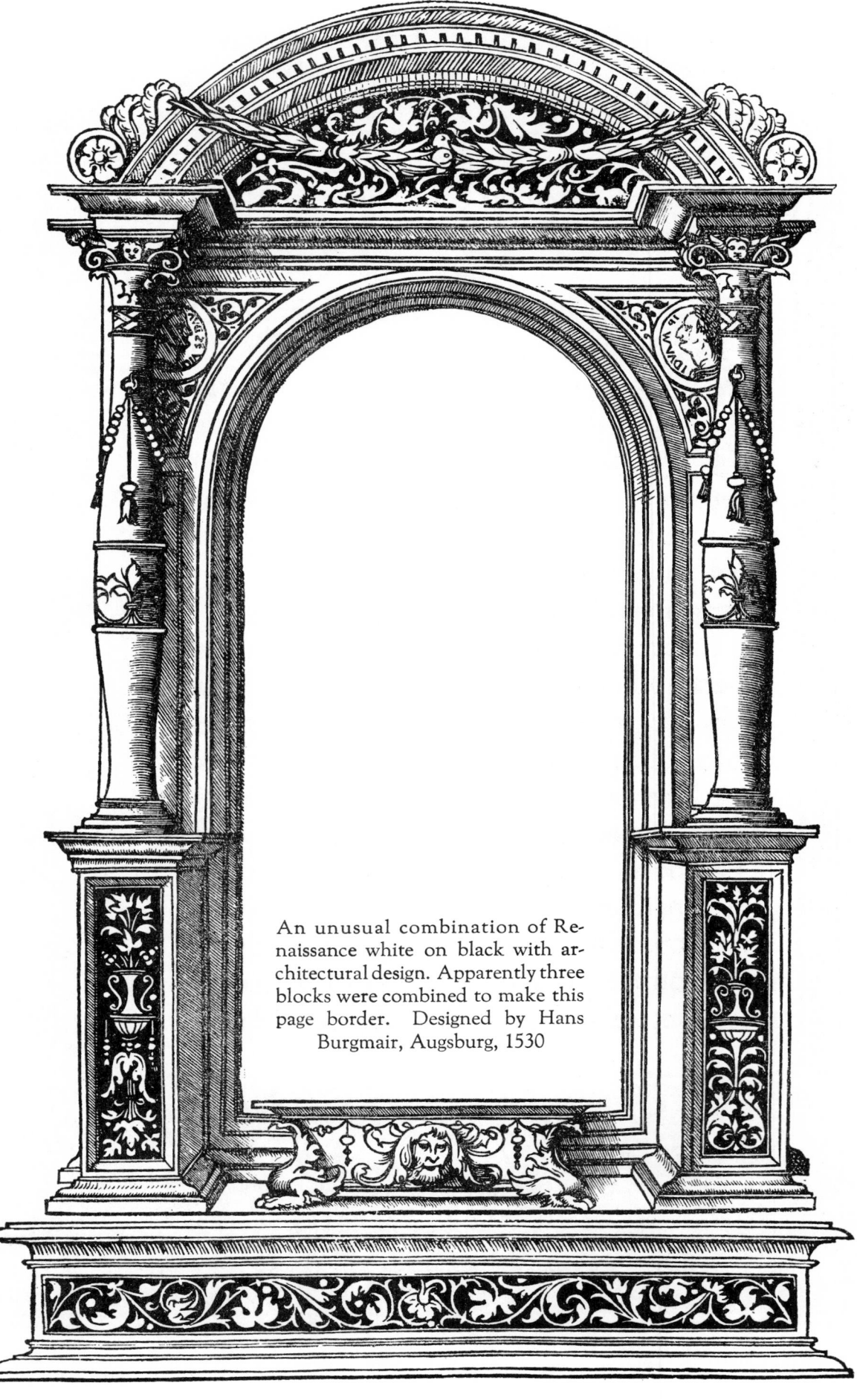

An unusual combination of Renaissance white on black with architectural design. Apparently three blocks were combined to make this page border. Designed by Hans Burgmair, Augsburg, 1530

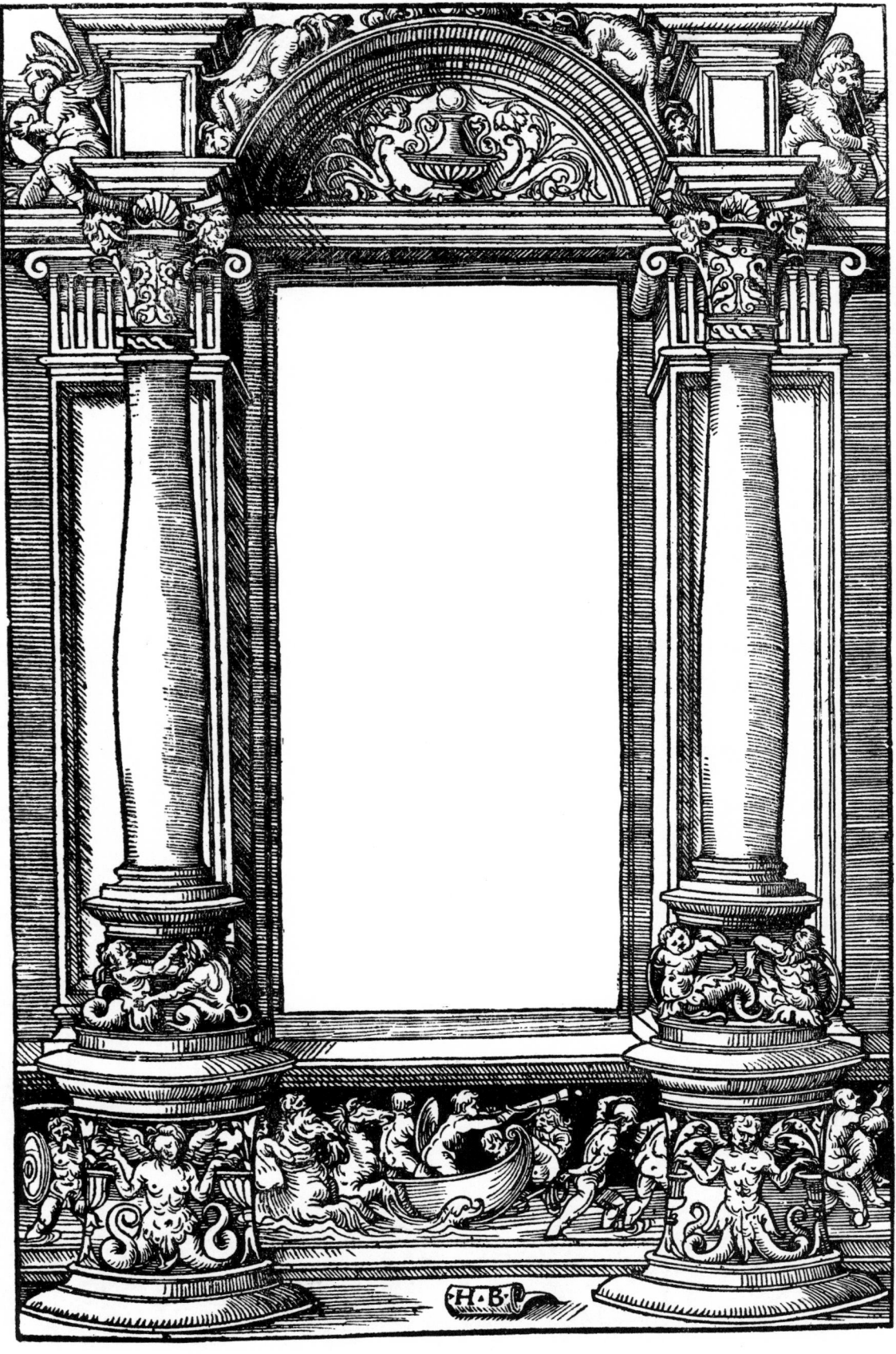

This massive and bold design was used as a border to an illustration. It is virtually a window frame with ornate architectural setting. Designed by Hans Burgmair, Augsburg, 1530

Crudely engraved but richly decorative border of 1511

Page border of 1494, practically pure white in design, and with another variation in dolphins

An illustration frame by Hans Burgmair, Augsburg, 1530. Dolphins are used eight times in the composition

The versatility of early printers in adapting a very limited number of borders and frames to succeeding works is paralleled somewhat at the present time. It is certain that many printers today do not have equal resources in what may be termed stock borders. This frame is more conventional than many of the early portrait borders and shows an oak leaf and acorn wreath which is somewhat rare as a decorative motive

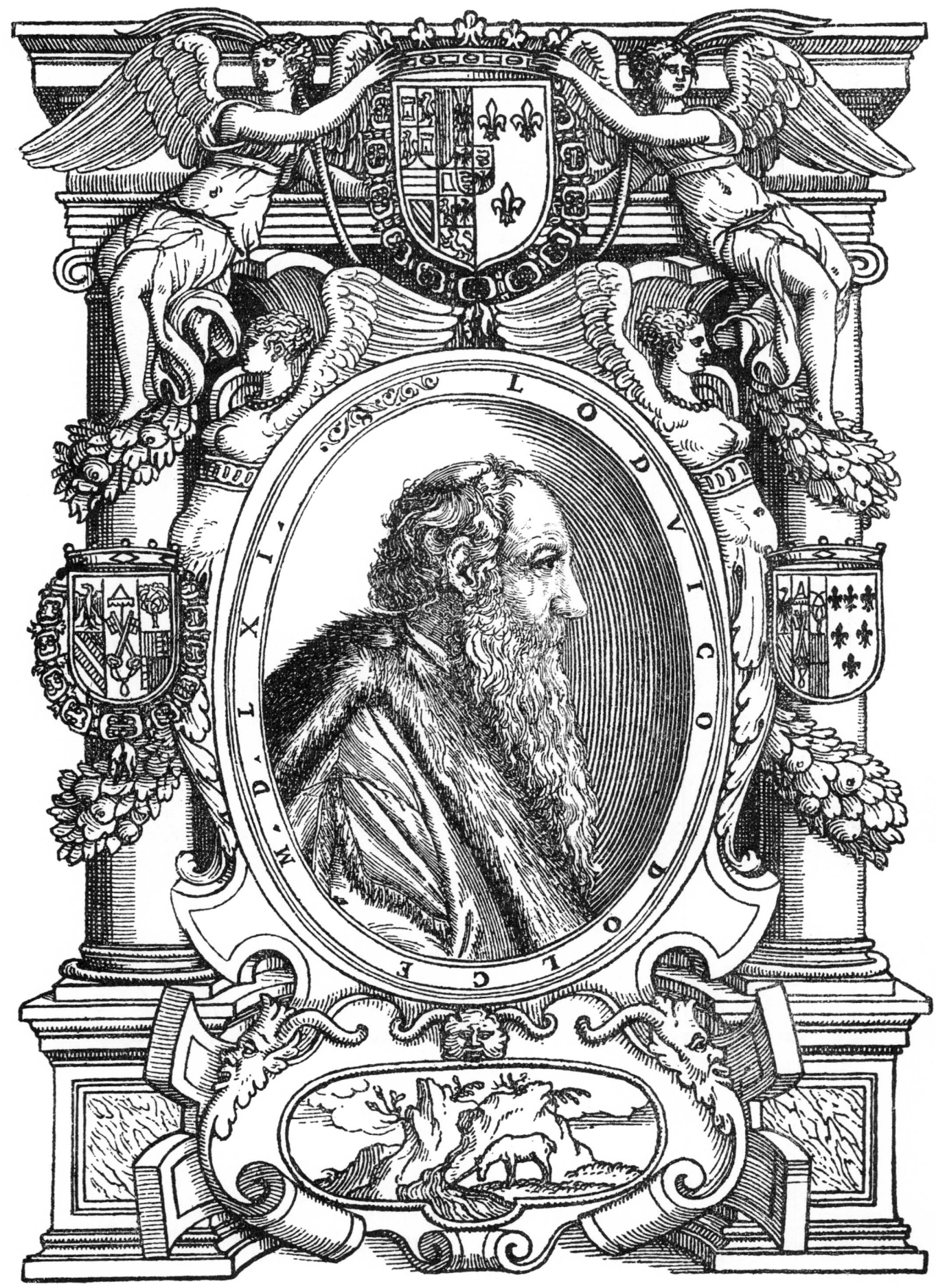

Portrait and border of 1561 by an unknown artist, printed in Venice by Gabrielle Giolito, 1562

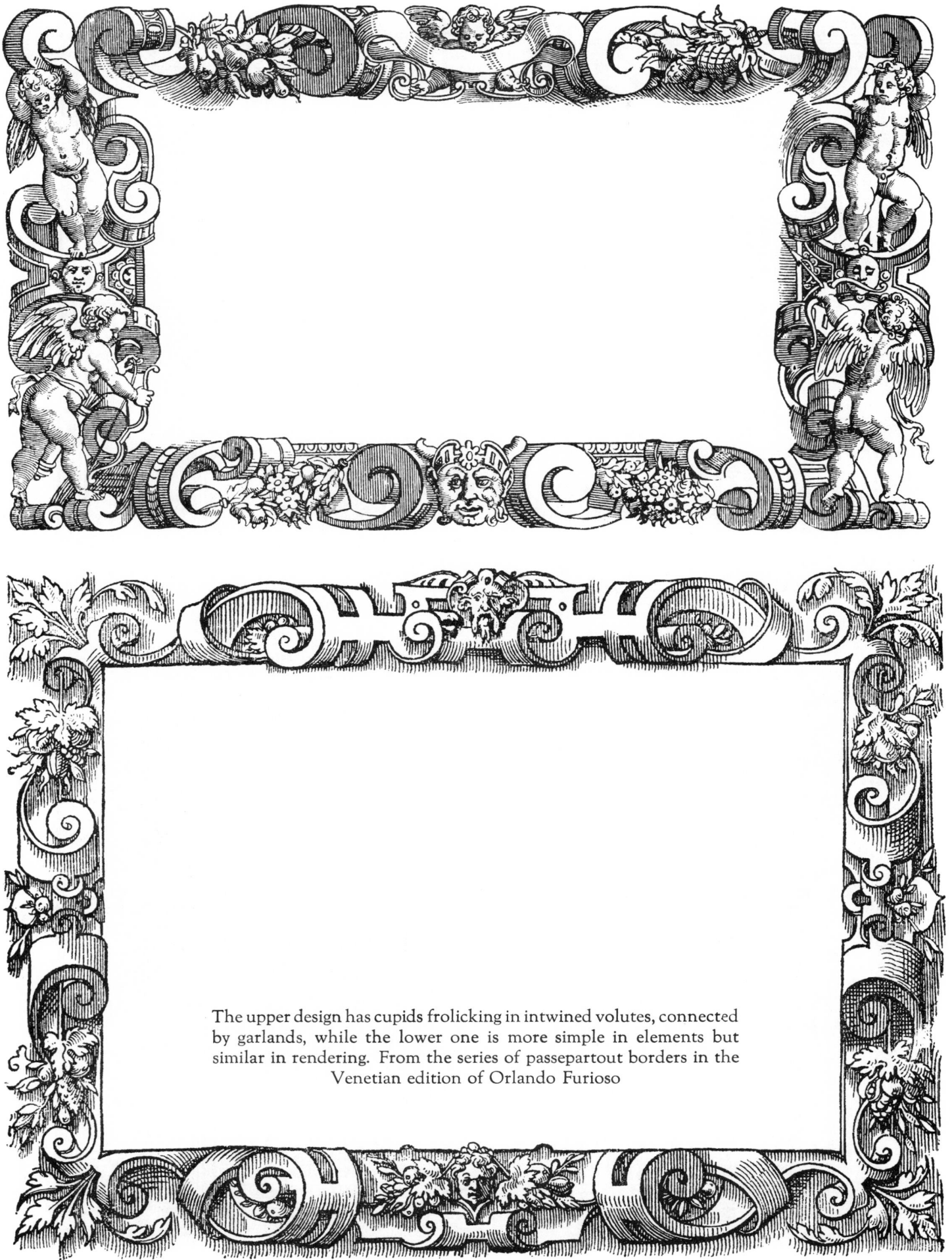

The upper design has cupids frolicking in intwined volutes, connected by garlands, while the lower one is more simple in elements but similar in rendering. From the series of passepartout borders in the Venetian edition of Orlando Furioso

These pages, dated 1508, show the early practice of cutting up borders and blocks to make uniform page sizes. Such pages are storehouses of decorative motives

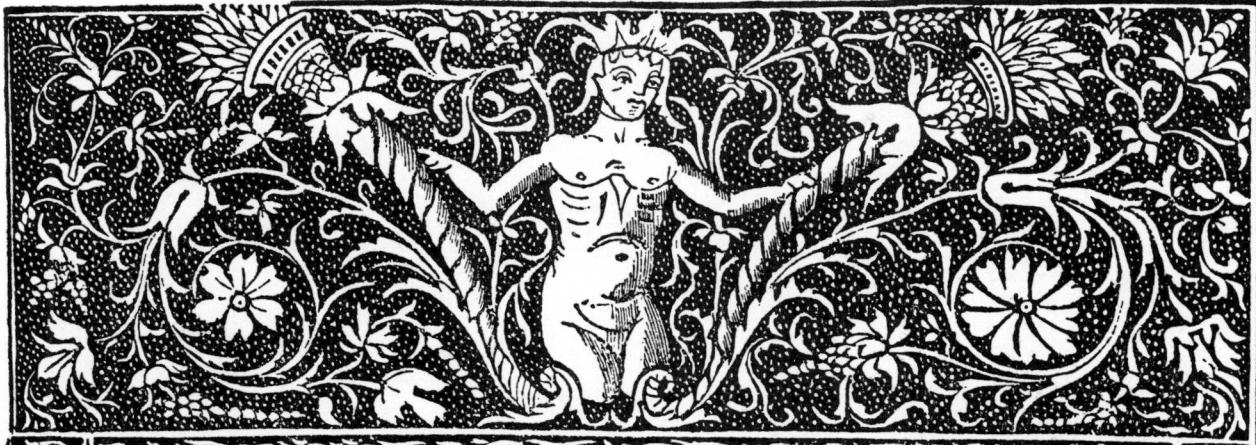

EARLY ORNAMENT AND ITS RELATION TO THAT OF TODAY

IT would be beyond the truth to say that the principles which underlie all old work are the same. Those principles are as diverse as the temperaments and characters of the races among whom they were developed. The Egyptians loved mystery and symbolism; the Greeks carried the refinement of form to perfection; the Romans revelled in richness; the Byzantines indulged in a brilliance of color that is yet always barbaric; the Arabs gave themselves up to the subtle interweaving of intricate detail; the artists of the Gothic period combined religious sentiment with energy of executions; and those of the Renaissance returned to the symbolism that runs through Egyptian ornament, the purity of line that characterizes Greek detail, or the sumptuousness that belongs to Roman scrollery. Inasmuch as all nations and all ages differ, their expression in ornament differs; and inasmuch as all nations and all ages are alike, they express themselves alike in their everyday art.

LEWIS F. DAY

A made up page border from a Venetian book of 1556 with top and bottom panels in characteristic crible backgrounds

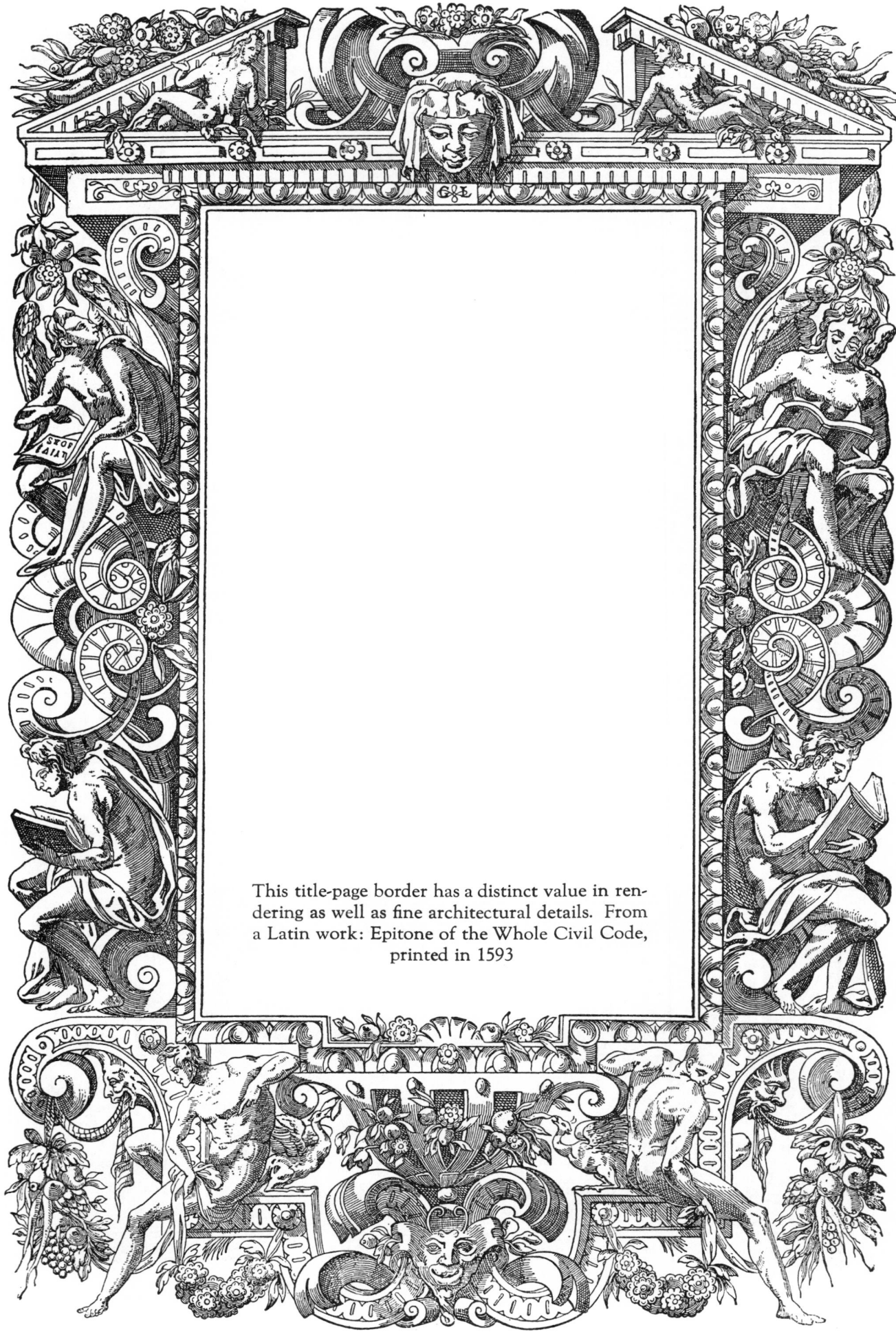

This title-page border has a distinct value in rendering as well as fine architectural details. From a Latin work: Epitone of the Whole Civil Code, printed in 1593

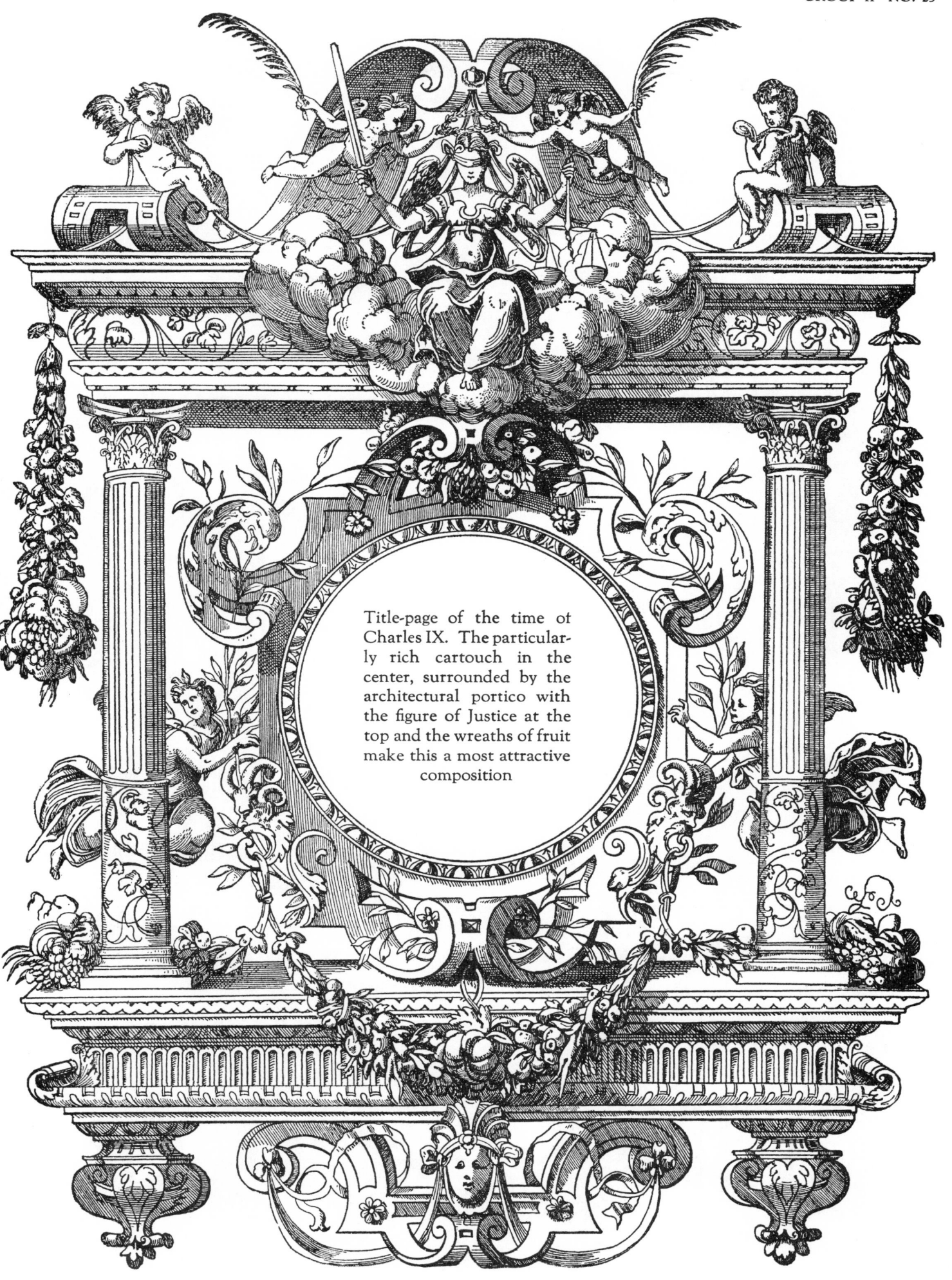

Title-page of the time of Charles IX. The particularly rich cartouch in the center, surrounded by the architectural portico with the figure of Justice at the top and the wreaths of fruit make this a most attractive composition

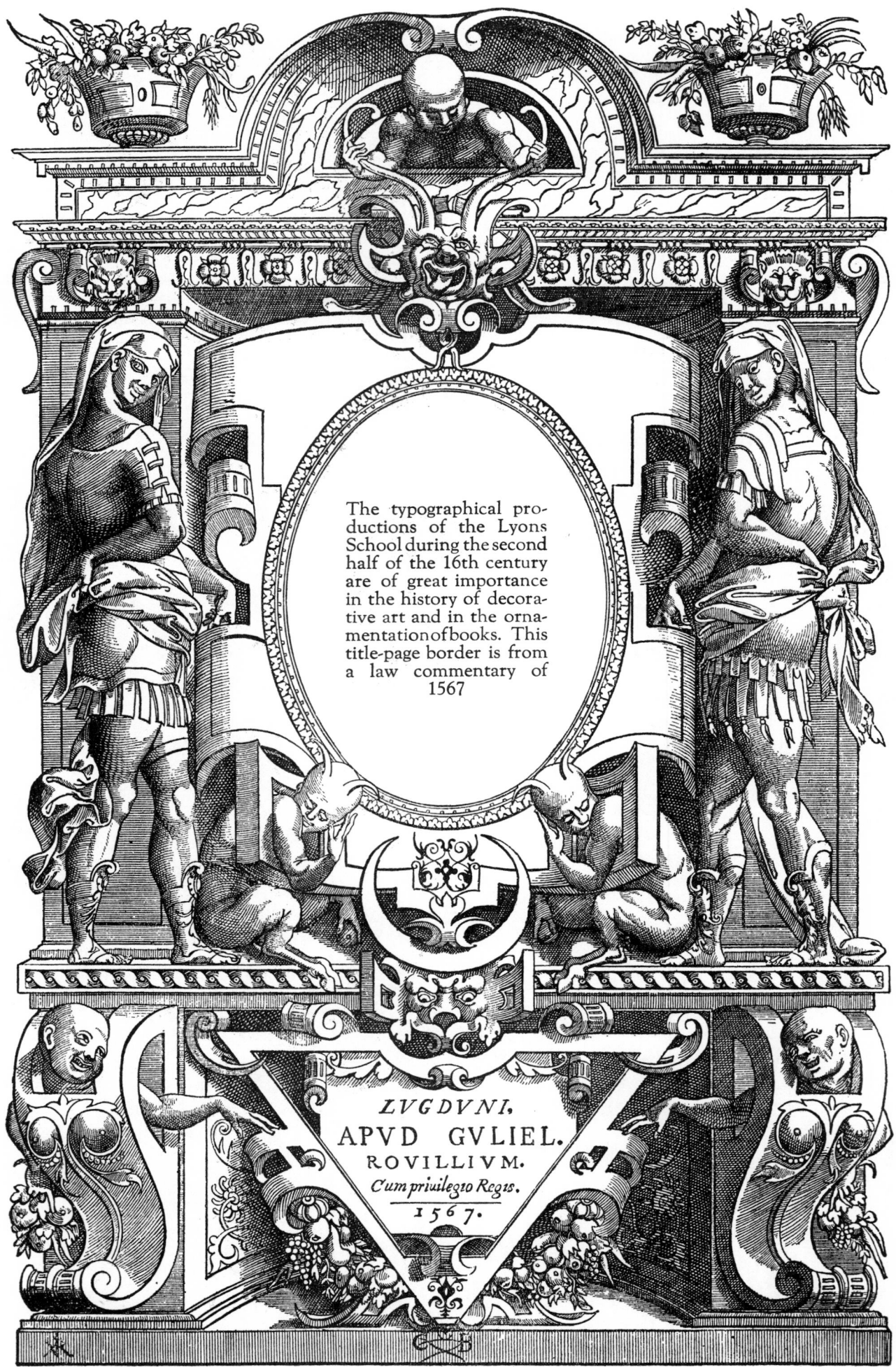

The typographical productions of the Lyons School during the second half of the 16th century are of great importance in the history of decorative art and in the ornamentation of books. This title-page border is from a law commentary of 1567

LVGDVNI,
APVD GVLIEL.
ROVILLIVM.
Cum priuilegio Regis.
1567.

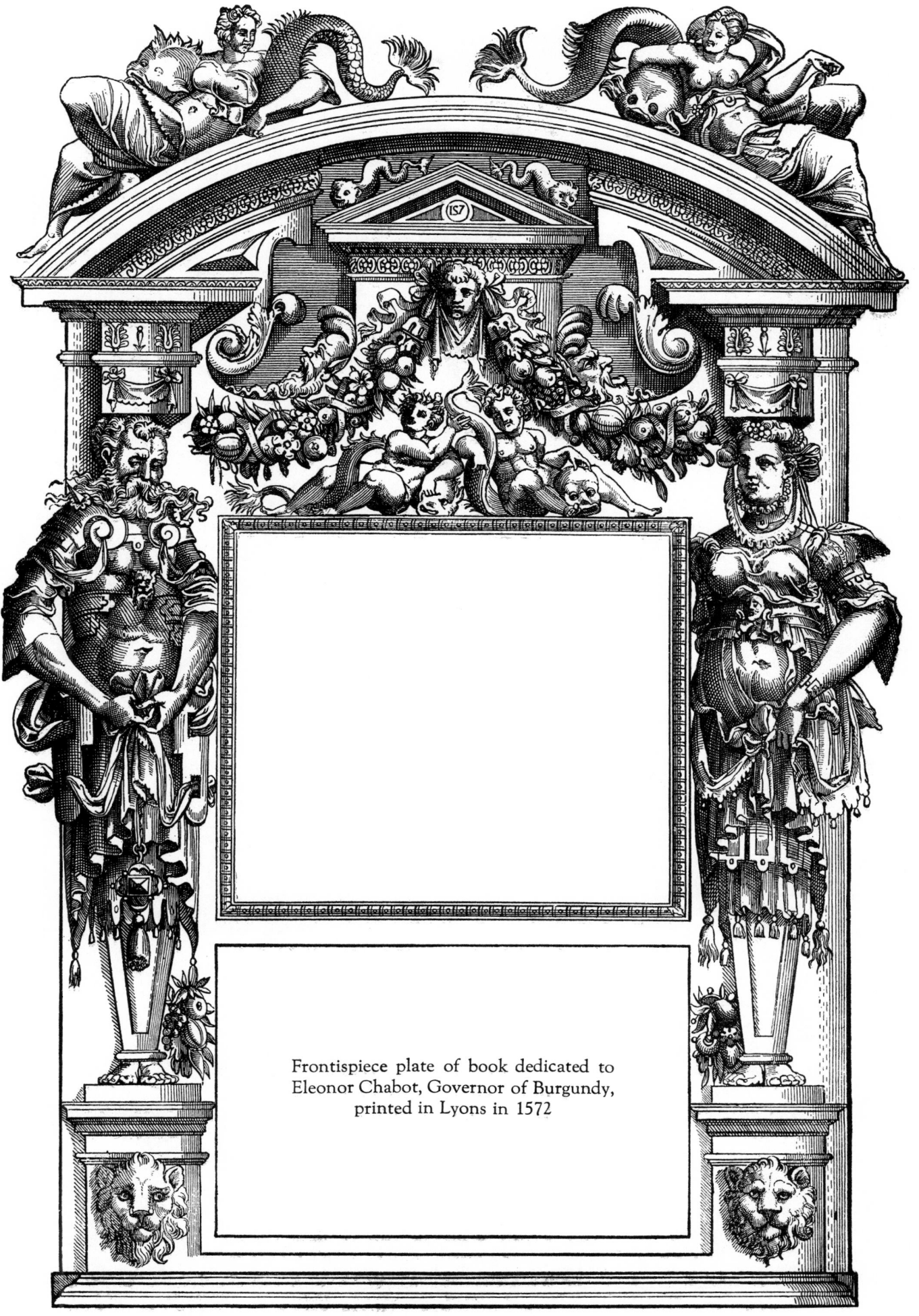

Frontispiece plate of book dedicated to
Eleonor Chabot, Governor of Burgundy,
printed in Lyons in 1572

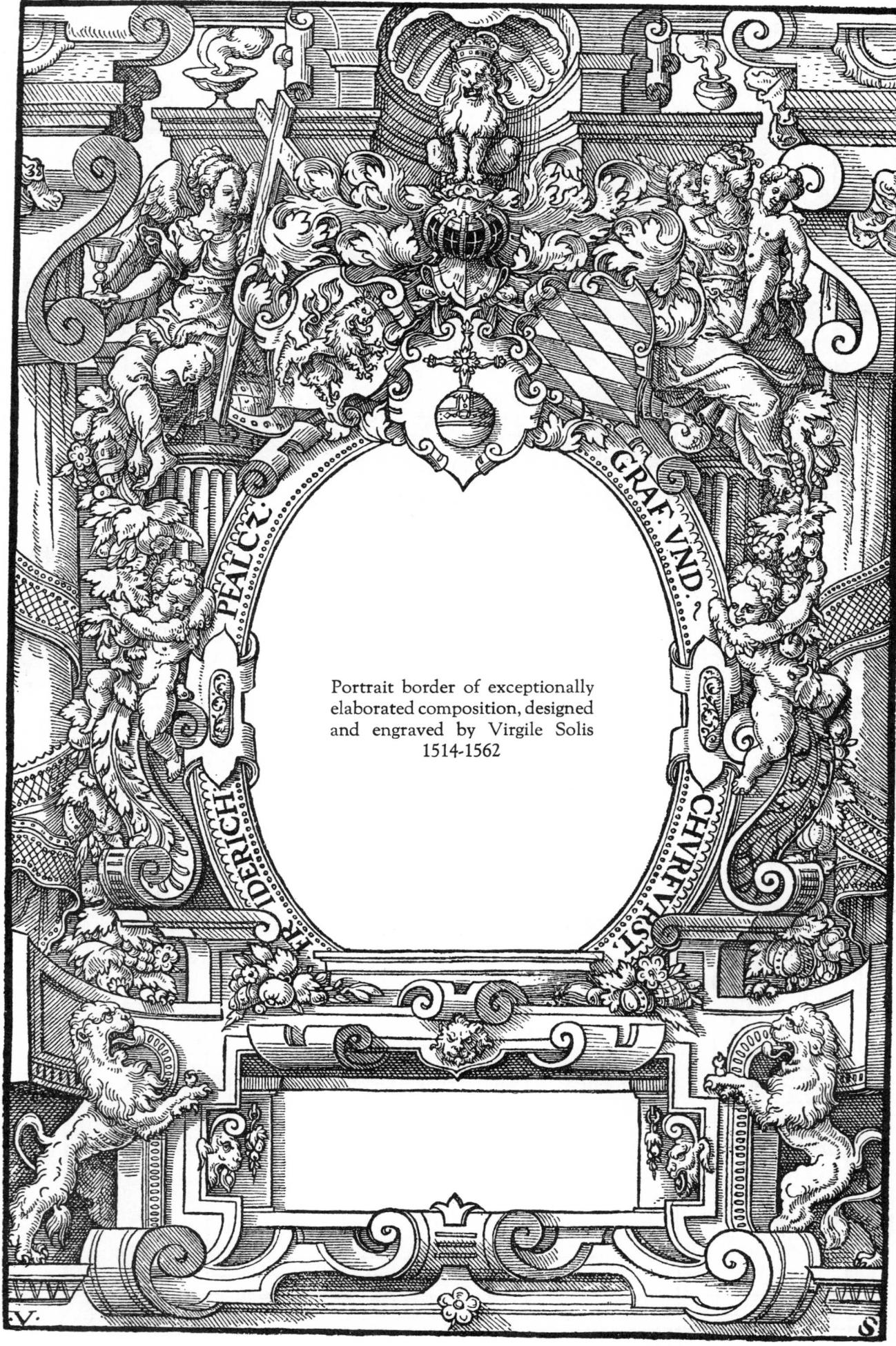

Portrait border of exceptionally elaborated composition, designed and engraved by Virgile Solis 1514-1562

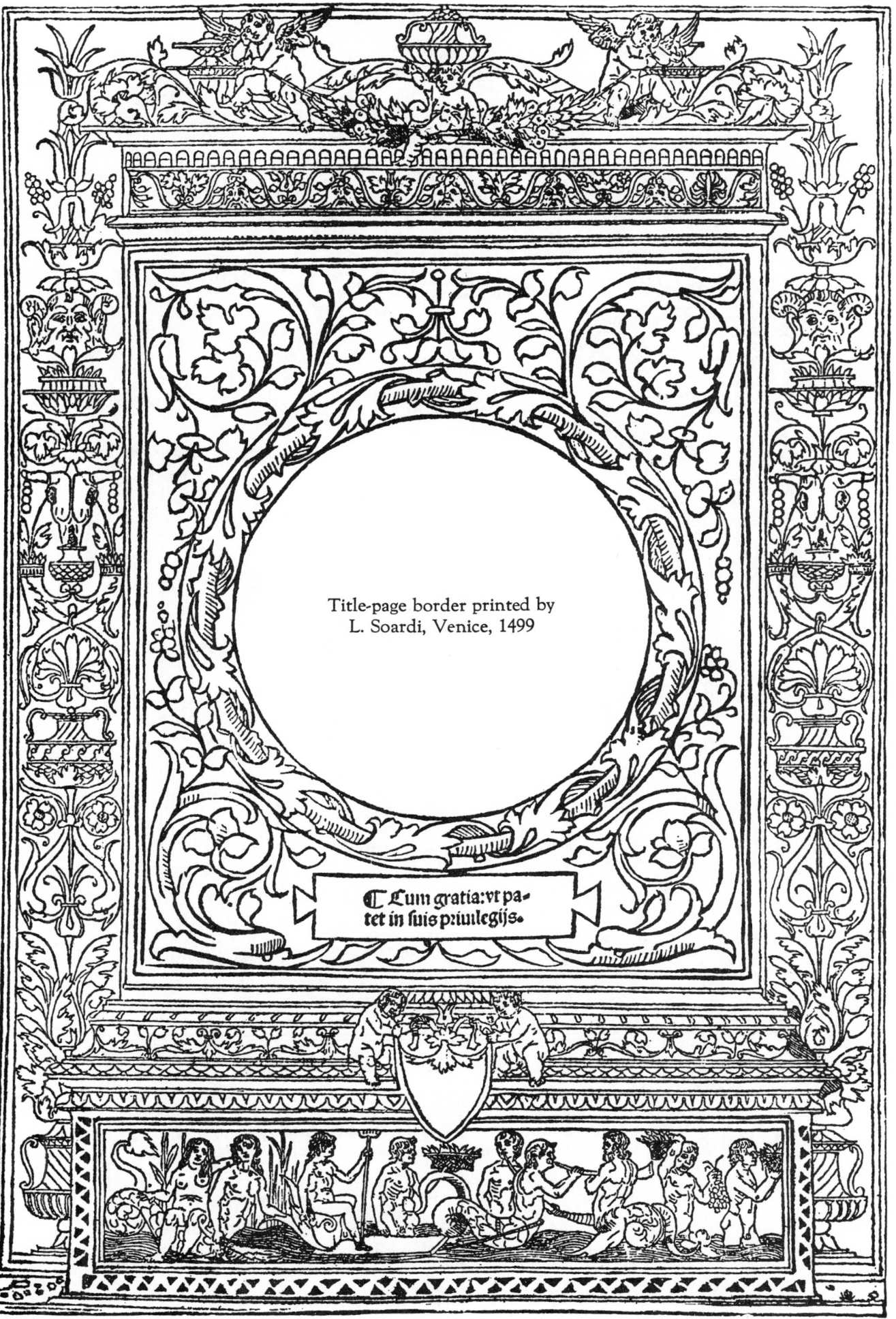

Title-page border printed by
L. Soardi, Venice, 1499

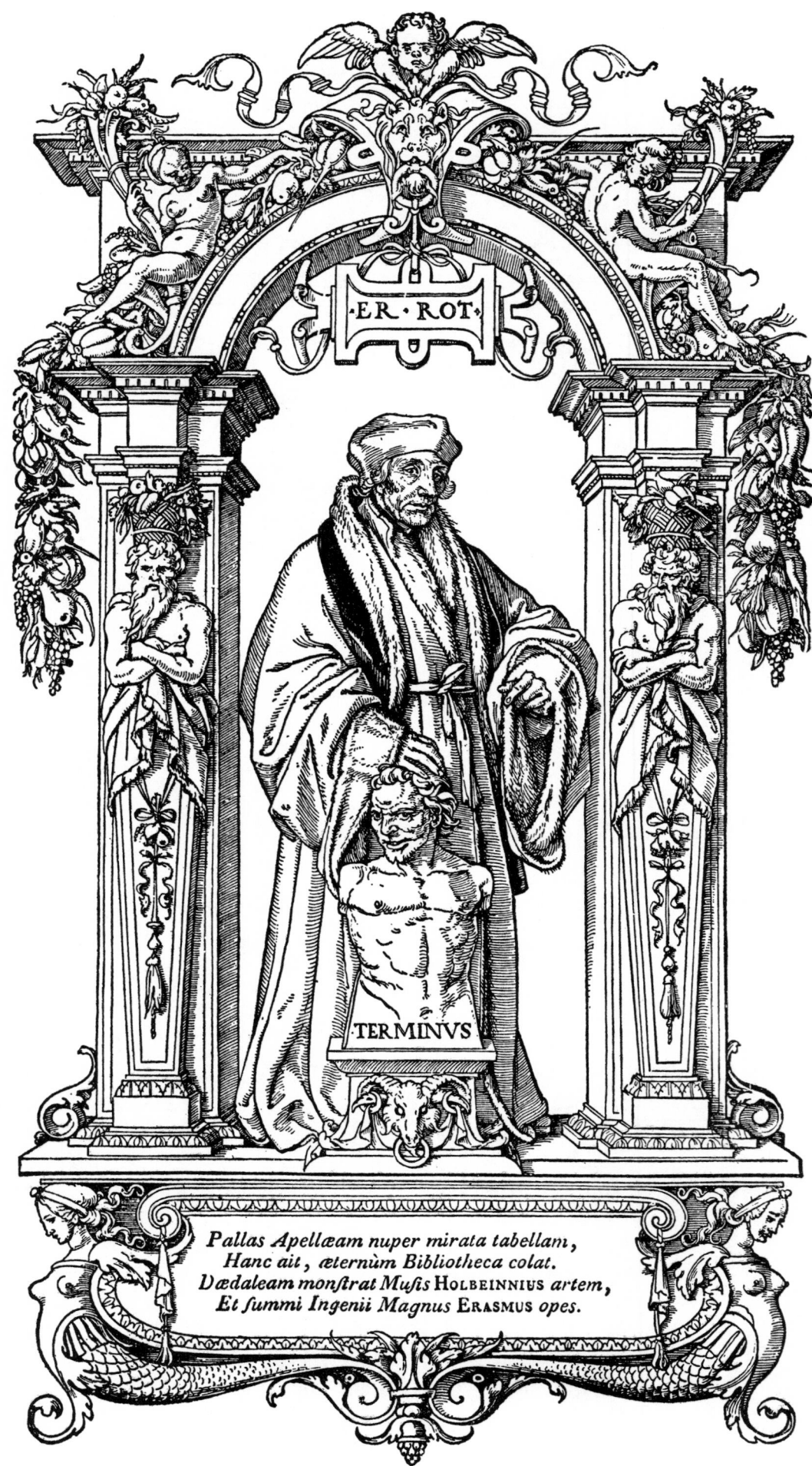

Title-page design by Hans Holbein

Title-page engraved on wood, 1503

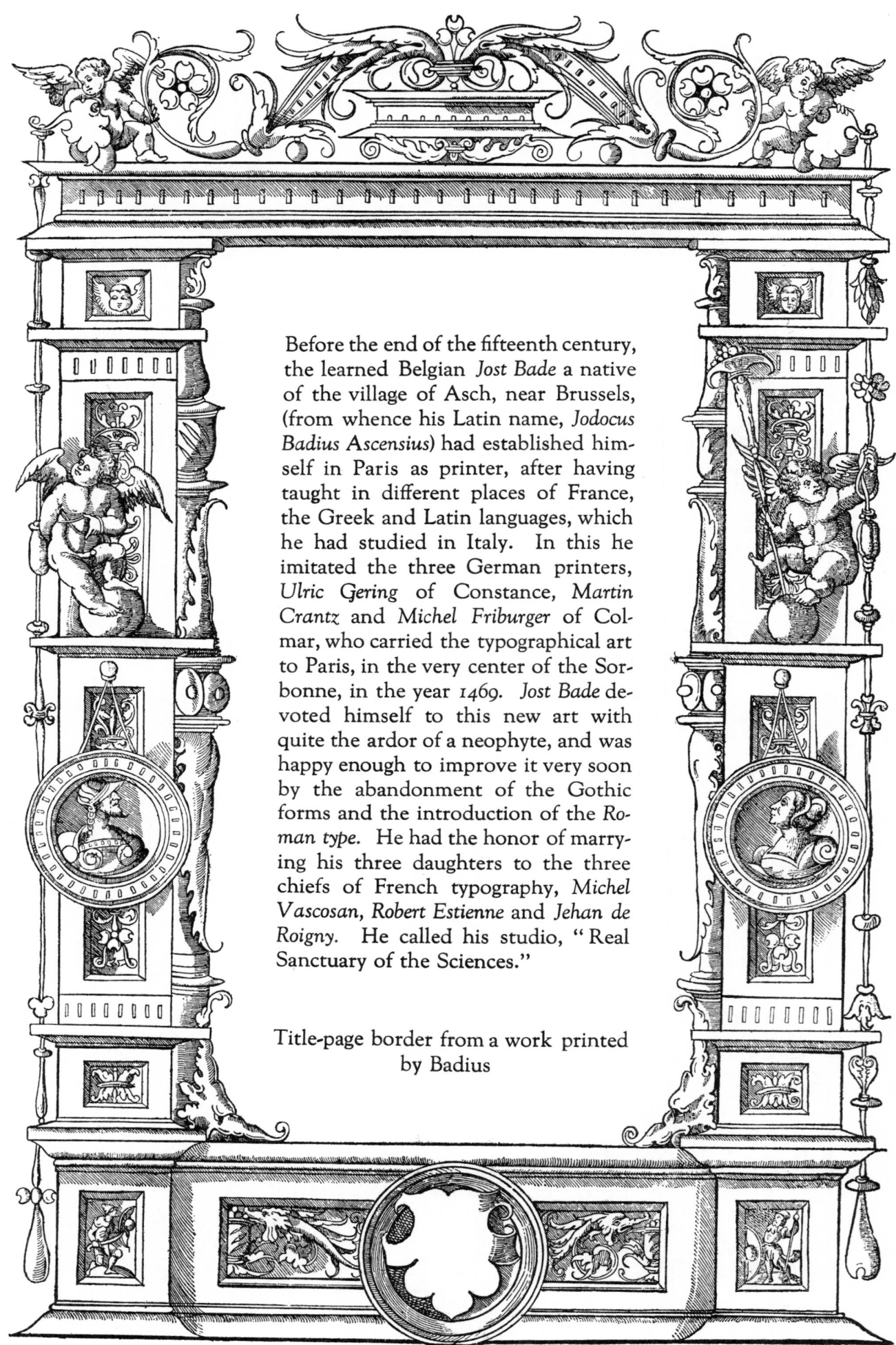

Before the end of the fifteenth century, the learned Belgian *Jost Bade* a native of the village of Asch, near Brussels, (from whence his Latin name, *Jodocus Badius Ascensius*) had established himself in Paris as printer, after having taught in different places of France, the Greek and Latin languages, which he had studied in Italy. In this he imitated the three German printers, *Ulric Gering* of Constance, *Martin Crantz* and *Michel Friburger* of Colmar, who carried the typographical art to Paris, in the very center of the Sorbonne, in the year 1469. *Jost Bade* devoted himself to this new art with quite the ardor of a neophyte, and was happy enough to improve it very soon by the abandonment of the Gothic forms and the introduction of the *Roman type.* He had the honor of marrying his three daughters to the three chiefs of French typography, *Michel Vascosan, Robert Estienne* and *Jehan de Roigny.* He called his studio, "Real Sanctuary of the Sciences."

Title-page border from a work printed by Badius

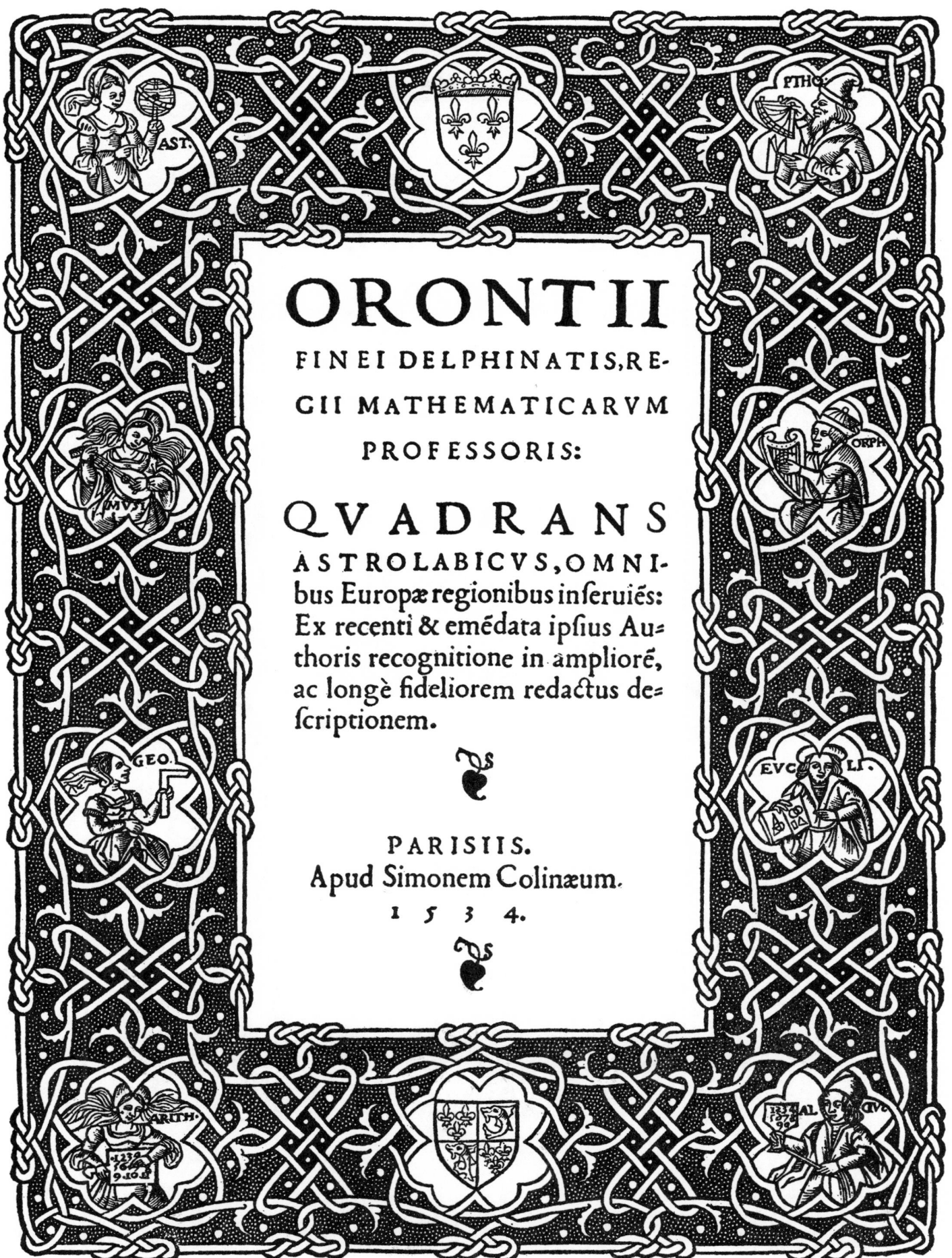

ORONTII

FINEI DELPHINATIS, RE-
GII MATHEMATICARVM
PROFESSORIS:

QVADRANS

ASTROLABICVS, OMNI-
bus Europæ regionibus inſeruiés:
Ex recenti & emédata ipſius Au-
thoris recognitione in ampliorḗ,
ac longè fideliorem redactus de-
ſcriptionem.

PARISIIS.
Apud Simonem Colinæum.
1 5 3 4.

Wood engraved title-page border with criblè background, having ribbon and interlacing in Italian style, designed
by Oronce Fine for Simon de Colines, Paris, 1534

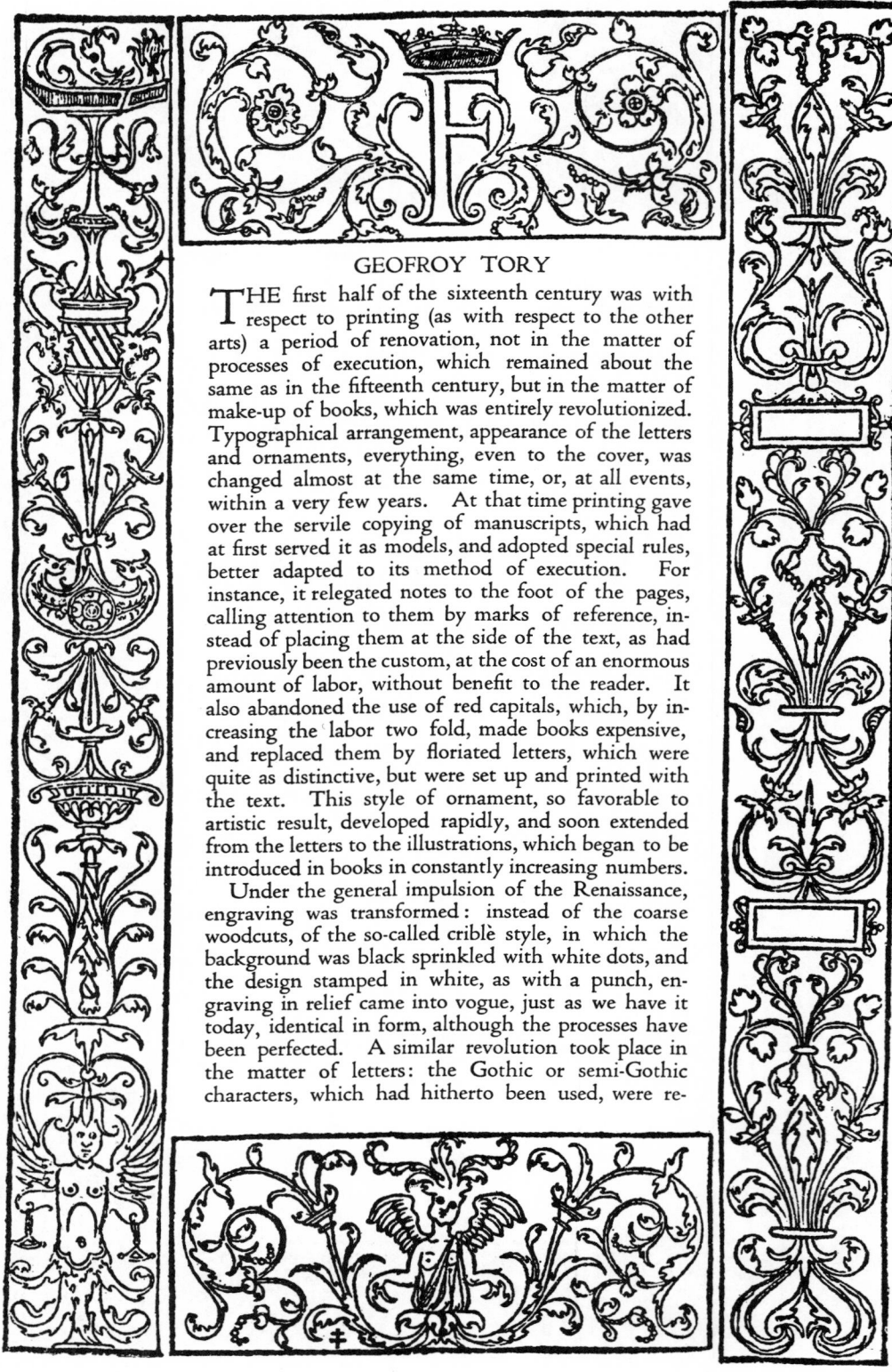

GEOFROY TORY

THE first half of the sixteenth century was with respect to printing (as with respect to the other arts) a period of renovation, not in the matter of processes of execution, which remained about the same as in the fifteenth century, but in the matter of make-up of books, which was entirely revolutionized. Typographical arrangement, appearance of the letters and ornaments, everything, even to the cover, was changed almost at the same time, or, at all events, within a very few years. At that time printing gave over the servile copying of manuscripts, which had at first served it as models, and adopted special rules, better adapted to its method of execution. For instance, it relegated notes to the foot of the pages, calling attention to them by marks of reference, instead of placing them at the side of the text, as had previously been the custom, at the cost of an enormous amount of labor, without benefit to the reader. It also abandoned the use of red capitals, which, by increasing the labor two fold, made books expensive, and replaced them by floriated letters, which were quite as distinctive, but were set up and printed with the text. This style of ornament, so favorable to artistic result, developed rapidly, and soon extended from the letters to the illustrations, which began to be introduced in books in constantly increasing numbers.

Under the general impulsion of the Renaissance, engraving was transformed: instead of the coarse woodcuts, of the so-called criblè style, in which the background was black sprinkled with white dots, and the design stamped in white, as with a punch, engraving in relief came into vogue, just as we have it today, identical in form, although the processes have been perfected. A similar revolution took place in the matter of letters: the Gothic or semi-Gothic characters, which had hitherto been used, were re-

Title-page border in separate blocks, designed by Geofroy Tory and printed by Simon de Colines, Paris, 1529

placed by roman characters of a novel shape, borrowed from the monuments of antiquity (then studied with great ardor) which continued in use until the Revolution. Lastly, the covers of books also underwent a transformation brought about by the force of events; the parchment rolls used by the ancients had been succeeded, during the Middle Ages, by bound volumes, of a shape more convenient for reading; these volumes, of which those who were fortunate enough to own any never owned more than a very small number, being intended to be arranged on the library shelves in such wise as to present one side to the visitor's eye, were adorned with numerous ornaments of various sorts on that side, so that they could easily be distinguished.

Later, these ornaments were omitted and the title of the book substituted, in huge black or gauffered letters. But the invention of printing soon caused that device to be abandoned. As the increasing numbers of books made it impossible to give up so much space to them, they were arranged side by side on the shelves, care being taken to print the title in gold letters (so that it might be more legible) on the back of the book, which was the only part of it in sight. This innovation compelled the doing away with raised decorations, especially those in precious stones or in metal, which would have torn the books that stood next them. Thereafter leather binding came into general use; the gauffering on the sides was continued for some time; but in the sixteenth century this in turn was replaced by gold tooling 'à filet' and the transformation was complete.

From the series of wood engraved borders designed by Geofroy Tory from
Lefévre d' Estaples' Commentar zu den 4 Evangelisten

The man who contributed most largely to this evolution I have described was Geofroy Tory, a man who is hardly known today, despite all his talents, although he received in 1530, as reward of his labors, the title of King's Printer, which Francis I had never before bestowed upon anyone. I say that Tory is hardly known today; in truth, it is, in his case, equivalent to being unknown, to be known, as he is, only as a publisher. Some few scholars, to be sure, are aware that he was a printer; but the fact is so little known that his biographer has denied it.

As for his noblest title to fame, that of engraver, nobody is aware of it; and yet we owe to Tory the resuscitation of engraving in France. As the historian of typography, I have thought that it was for me to describe with special care one of the fairest jewels in his crown. Such is the purpose of the work here presented, wherein will also be found, in connection with the honor paid to Tory by Francis I, some information concerning the first royal printers, and a list of those officers from the beginning down to the extinction of the office in 1830, three centuries, year for year, after its creation. Francis I is, in truth, entitled to be considered the creator of the office of King's Printer, for prior to his reign we find but one typographer who bore that title, while, from Francis I down, the series of king's printers was not again interrupted. The appointment of Pierre le Rouge, on whom the title was bestowed in 1488, may be creditable to Charles VIII, but it was without result. The honor of having made of the eminently literary post of King's Printer a permanent office reverts of right

From the series of wood engraved borders designed by Geofroy Tory from Lefévre d'Estaples' Commentar zu den 4 Evangelisten

and naturally to the prince who has been called the Father of Letters. In truth that prince, as we shall see hereafter, was not content with a single printer; he had several at once, with distinct functions, and appointed successors without loss of time to such as retired or died during his lifetime.

But, I repeat, the principal purpose of my work is to make Tory known as one of the most skilful engravers we have ever had. Of course I cannot forget that he was the learned editor of the 'Cosmographie du Pape Pie II,' the 'Itinéraire Antonin,' etc.; the publisher, of rare taste, who put forth the Hours of 1525, 1527, etc.; the accomplished printer of the 'Sacre de la Reine Eléonore,' and the distinguished philologist of 'Champ fleury,' to whom, as we shall see, we owe the invention of the orthographic forms peculiar to the French language. But what has especially attracted me in Tory is his work as an engraver. In that role he was without predecessor or rival, for those persons who may be represented as such may have been his pupils, nothing more. Jean Duvet alone might quarrel with this limitation; but, although he was Tory's contemporary, he was not his teacher; for Tory had gone for his schooling in the art to the very fountain-head, to Italy, before Duvet produced anything. As for Jean Cousin, de Laulne, du Cerceau, Leonard Gauthier, and the rest, they did not come until after Tory. The honor of revivifying the art of engraving in France belongs to Tory alone, bestriding two centuries, the fifteenth and sixteenth; indeed, some of his productions are pure Gothic. AUGUSTE BERNARD

From Geofroy Tory, by Auguste Bernard, as translated by George Ives, illustrated by drawings by Bruce Rogers, and published by Houghton Mifflin Co., Boston, 1909. The reproductions from Mr. Rogers' drawings give a much more correct showing of the beauty of line and design than in these direct reproductions which have the imperfections of the early printing

Four page borders similar in proportions and color but presenting an interesting variety in decorative details and patterns. These are from the series of decorative and pictorial borders in Ovid's Metamorphoses, commonly attributed to Salomon Bernard. They are sometimes credited to Geofroy Tory but only one border of the entire series carries his mark. Printed by Jean de Tournes at Lyons, 1558

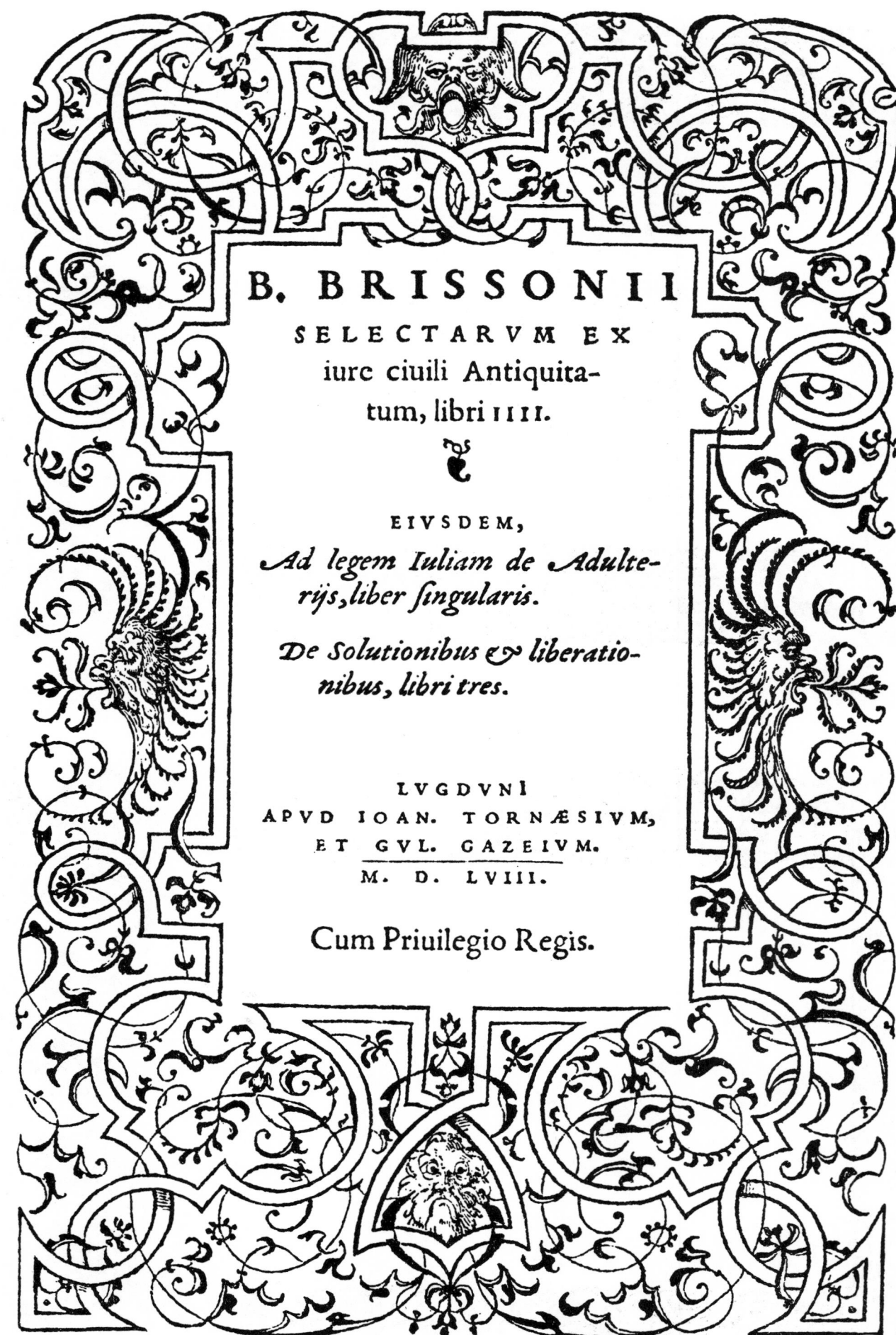

B. BRISSONII

SELECTARVM EX
iure ciuili Antiquita-
tum, libri IIII.

EIVSDEM,

*Ad legem Iuliam de Adulte-
rijs, liber singularis.*

*De Solutionibus & liberatio-
nibus, libri tres.*

LVGDVNI
APVD IOAN. TORNÆSIVM,
ET GVL. GAZEIVM.
M. D. LVIII.

Cum Priuilegio Regis.

Wood engraved border designed by Salomon Bernard and printed by Jean de Tournes, Paris, 1558

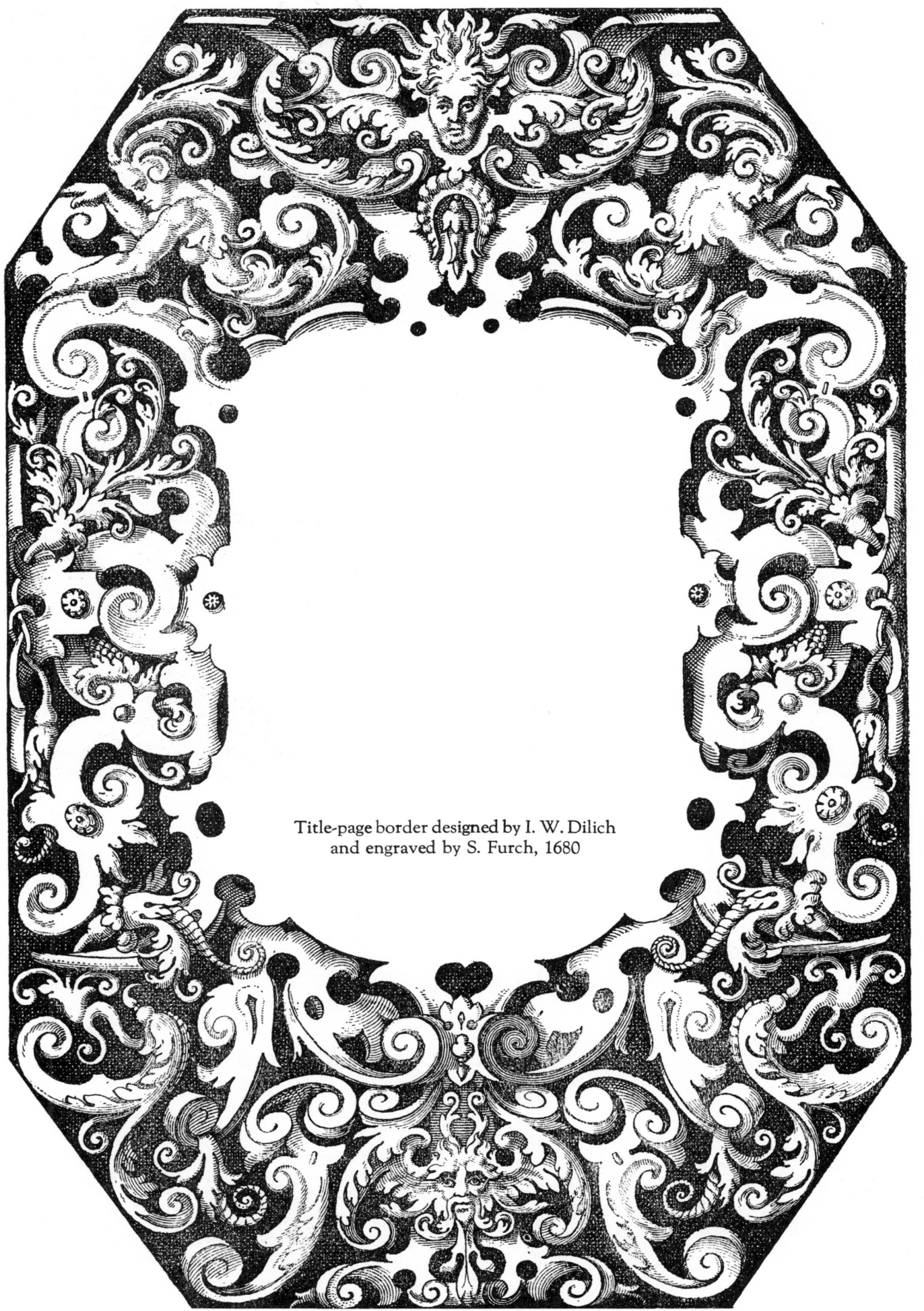

Title-page border designed by I. W. Dilich
and engraved by S. Furch, 1680

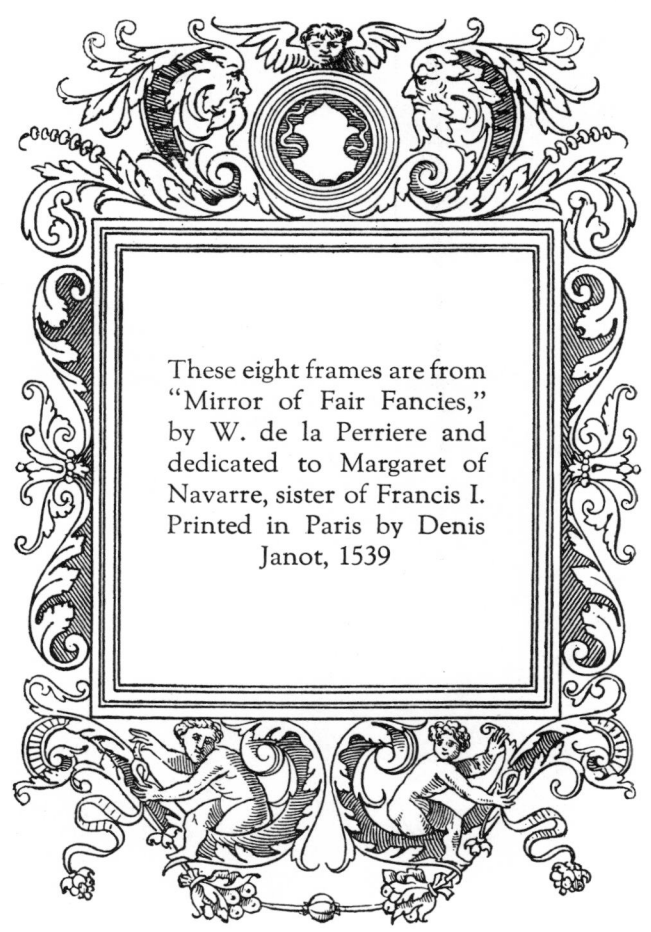

These eight frames are from "Mirror of Fair Fancies," by W. de la Perriere and dedicated to Margaret of Navarre, sister of Francis I. Printed in Paris by Denis Janot, 1539

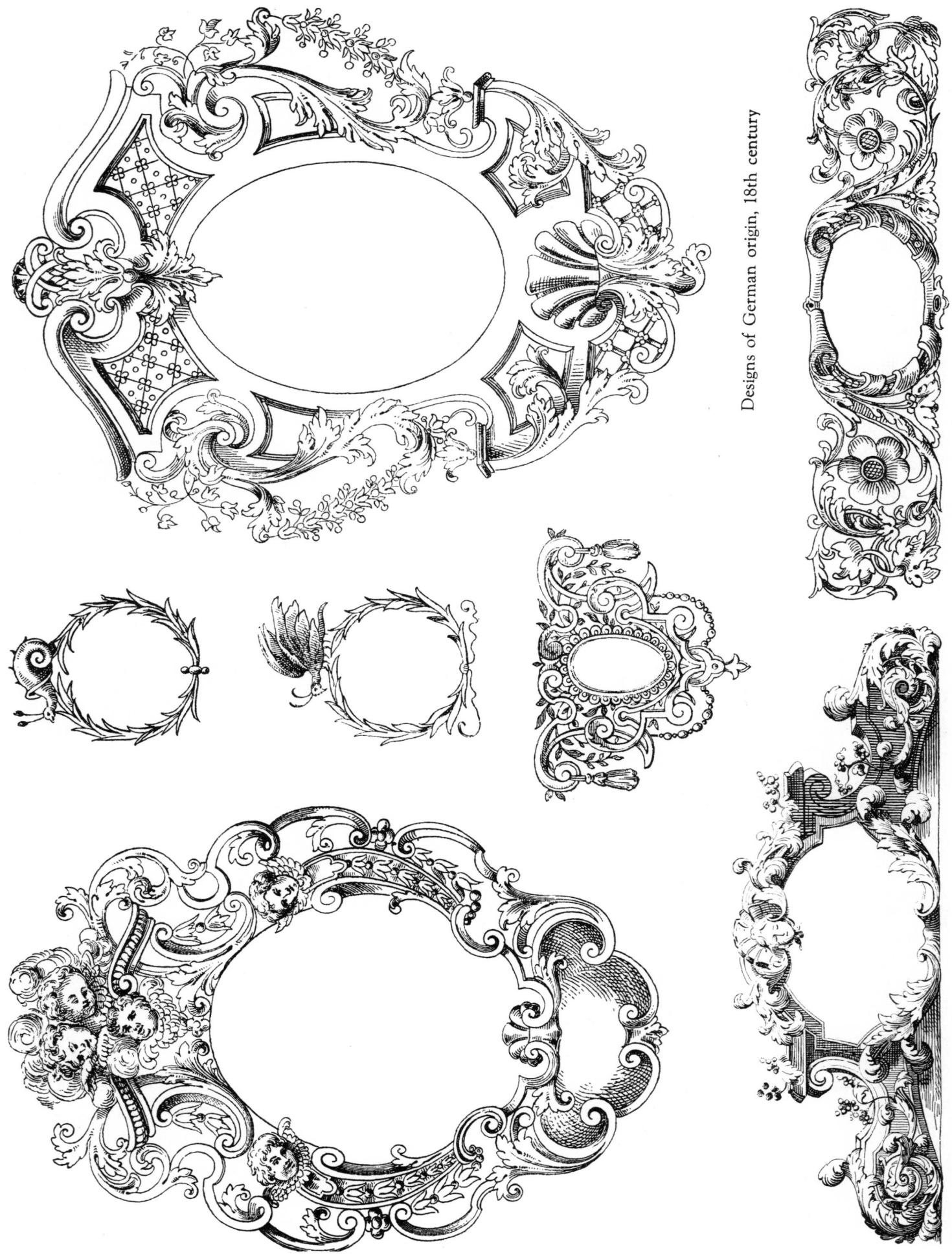

Designs of German origin, 18th century

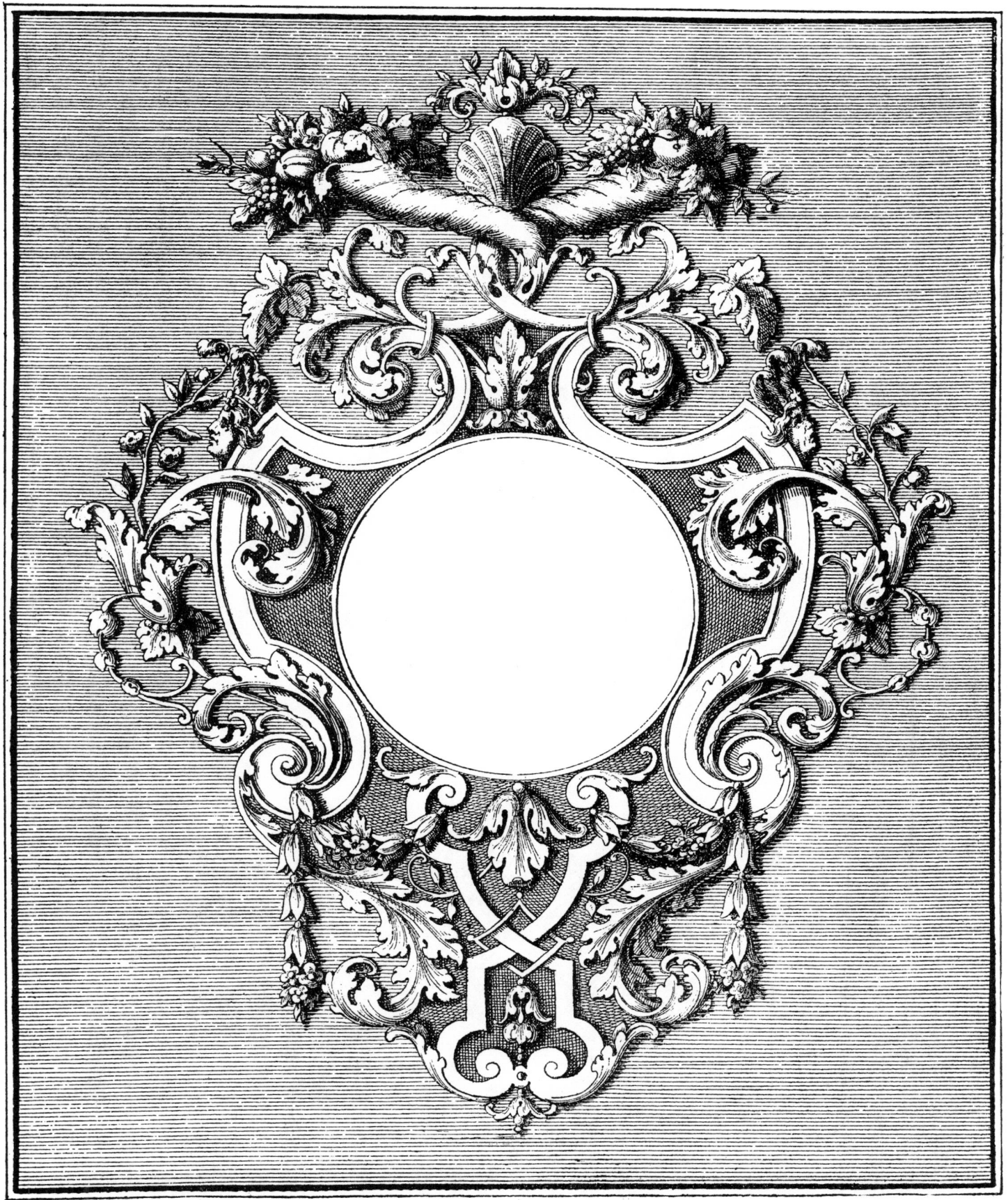

Cartouch designed by John Leonard Eysler, and engraved by H. Bolman, 1730

Scroll frame with excellent delineation of acanthus forms

Cartouch designs of the Spanish School of the 16th century, by Frederic Zuccaro

German designs from a work
printed in 1559

HISTORIC DESIGN IN PRINTING
GROUP III—DECORATIONS

The successful designer of ornament should have a thorough knowledge of the historic styles, not for the purpose of reproducing their forms, but in order to discover for himself the methods by which the old artists arrived at the successful treatment of nature and of former styles, so that by the application of his knowledge, derived from the study of nature and the works of former artists, he may be enabled to give to the world some original and interesting work.

JAMES WARD

A MIRACLE OF GENIUS

Yes, he is a miracle of genius, because he is a miracle of labor; because, instead of trusting to the resources of his own single mind, he has ransacked a thousand minds; because he makes use of the accumulated wisdom of ages, and takes as his point of departure the very last line and boundary to which science has advanced; because it has ever been the object of his life to assist every intellectual gift of nature, however munificent and however splendid, with every resource that art could suggest and every attention that diligence could bestow.

SIDNEY SMITH

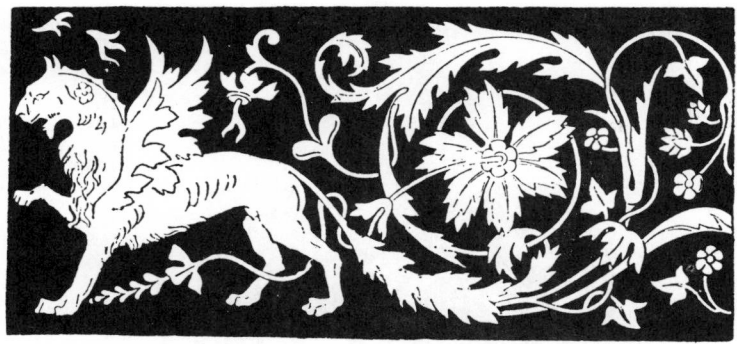
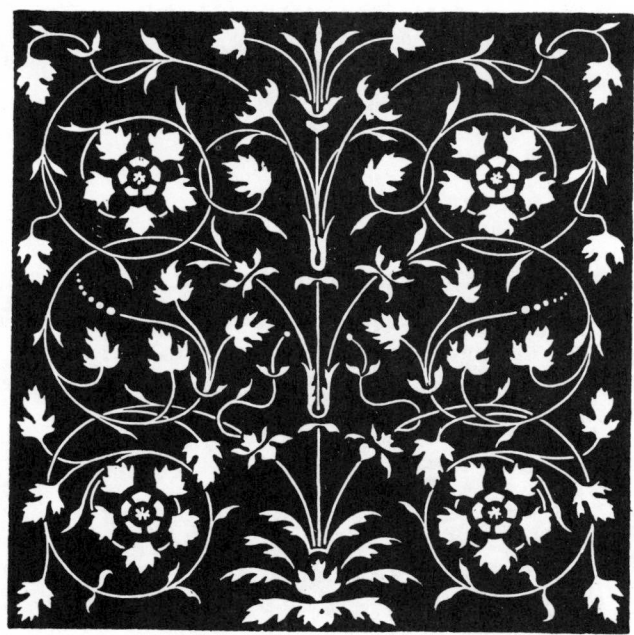
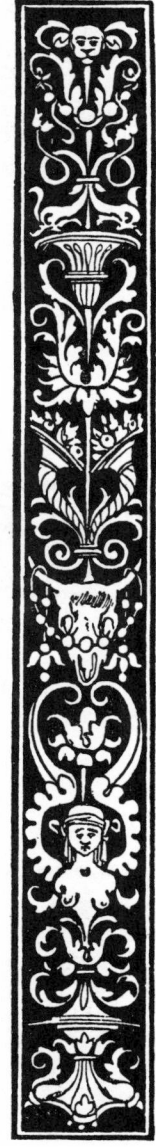

 VERY day and all day long we breathe the atmosphere of ornament. There is no escape from its influence. Good or bad, it pervades every object with which our daily doings bring us in contact. We may, if we choose, keep away from picture galleries and not look at pictures; but, our attention once turned to ornament, we can no longer shut our eyes and decline to take heed of it, though there are all about us forms of it which every cultivated man would evade at any cost if he could. It may be to us a dream of beauty or a horrible nightmare, but we cannot shake it off. At every turn in life we come face to face with some fresh phase of it.

12 point Bodoni

LEWIS F. DAY

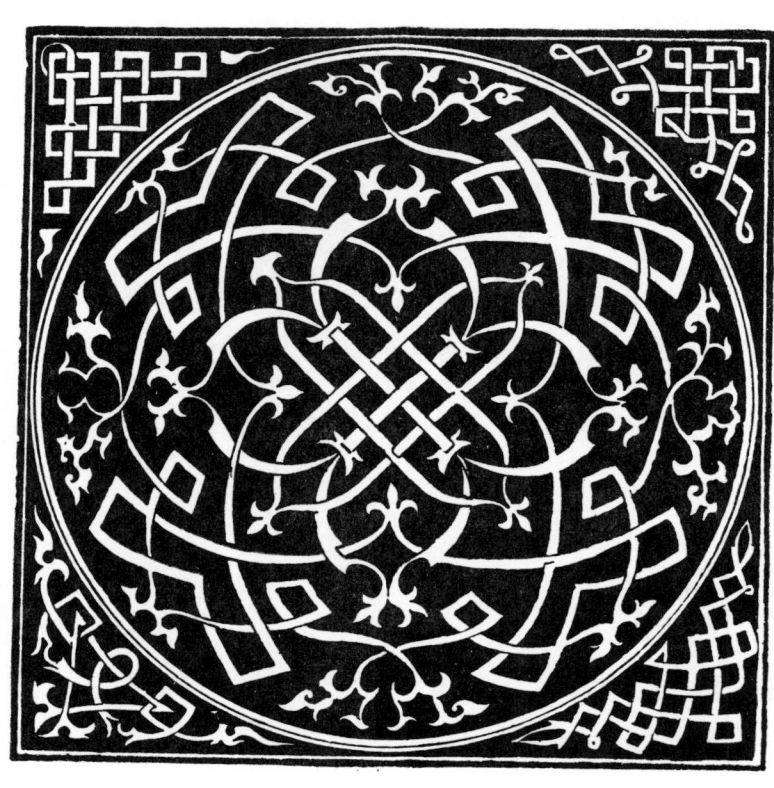

Interlacing and repeating patterns affording motives suitable for borders

The four large circles and the vertical panel are exceptional in the amount of white on black

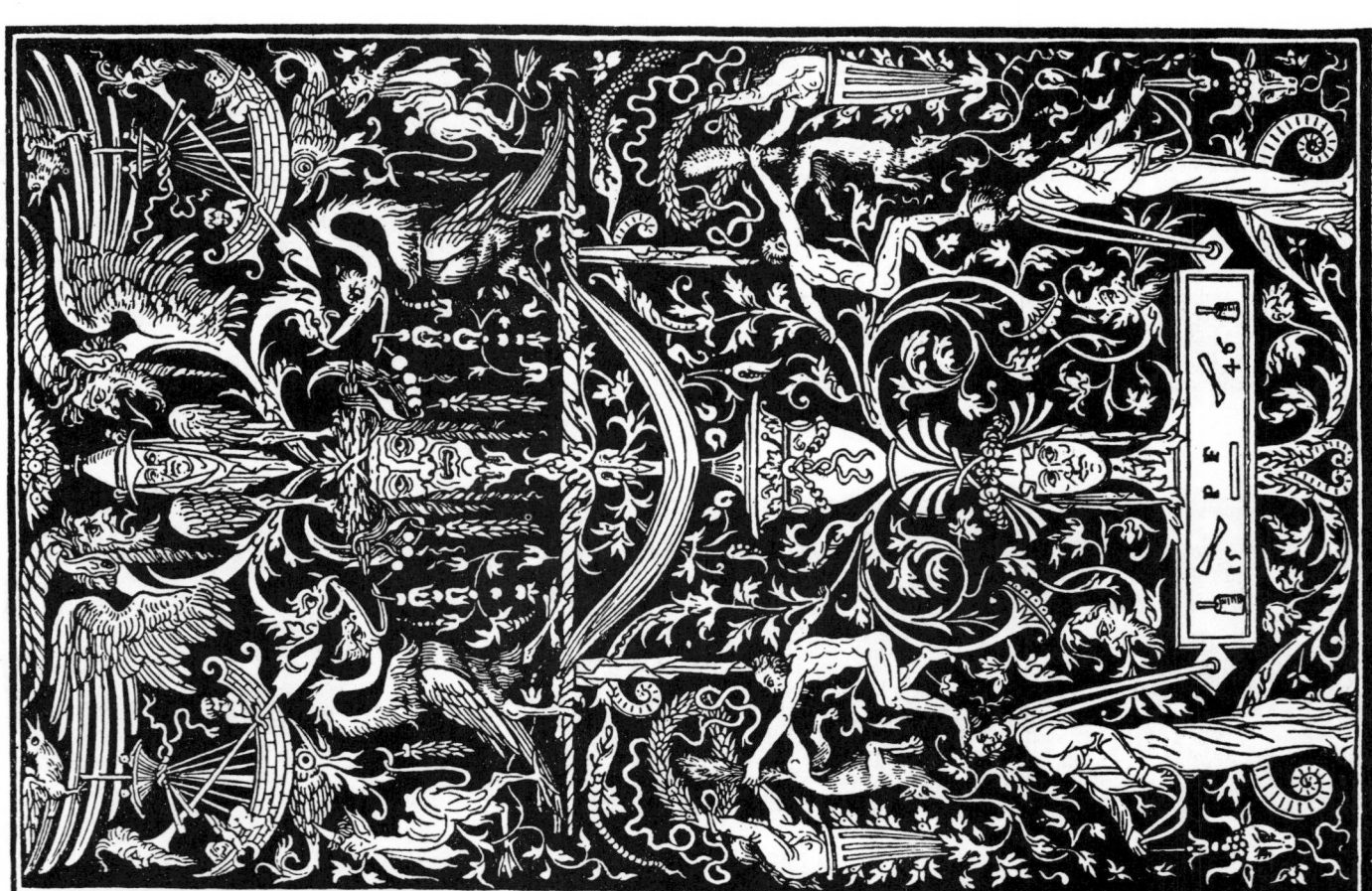

The panel at the left bears the initials of its designer, Pierre Floetner, 1546, and was used in an architectural book published in Zurich about 1547 by the celebrated printer, Andreas Gessner. The other examples on this page are of German origin, affording useful motives in white on black

Book-binding corners and panels of the 16th century

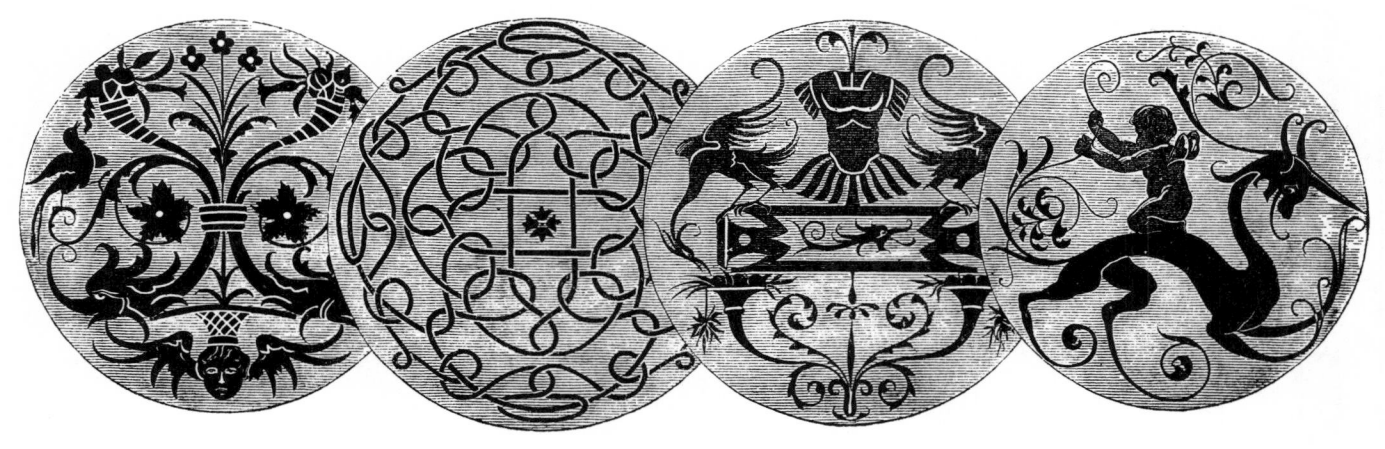

MEANING OF HISTORY

Decorative design appears at first sight to be so entirely a matter of the designer's unhampered fancy, that a history of the art might seem an impossibility; for how can there be a history of millions of independent, unrelated fancies? But as a matter of fact no designer is or ever has been wholly free. In the first place, he knows but an infinitesimal fraction of the world of possible decorative forms — those, in short, which he has been taught or has seen, or has learned by experience. He is hampered by the traditions of his art, by the taste of his age and the demands of the market, by the tools and materials he uses, by his own mental and artistic limitations. By reason of common limitations and environment, the designers of any one place and time tend to work alike in certain respects, and those characteristics which are common to their work constitute the style of that time and region. The history of ornament is, then, the record of the origin, growth, decay, succession and inter-relation of the various styles of decorative design.

A. D. F. HAMLIN

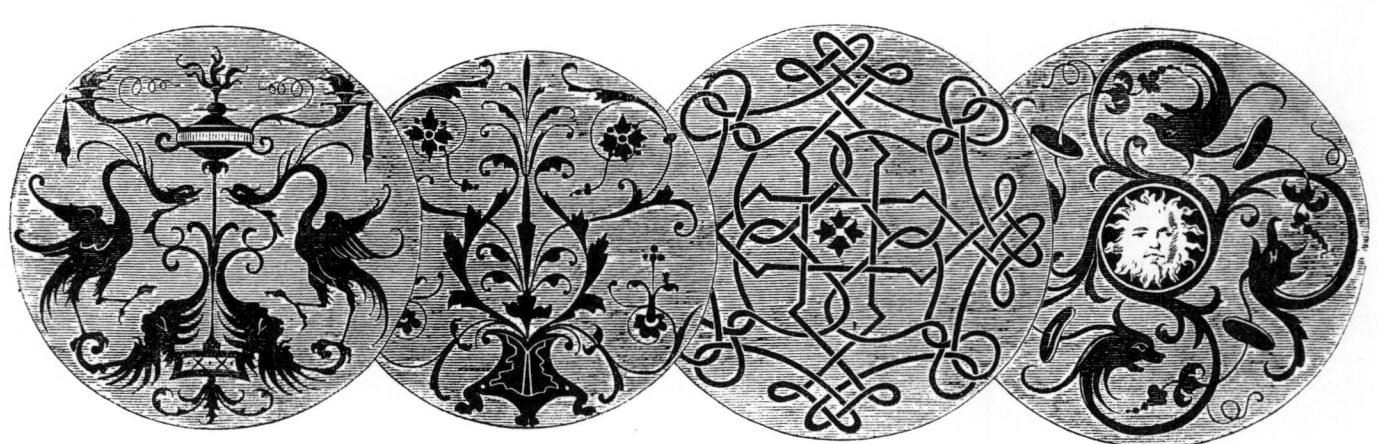

The infinity of motives and arrangements possible in decoration is evidenced in these eight varied circle forms

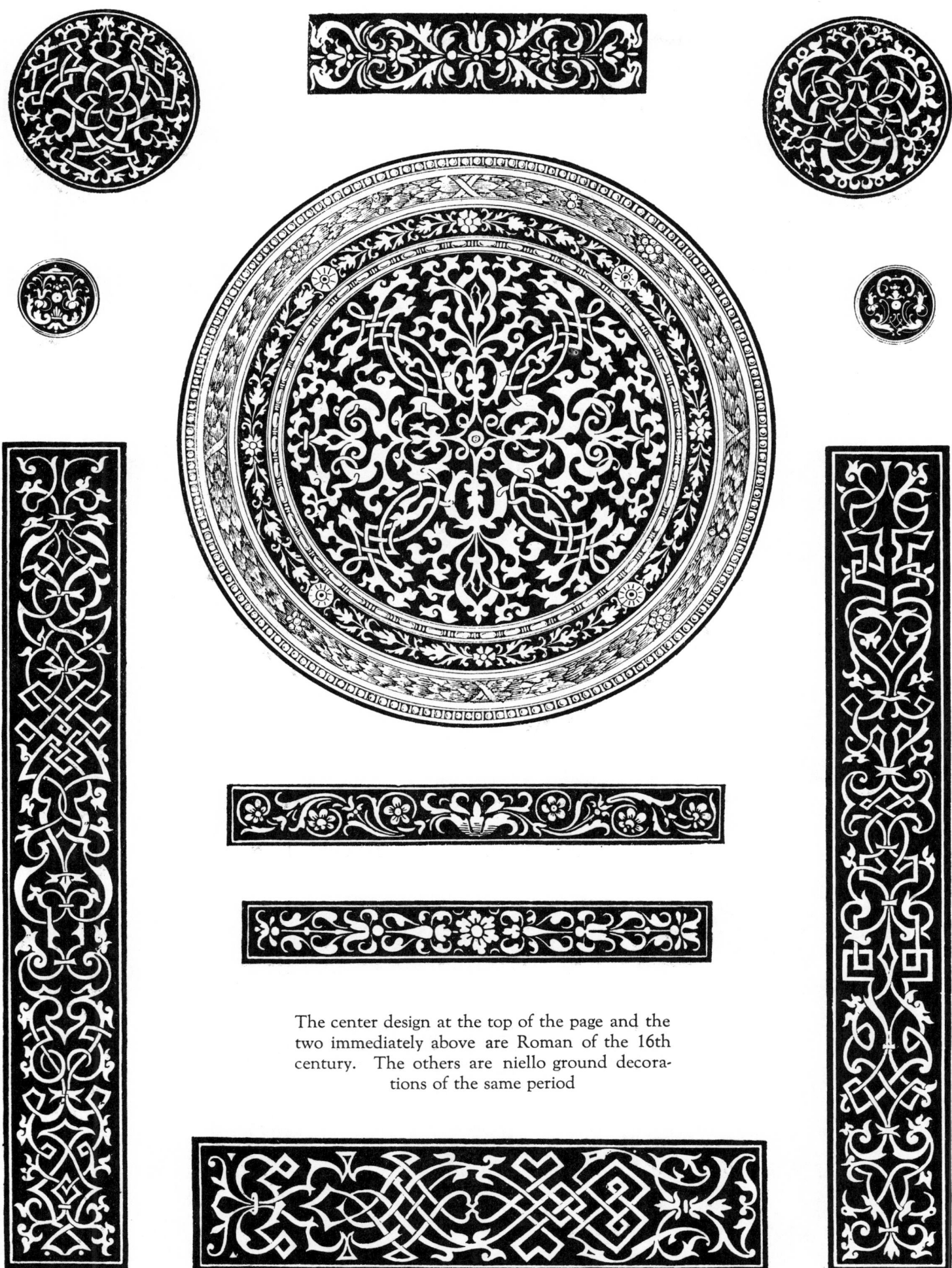

The center design at the top of the page and the two immediately above are Roman of the 16th century. The others are niello ground decorations of the same period

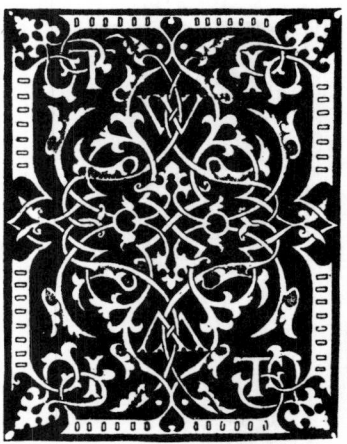

The book cover designs at the right and left are by Hans Holbein. The two panels below are of German origin. The balance are niello plates

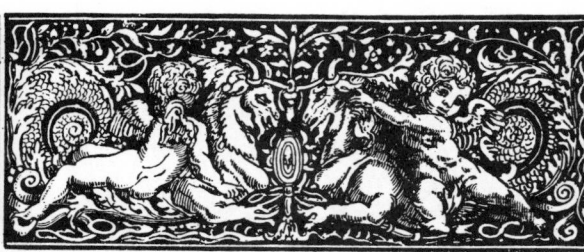

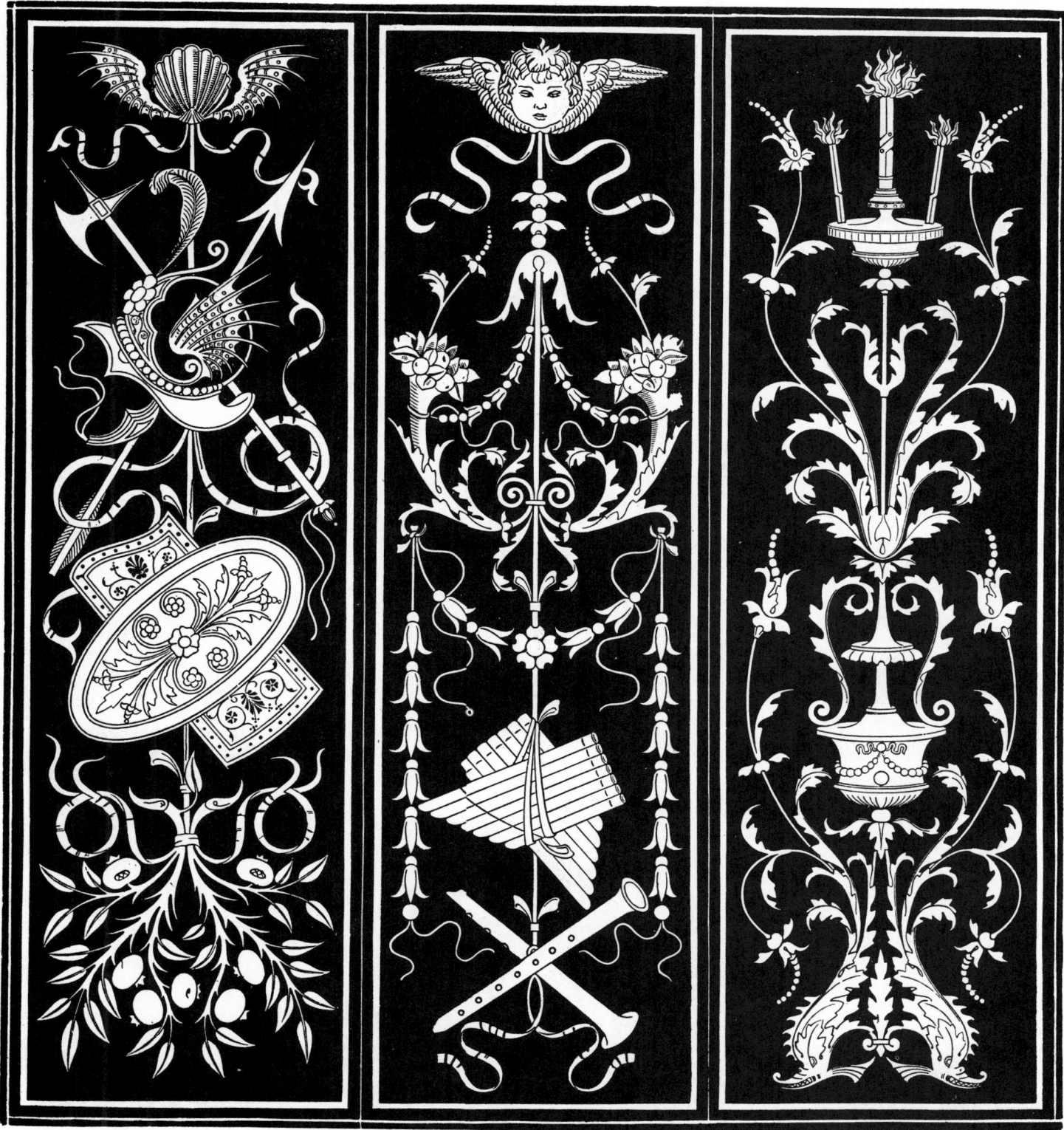

Intarsia ornaments dated Bologne, 1495. They afford studies in pendant and
vertical forms, set out by exceptional areas in solid backgrounds

ORNAMENTAL art, pure and simple, is like the measure and rhythm of a verse. A verse may scan, may have a proper accent and cadence. In short, may have all the music of harmonious versification, and yet be made up of words that are mere nonsense; and so in ornament, it is not necessary to its beauty, as ornament, that it should have any meaning. It is quite sufficient that it should be beautiful.

F. W. MOODY

The oval plates suggest types of design for title page and
cover decorations

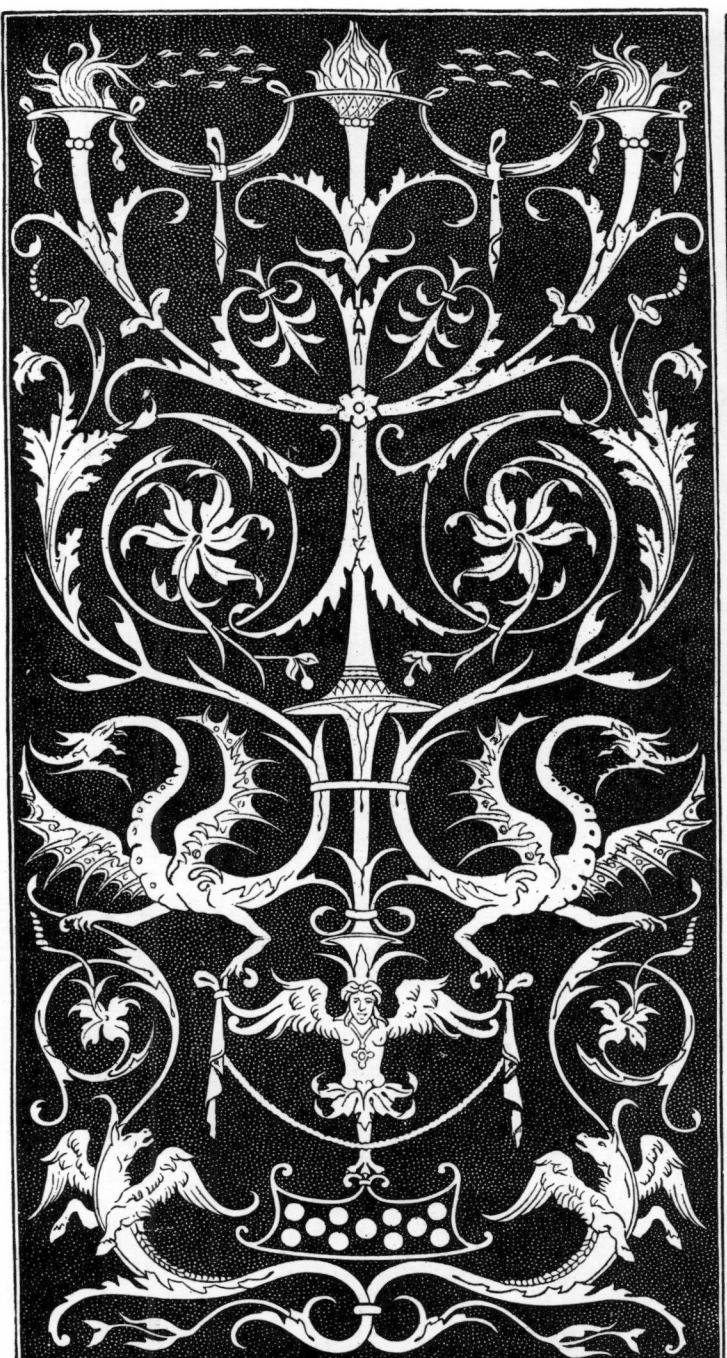 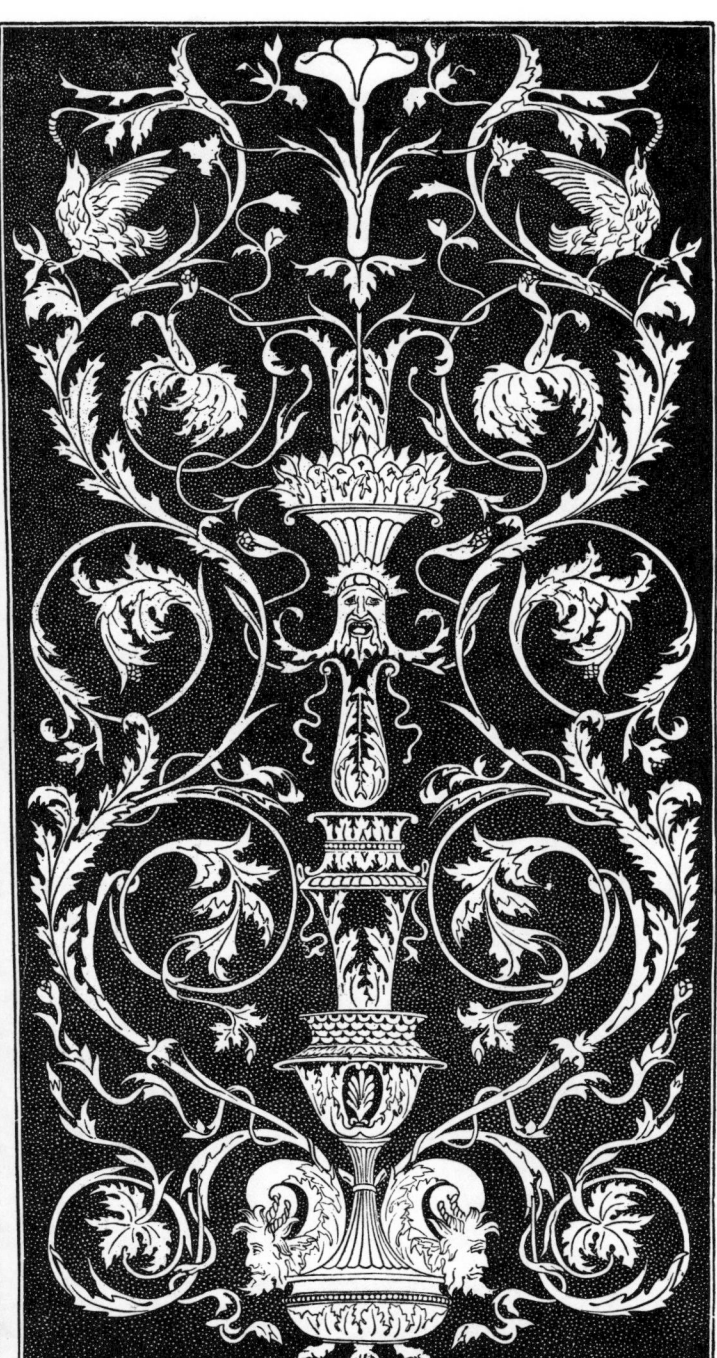

Light and graceful evolutions, similar in effect but totally different in
details. Panels of the 16th century

ISTORIC styles of ornament remain for us, vast accumulations of tried
experiments, for the most part in the character of conventional render-
ings of natural forms; for however remote from nature some of these
may be, they can, as a general rule, be traced directly back without
much difficulty to the natural origin, where in most cases they were
used symbolically.

JAMES WARD

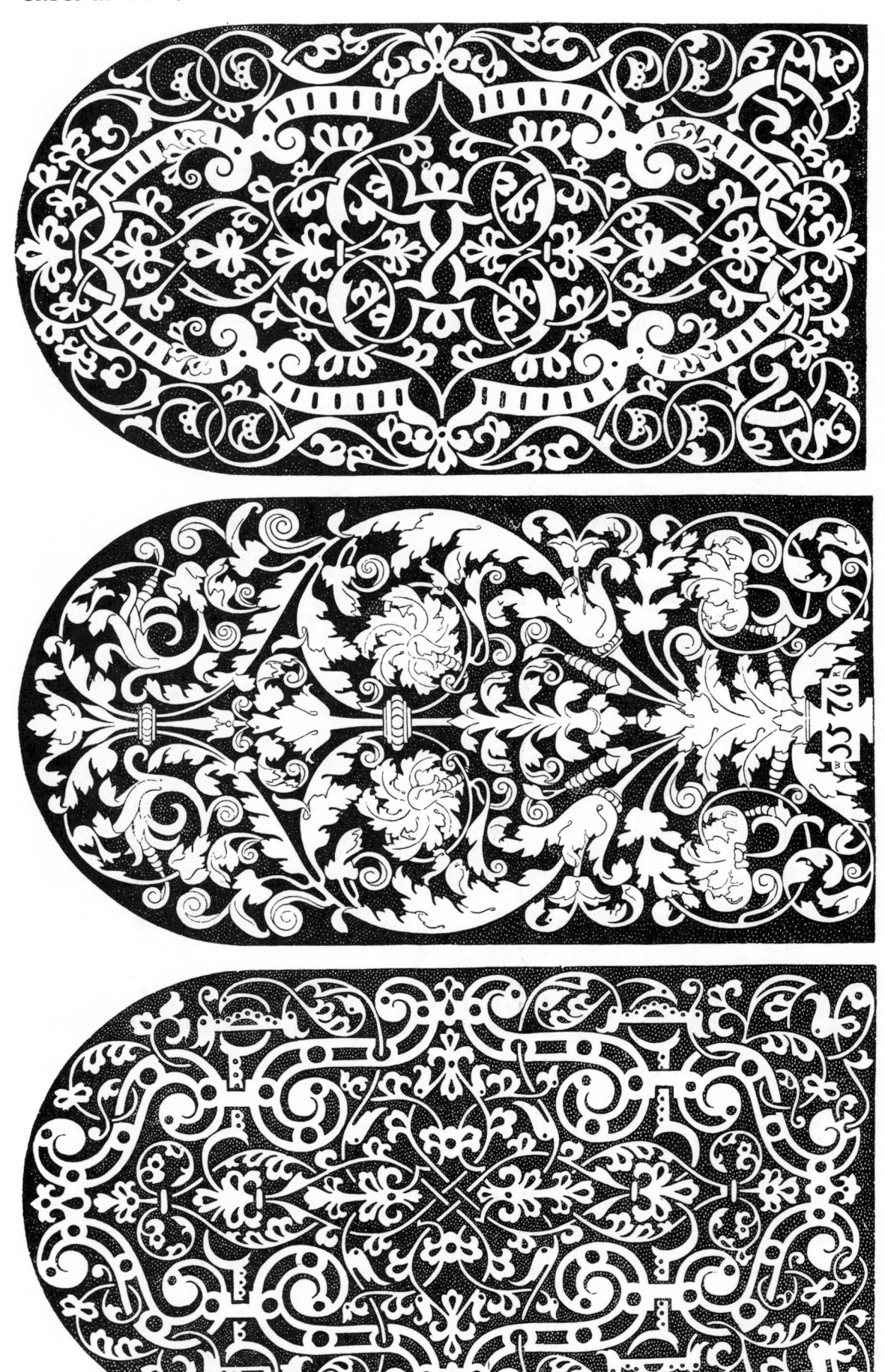

Decorative Panels from a church in Breslau, 1576

WHATSOEVER THINGS ARE TRUE ❧ WHATSOEVER THINGS ARE HONEST ❧ WHATSOEVER
THINGS ARE JUST ❧ WHATSOEVER THINGS ARE PURE ❧ WHATSOEVER THINGS ARE
LOVELY ❧ WHATSOEVER THINGS ARE OF GOOD REPORT ❧ ❧ IF THERE BE ANY VIRTUE
AND IF THERE BE ANY PRAISE ❧ THINK ON THESE THINGS
PHILIPPIANS IV · 8

Base and vase forms, Florence, 1440

This panel is a Roman design of the 16th century and the others are diverse types of book ornaments

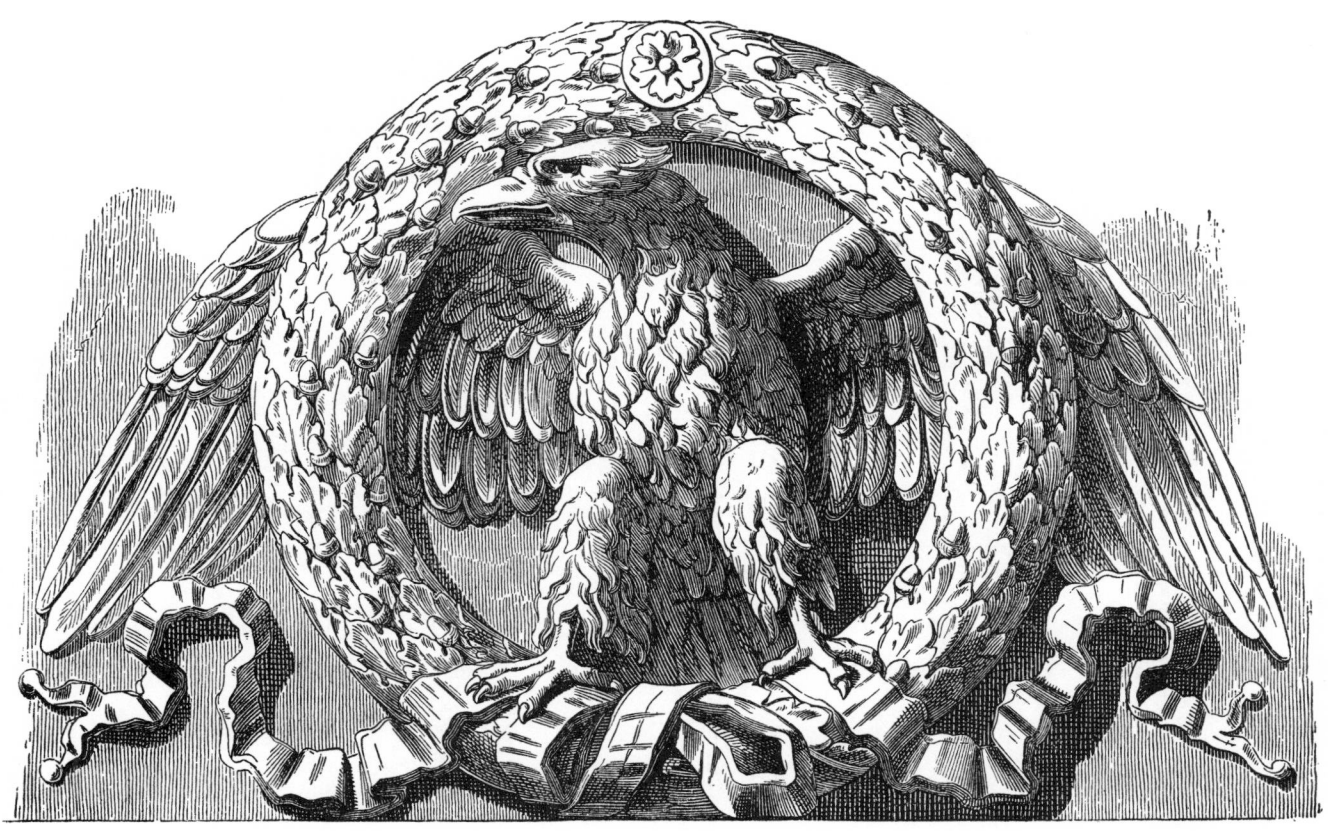

The Roman eagle is an excellent model and the oak wreath indicates sculptural origin

The six decorations on the sides are arabesques **with criblé** backgrounds

The three long strips are borders used at the Plantin Press, and the others are motives for borders and cover ornaments

86

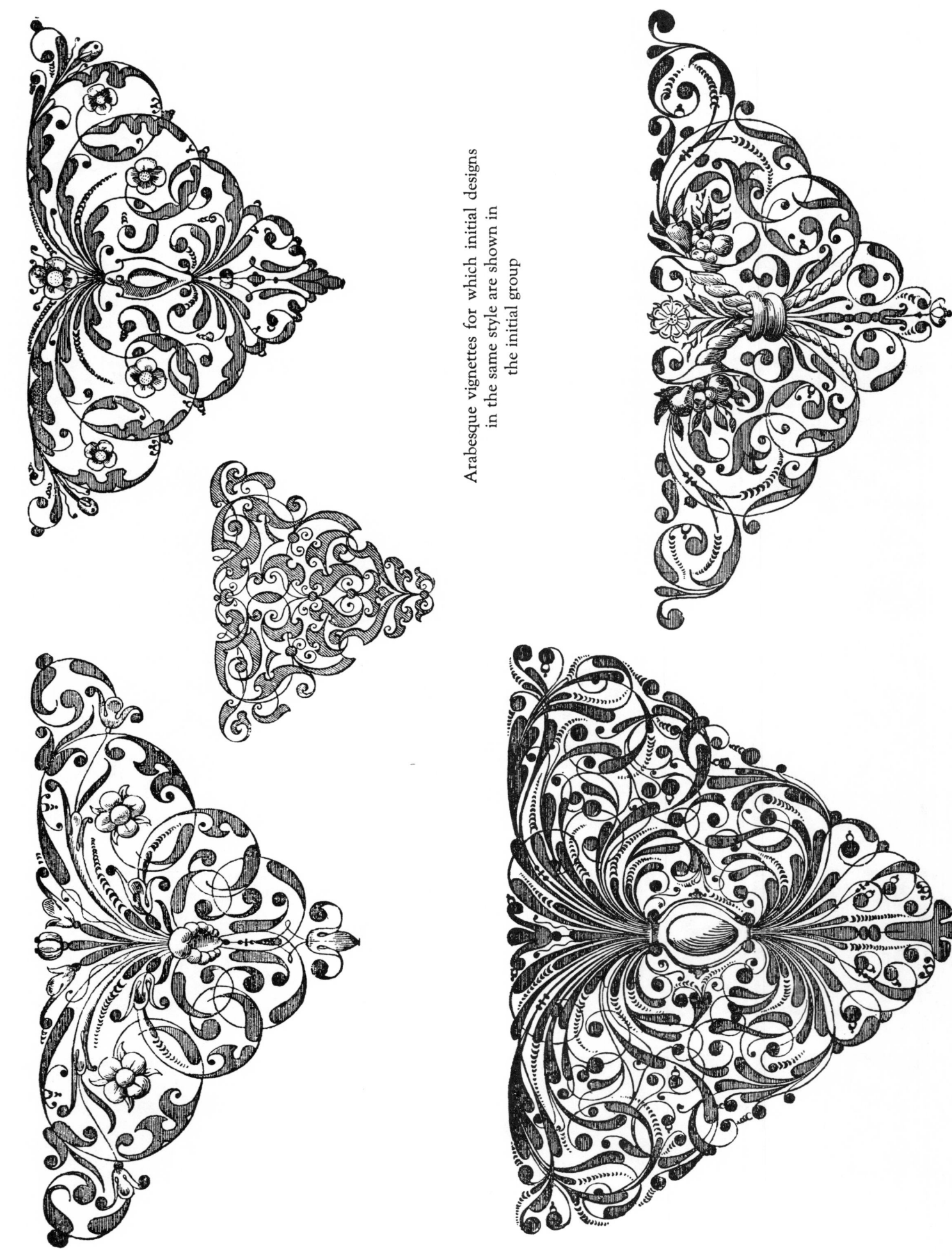

Arabesque vignettes for which initial designs in the same style are shown in the initial group

Book decorations and a pilaster of
contrasting periods

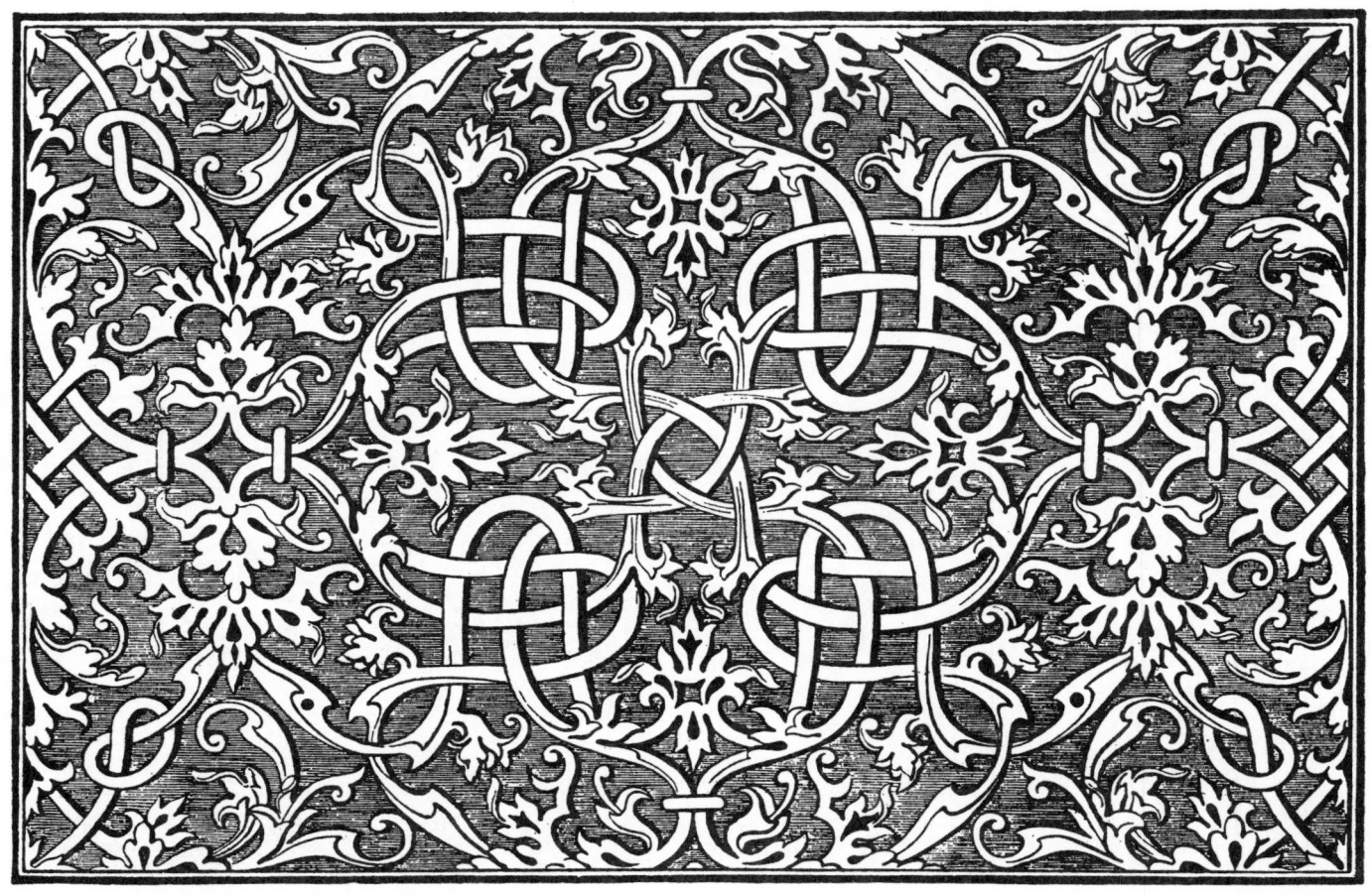

Interlacing designs from carved panels

Bands in technique suited to printing upon antique papers

Varied technique in line, shading and crosshatching from etchings

Typographic Vignettes, Panels and Niellos

Headbands and Decorations well suited to use on circulars

Studies in foliage patterns

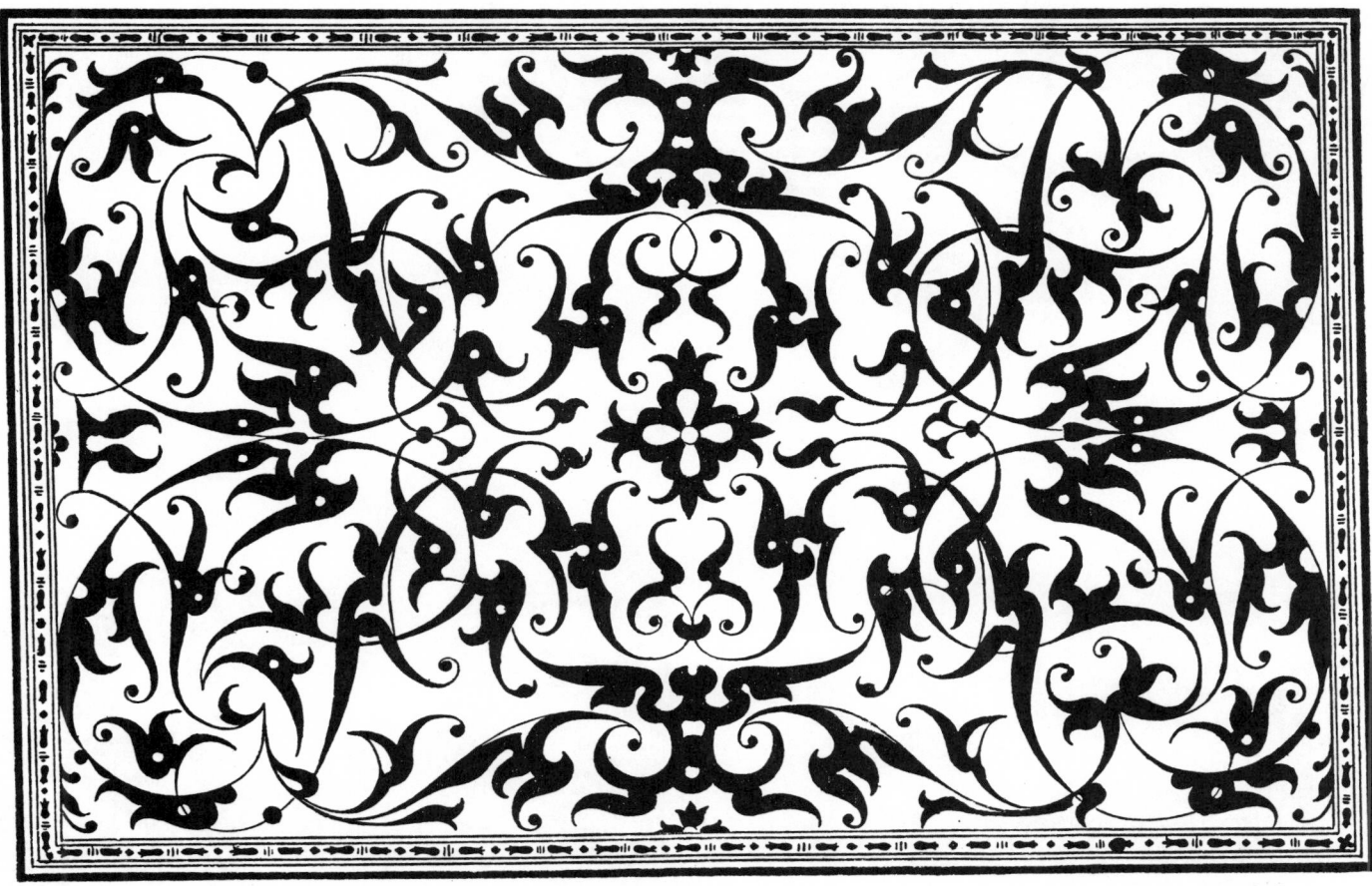

The large panel is from the top of a damascened coffer. The main
foliages develop their curves toward the four angles and the principal
enlargements are profiles of heads of birds, fishes, harpies and foliations

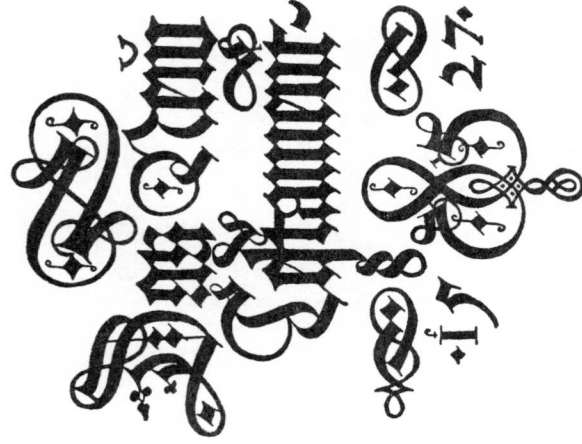

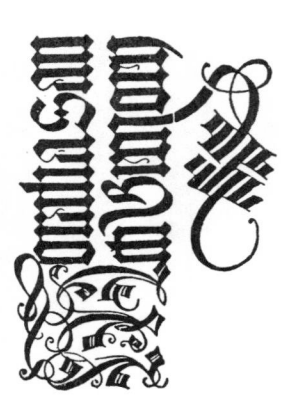

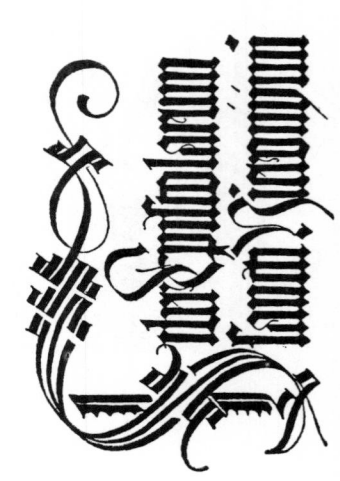

Designed titles of the 15th and 16th centuries, exhibiting decorative arrangements and a variety of black letter styles

Light and heavy flourishes from printed pages of the 17th
century

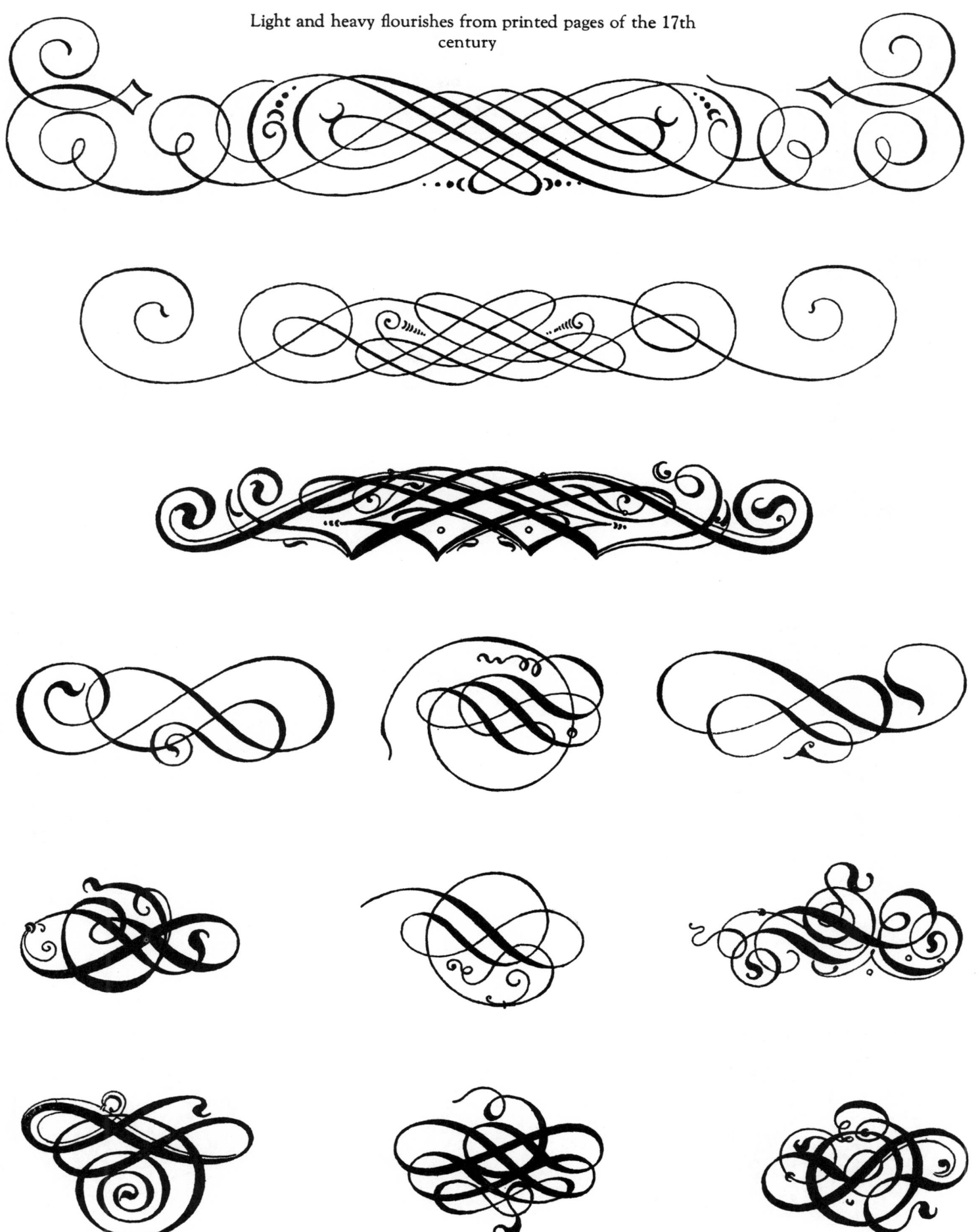

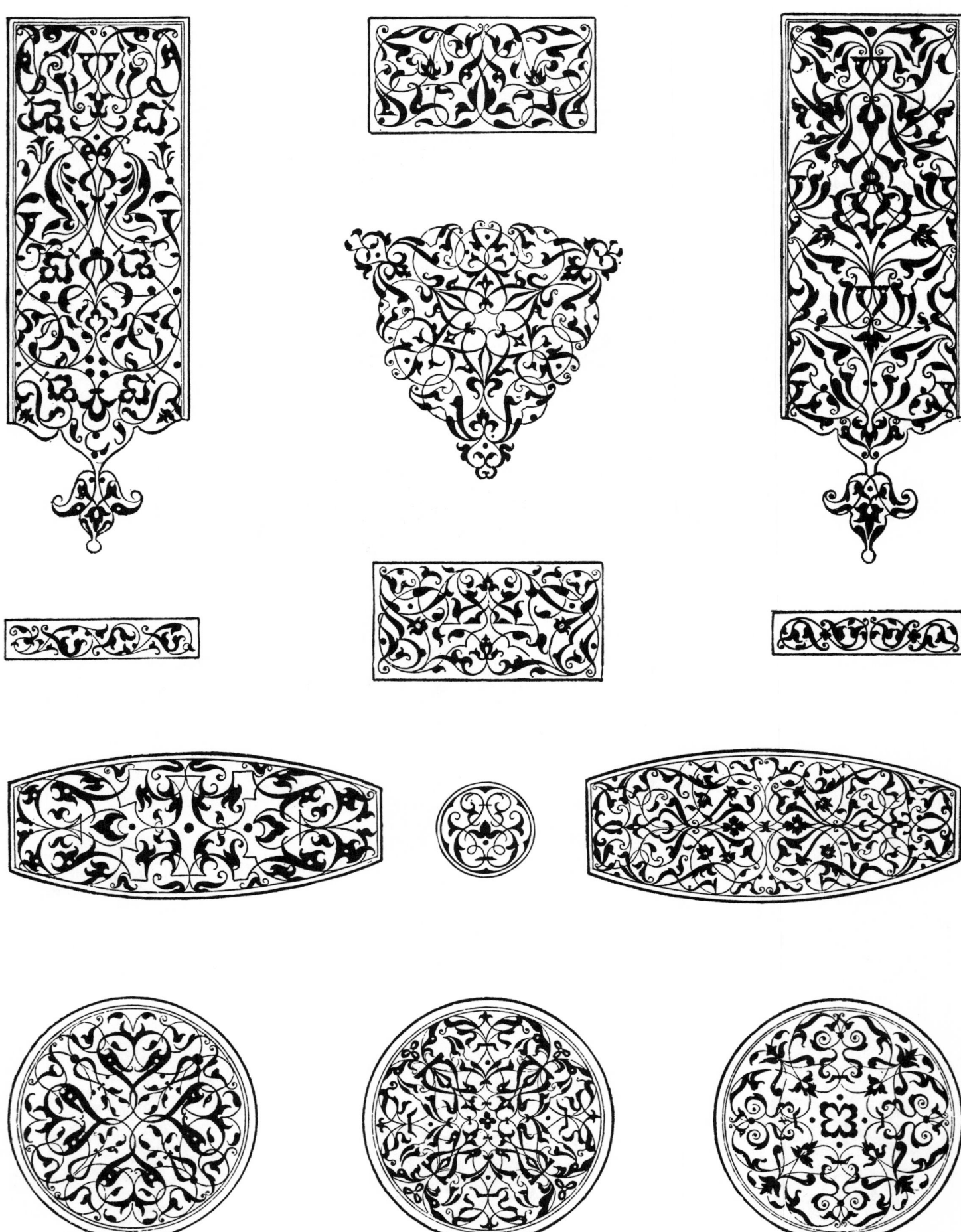

Niello foliages from box covers, watch cases and sword ends

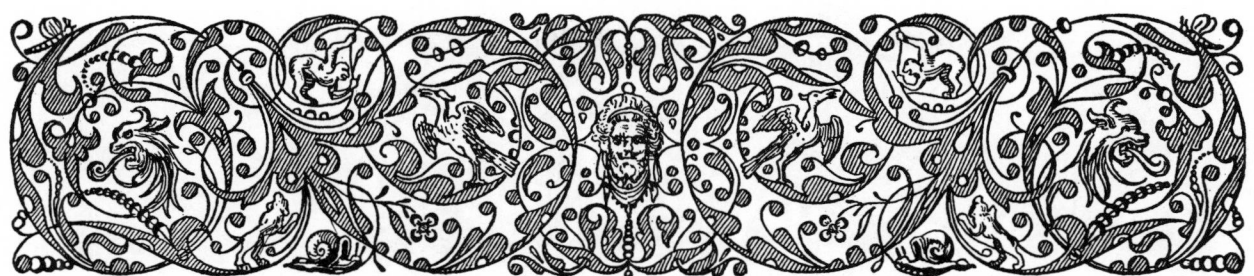

ORNAMENT AN ESSENTIAL ELEMENT

NIVERSAL efforts show a universal want; and beauty of effect and decoration are no more a luxury in a civilized state of society than warmth and clothing are a luxury to any state: the mind, as the body, makes everything necessary that it is capable of permanently enjoying. Ornament is one of the mind's necessities, which it gratifies by means of the eye; and, in its strictest aesthetic sense, it has a perfect analogy with music, which similarly gratifies the mind, but by the means of a different organ—the ear.

So ornament has been discovered to be again an essential element in commercial prosperity. This was not so at first, because, in a less cultivated state, we are quite satisfied with the gratification of our merely physical wants. But in an advanced state, the more extensive wants of the mind demand still more pressingly to be satisfied. Hence, ornament is now as material an interest in a commercial community as even cotton itself, or, indeed, any raw material of manufacture whatever.

12 pt. Caslon Old Style RALPH N. WORNUM

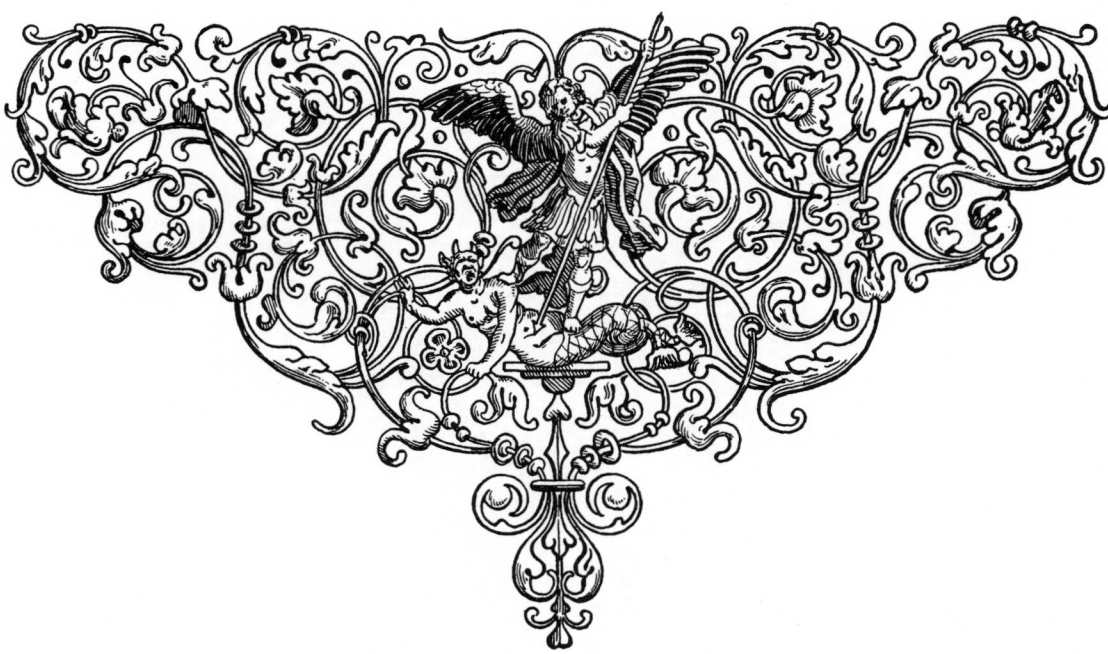

Arabesque book decorations of the 15th century

Gothic panels of the 15th century

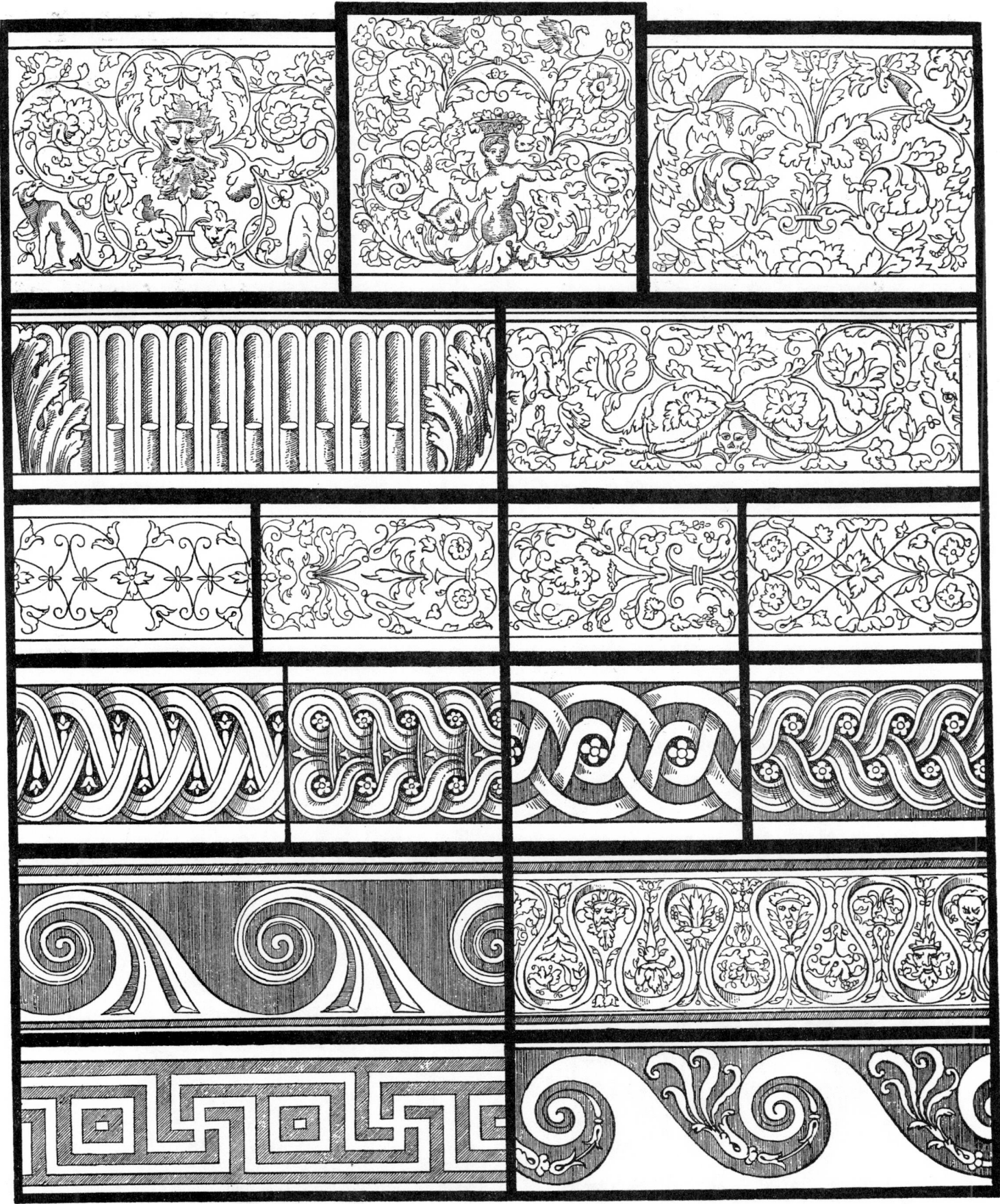

Friezes of 16th century Italian design, in foliage patterns and
sculptured ornaments

French Decorative Panels from engravings on steel

Arabesques and scrolls of French origin of the
18th century

Plantin Decorations as shown in the Plantin Museum Specimen Book

Five Plantin and other ornaments

The lunette above has an exceptionally decorative use of dolphins.

The pilasters at the right have useful border motives, French designs of 1520

German book decorations
of 1530

Frames and ornaments from a geography of the 18th century

Frames and ornaments from a German work of 1559

Frames and ornaments of French origin, 17th century

The side panels are designs by Albrecht Dürer

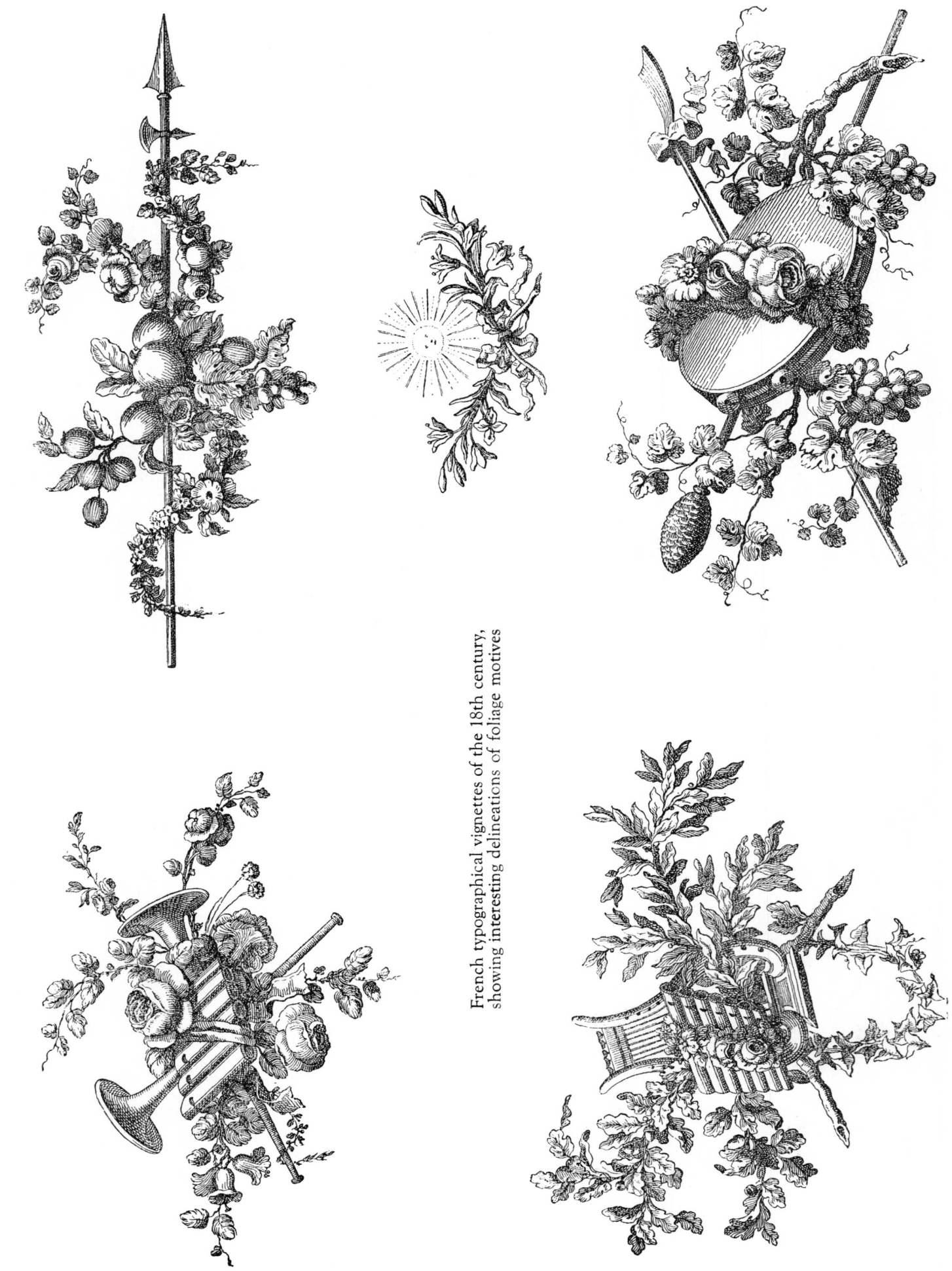

French typographical vignettes of the 18th century,
showing interesting delineations of foliage motives

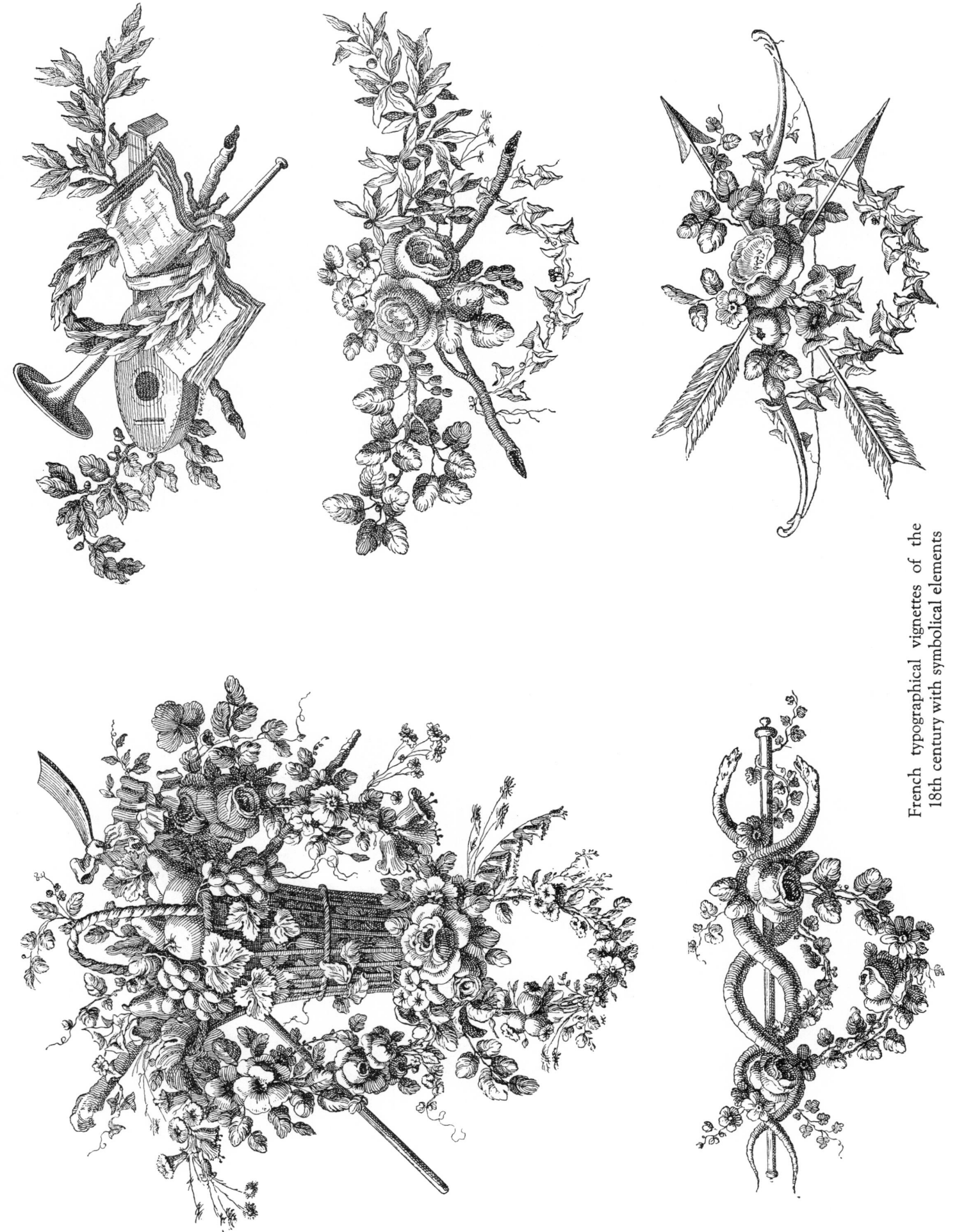

French typographical vignettes of the
18th century with symbolical elements

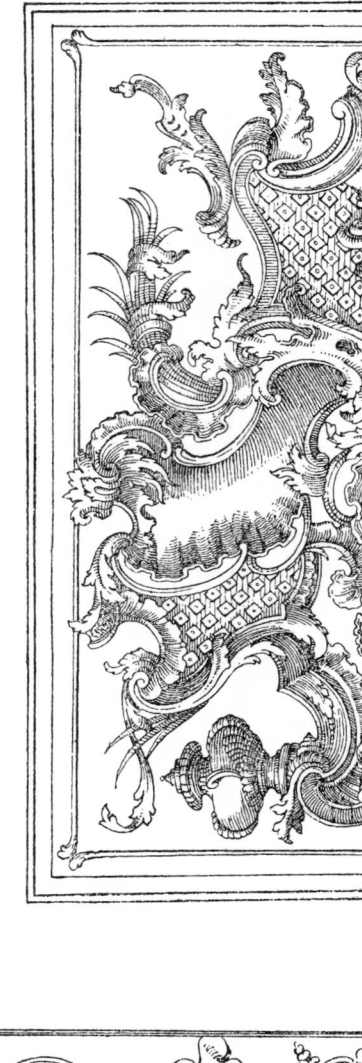
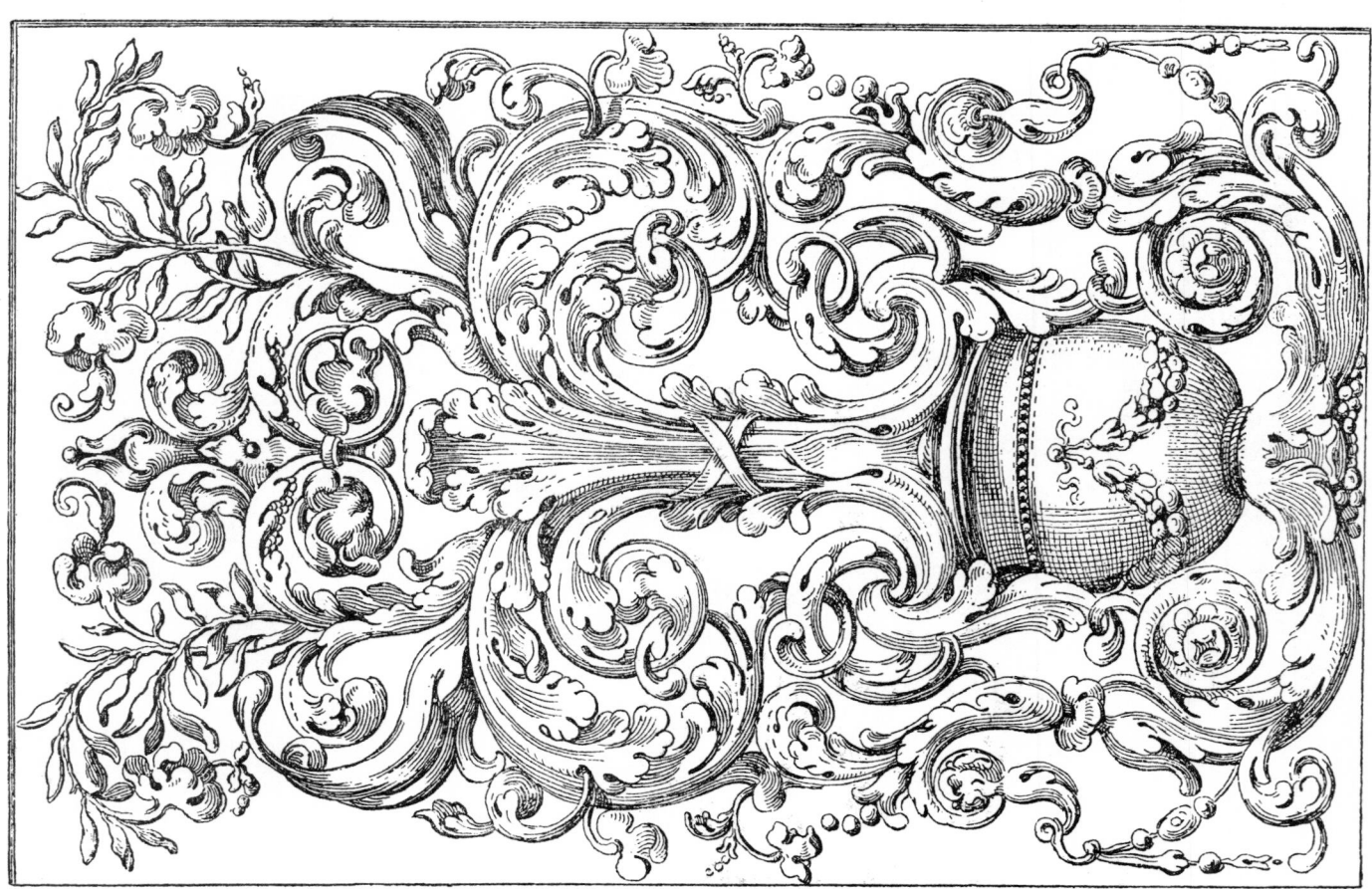

French decorative panels by Joseph Mitelli, 1609-1660

HISTORIC DESIGN IN PRINTING
GROUP IV—INITIALS

This is the largest grouping in this work because of the importance and wealth of design of this class in early printing. The value of these initials is well defined by Mr. De Vinne in this text.

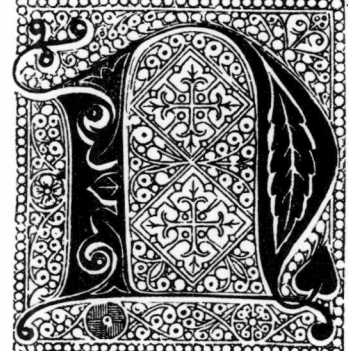

UMBERED chapters or chapter headings in some form have been approved guide-posts for a reader ever since books were written. For this purpose the Roman numeral still keeps its prominent position, but largely because its letters are broader and plainer than the thinner characters of Arabic figures. Numerals of Roman letters mate neatly with the capital letters that precede them in the line. The modern practice of beginning a chapter with a fresh leaf, with a broad margin at its head, and of ending that chapter with a blank that shows its finish at the end of its last page, was known in the fifteenth century.

For many years it was customary to have one chapter follow its predecessor without any intervening lane of white space, as must still be noticed in all compact modern editions of the Bible. This huddling of print, without a rest for the eye in the form of blank space, made study fatiguing and the print repelling.

Early writers of fine manuscript books were more considerate, and provided blank space for added decorations of borders, center bands, initial letters, or illustrative miniatures. Initial letters were most frequently employed, for they permitted an infinite variety of ornamentation. It was not possible for any typographic printer to imitate the gold and bright color and beautiful designs of the calligraphers, yet Ratdolt and others did engrave initial letters of merit, spanning and filling in height two or more lines of text-type. Initial letters of large size, whether plain or engraved, were a pleasant relief to eyes wearied with the monotony of compacted composition, and were as effective in arresting the attention of a hasty reader as numbered chapter headings.

This time-honored device for adding to the attractiveness of a page has been for many years undervalued, but largely so because the letters now furnished for this purpose are seldom good mates for the text and are hackneyed by repetition. They are often inferior in design to the approved initials of the fifteenth century.

THEODORE L. DE VINNE

THE EARLIEST
NOTABLE ENGRAVED AND PRINTED INITIALS

ATDOLT was unquestionably one of the most remarkable of the early printers. He was born at Augsburg about the middle of the fifteenth century, and there practised the art by means of which Gutenburg had rendered his native city of Mayence forever celebrated in the year 1455, when the first printed book, in the form of the magnificent folio Bible, issued from the first-established printing-press under his direction. Ratdolt quitted Augsburg in 1475, just twenty years after the first appearance of Gutenberg's ever-famous Bible, and established himself in Venice in that year, in partnership with his countrymen, Loslein and Maler. The works which he at once began to produce in Venice were marked by conspicuous advances in the art; the Kalendar which he issued in 1475 being the first example of the adoption of a regular frontispiece; and in the introduction of handsome initial letters, engraved on wood, to print with the type, he was more successful than any of his predecessors or immediate followers.

The edition of the Roman History of Appianus, which appeared in 1477, has, in addition to a noble series of splendid initials, an elaborately enriched border, which, like the initials, is so finely designed and engraved, that the book is sought by collectors with as much avidity as a manuscript richly adorned by the pencil of the illuminator.

He was also the first to introduce mathematical figures engraved on wood and printed with the text; an example of which will be found in the annexed facsimile of the first page of his magnificent edition of "Euclid's Elements of Geometry." So confident was Ratdolt of the superiority and beauty of the decorations with which he enriched his volumes, that he occasionally printed them in gold.

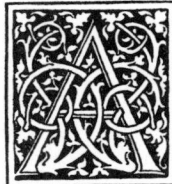

FINE copy of his Euclid, printed on vellum, with the decorations of the first page in gold, is preserved in the Bibliotheque Imperiale of Paris. The designs of these exquisite initials and borders of this and other works were doubtless the work of Bernardo the painter, who is mentioned in the colophon at the end of the beautiful edition of Appianus just referred to: "Venetiis, per Bernardum Pictorum et Erhardum Ratdolt de Augusta, 1477."

Such was the fame acquired in Venice, Ratdolt was invited to several of the principal monasteries in Italy to superintend the printing of Missals and other works. But notwithstanding his great success, the lure of country appears to have overborne all other feelings, and in 1486 he returned to Augsburg, where he continued the exercise of his art till the year 1516. The works then produced have scarcely the same high degree of merit as those produced during his short but brilliant career in Venice; and their illustrations are always in the German style, except a few of the fine initials designed by Bernardo Pictor. These initials were, indeed, imitated by other printers, far and wide. Those, for instance, in a fine folio Psalter printed in Venice in 1496, were evidently imitated from Ratdolt's; and they are very fine, especially an "A" and a "P;" but the "B" at the commencement of the first Psalter exhibits the closest copy of Ratdolt's style.

In St. Gregory's treatise in the Book of Job, printed at Seville in 1527, a magnificent initial "C" and an "E" are evidently copied from Ratdolt; and in a Psalter printed in Paris in 1532, by Jehan de Roigny, a noble initial "D" and an "I" are imitated from those designed at Venice for Ratdolt by Bernardo the painter.

H. NOEL HUMPHREYS

The initials in this page were used by Erhart Ratdolt first in "Appiani Alexandrini historiae Romanae" and later in "De civilibus Romanorum bellis."

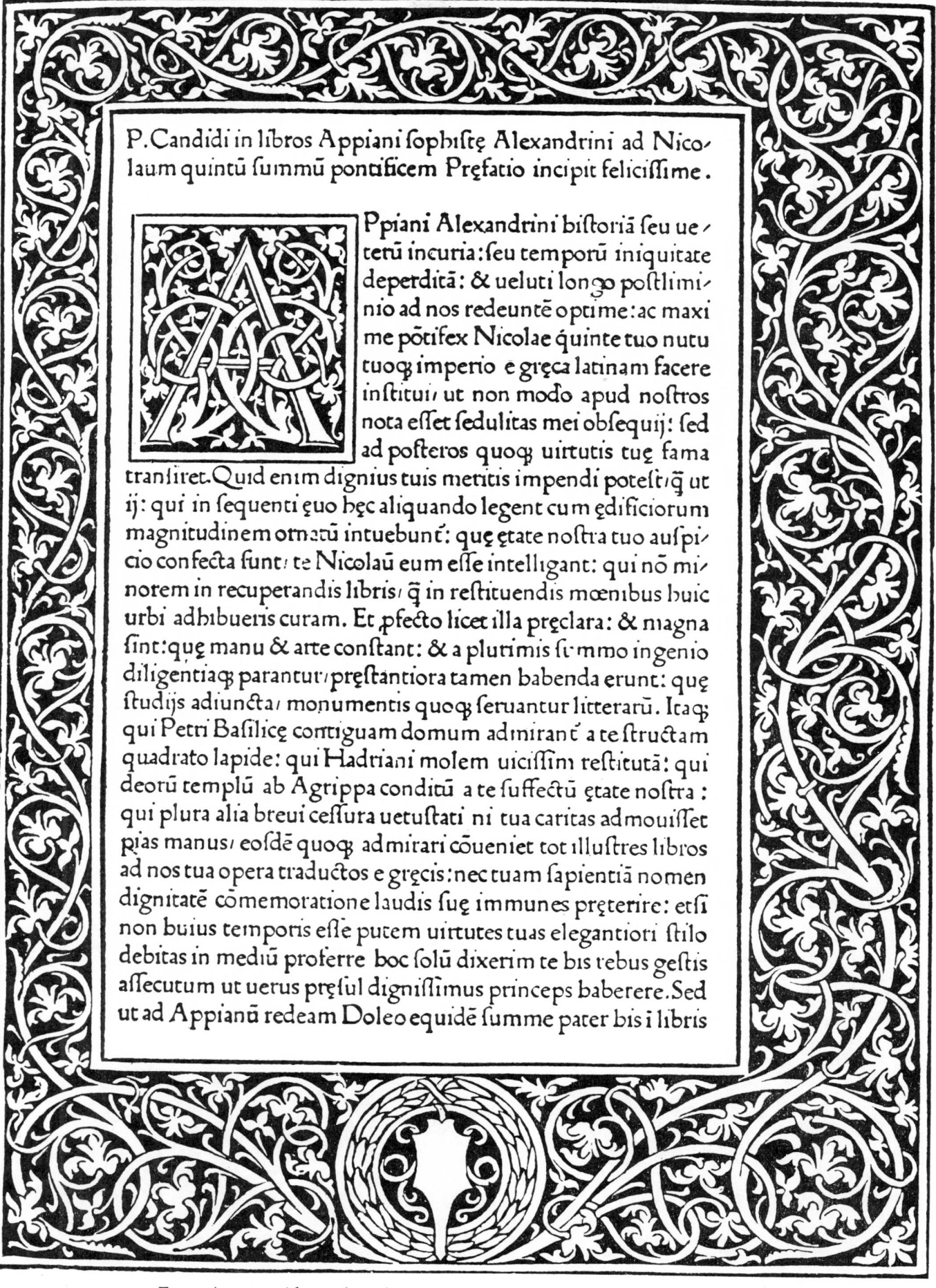

P. Candidi in libros Appiani fophiſtę Alexandrini ad Nico-
laum quintū ſummū pontificem Pręfatio incipit feliciſſime.

Ppiani Alexandrini hiſtoriā ſeu ue-
tetū incuria:ſeu temporū iniquitate
deperditā: & ueluti longo poſtlimi-
nio ad nos redeunte optime:ac maxi
me pōtifex Nicolae ǵuinte tuo nutu
tuoǵ imperio e gręca latinam facere
inſtitui, ut non modo apud noſtros
nota eſſet ſedulitas mei obſequij: ſed
ad poſteros quoǵ uirtutis tuę fama
tranſiret. Quid enim dignius tuis meritis impendi poteſt,ǵ ut
ij: qui in ſequenti ęuo hęc aliquando legent cum ędificiorum
magnitudinem ornatū intuebunt: quę ętate noſtra tuo auſpi-
cio confecta ſunt, te Nicolaū eum eſſe intelligant: qui nō mi-
norem in recuperandis libris, ǵ in reſtituendis mœnibus huic
urbi adhibueris curam. Et ,pfecto licet illa pręclara: & magna
ſint:quę manu & arte conſtant: & a plurimis ſummo ingenio
diligentiaǵ parantur,pręſtantiora tamen habenda erunt: quę
ſtudijs adiuncta, monumentis quoǵ ſeruantur litterarū. Itaǵ
qui Petri Baſilicę contiguam domum admirant a te ſtructam
quadrato lapide: qui Hadriani molem uiciſſim reſtitutā: qui
deorū templū ab Agrippa conditū a te ſuffectū ętate noſtra :
qui plura alia breui ceſſura uetuſtati ni tua caritas admouiſſet
pias manus, eoſdē quoǵ admirari cōueniet tot illuſtres libros
ad nos tua opera traductos e gręcis:nec tuam ſapientiā nomen
dignitatē cōmemoratione laudis ſuę immunes pręterire: etſi
non huius temporis eſſe putem uirtutes tuas elegantiori ſtilo
debitas in mediū proferre hoc ſolū dixerim te his rebus geſtis
aſſecutum ut uerus pręſul digniſſimus princeps haberere.Sed
ut ad Appianū redeam Doleo equidē ſumme pater his i libris

From Appiani Alexandrini historiae Romanae, Printed by Ratdolt, 1477

Ad diuum Alfonfum Aragonum & utriufcp Siciliȩ
regem in libros ciuiliū bellorū ex Appiano Alexan‑
drino in latinū traductos Prȩfatio incipit feliciffime.

Arthorū regem ut ab'Anneo accepi‑ *Anneus Seneca de*
mus fine munere falutare nemo po‑ *rege parthorum.*
teft. Ego uero gloriofiffime rex cum
tuam uirtutē humanitatē cȏfidero
tum cȩteras naturȩ dotes:quibus in‑
ter ȩtatis noftrȩ principes uel in pri‑
mis illuftris es: fublime ingenium :
fummā caritatē: fummā continentiā
nulla rātione adduci poffum ut non
pluris apud te fidem meā effe exiftimem q̃ ullas opes. Quip‑
pe cū te indigentibus & ueluti e nauftagio emerfis q̃q̃ ignotis
offerre uideam pias manus.Cȩterȩ nec fine munere ad te ueni
nec uacuis(ut aiunt)manibus tuā maieftatē fum adoraturus .
Nam cū priores Appiani libros/Libycum: Syrium: Parthicū *Nicolaus papa quin‑*
& Mithridaticū Nicolao quinto fūmo pontifici dum i huma‑ *Libycus. (tus.*
nis ageret e grȩco tranftuliffem/ Reliquos ciuilium bellorum *Syrius.*
cȏmentarios:quȩ Senatus: populufcp romanus inuicem geffit *Parthicus.*
nundū editos aut perfectos a me ad quem potius mitterem q̃ *Mithridaticus.*
ad te iuictiffime princeps/Hifpaniȩ pariter & Italiȩ noftrȩ de‑
cus: & qui non minus optimarum artium ftudijs:& litteris/q̃
armis inclytus es: atcp memorandus.Accipies igit nouū opus:
nec indignū regio animo:regiocp cȏfpectu tuo.Sed quod cum
prifcis illis uoluminibus ab his:qui hiftorias fcripfere pofteri‑
tati traditis/ facile conferri queat. Q̃ fi in contrarium nȏ nulli
refragentur(ut ȩmulorum mos eft)quem uelint ex latinis in
medium adducant/ fiue Crifpū:fiue Cȩfarem:fiue Curtium: *Crifpus.*
fiue alia uulgata doctorū nomina/ eorū: qui hiftorias fcripfe‑ *Cȩfar.*
runt/ nullos ex his: qui cum ciuilibus Appiani libris conferri *Curtius.*

2 2

Ratdolt border of 1478. Note the closeness of the type to the initial and the close set of the text page. There are no rivers dis‑
cernable as often seen in the present day book page

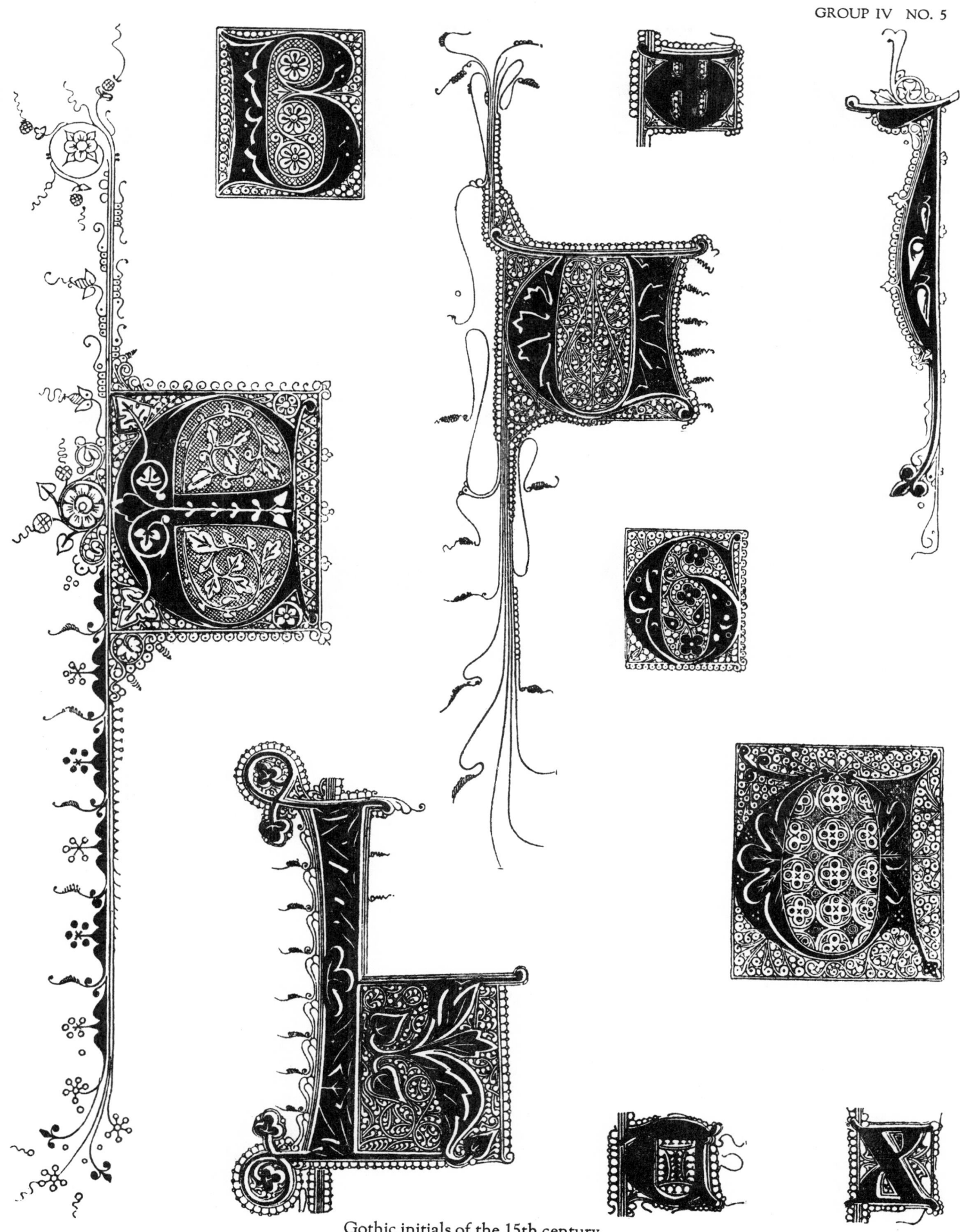

Gothic initials of the 15th century

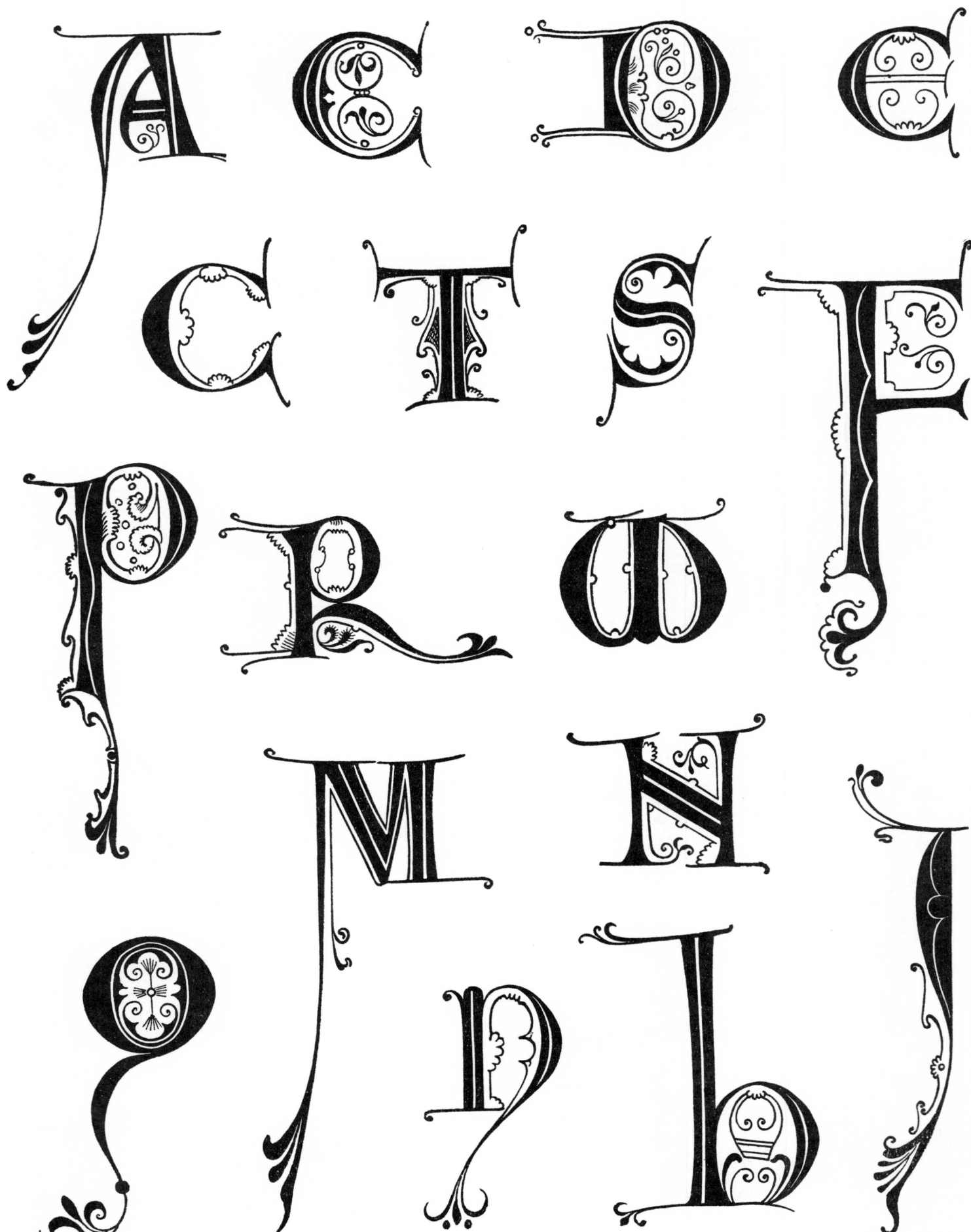

Italian manuscript initials of the 12th century, having intense color and flourishes in a style now being used somewhat in accentuating magazine pages

Designs of a missal character from an ecclesiastical work of 1531

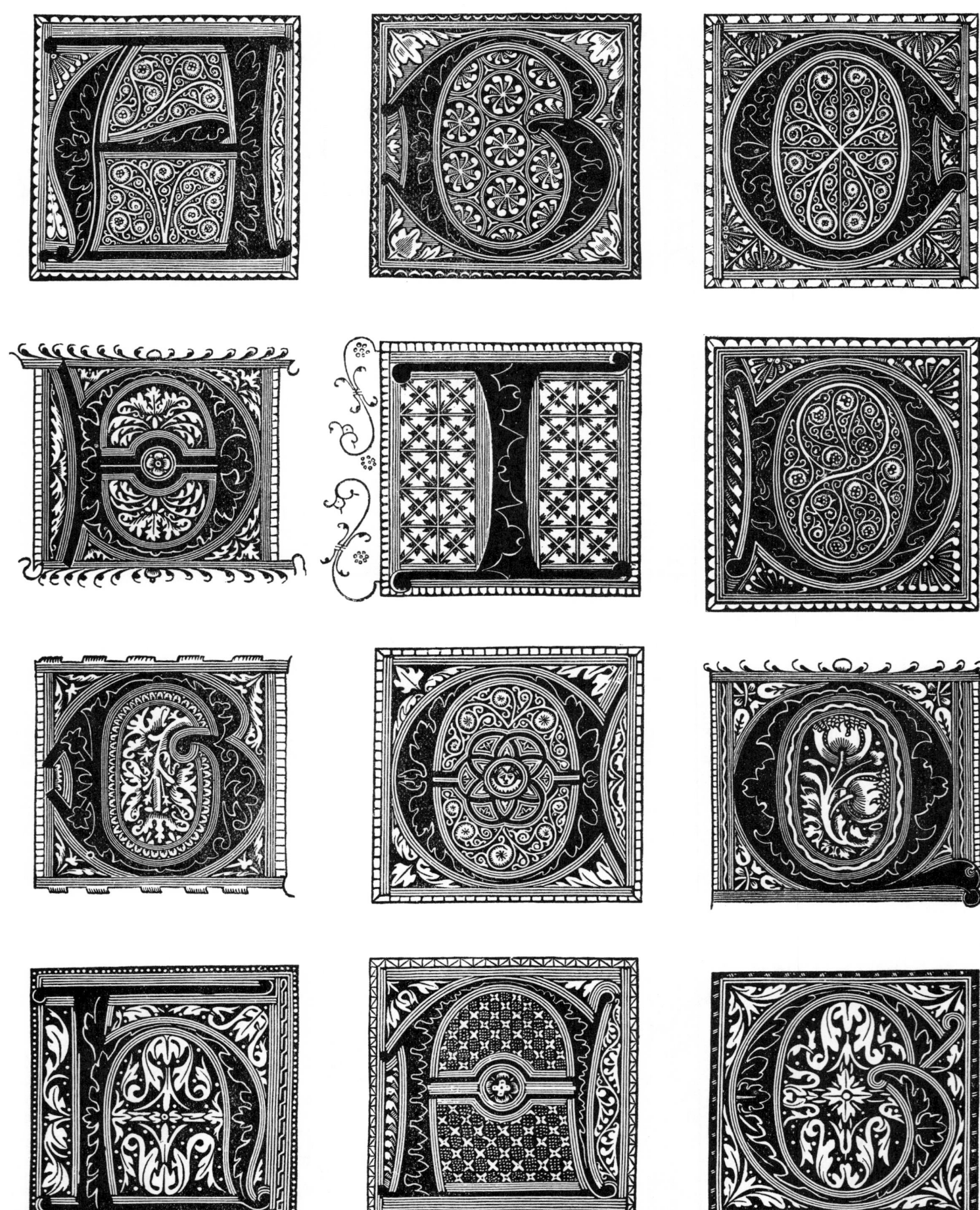

Spanish initials of the 16th century by Juan Yciar and Jean de Vingle

It is quite the fashion still as it has always been to depreciate the importance of technique, to put it down as the mechanical part of the book or the picture, something subsidiary to the thought; but when, where, and how in the history of any art has there been great work without it? How does it happen that the world's great writers, musicians, painters, sculptors are also the world's great craftsmen?

JOHN C. VAN DYKE

German initials of the 15th century

THE WEALTH OF OLD WORK

Whatever we may think of the various styles of ornament that have come down to us, it is impossible for us to ignore them altogether. They are the various languages in which the past has expressed itself, and unless we fancy in our foolishness that we can evolve from inner consciousness something at once independent of and superior to all that has been done before our time, we must begin by some study of the ancient principles and practice. It will save time in the end. Even those who flatter themselves that it will be easy for them to take one bound into successful originality, would do well to reflect that they are more likely to succeed by stepping back a pace or two for a spring than by "toeing the line."

If there were no other reason why we should know something of past styles, it

German initials of the 16th century modeled after manuscript initials of the 10th century

would be sufficient that, in the absence of any marked national style among us at present, we have taken to "reviving" in succession all manner of bygone styles. The ornament of today is to so great an extent a reflection, in some instances a distortion of old work, that one cannot well discuss it without reference to its origin. These "revivals," irrational as they are in themselves, are not without good results. We have such a wealth of old work about us, accessible through modern facilities of travel, purchasable through modern processes of reproduction, brought to our notice by modern methods of publication, that we cannot escape their influence if we would; and the "revivals" have involved such a thorough study of the various styles that, when we shall have arrived at reason and begin to express ourselves naturally in the language of our own day, it will surely tell in our work to some purpose.

LEWIS F. DAY

These initials are exceptional in their areas of black back ground and they will be less dominant when used in smaller sizes

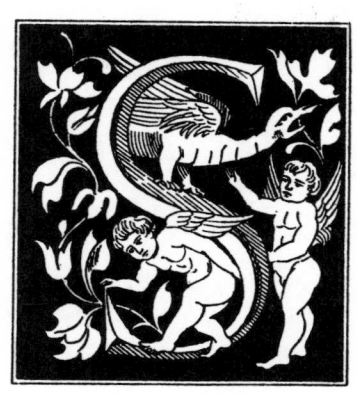
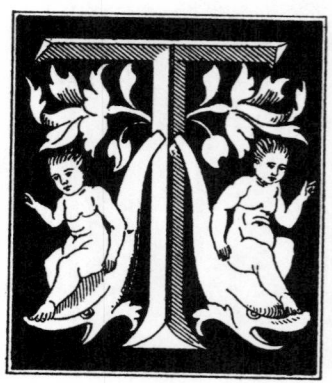

Italian Renaissance initials of 1517

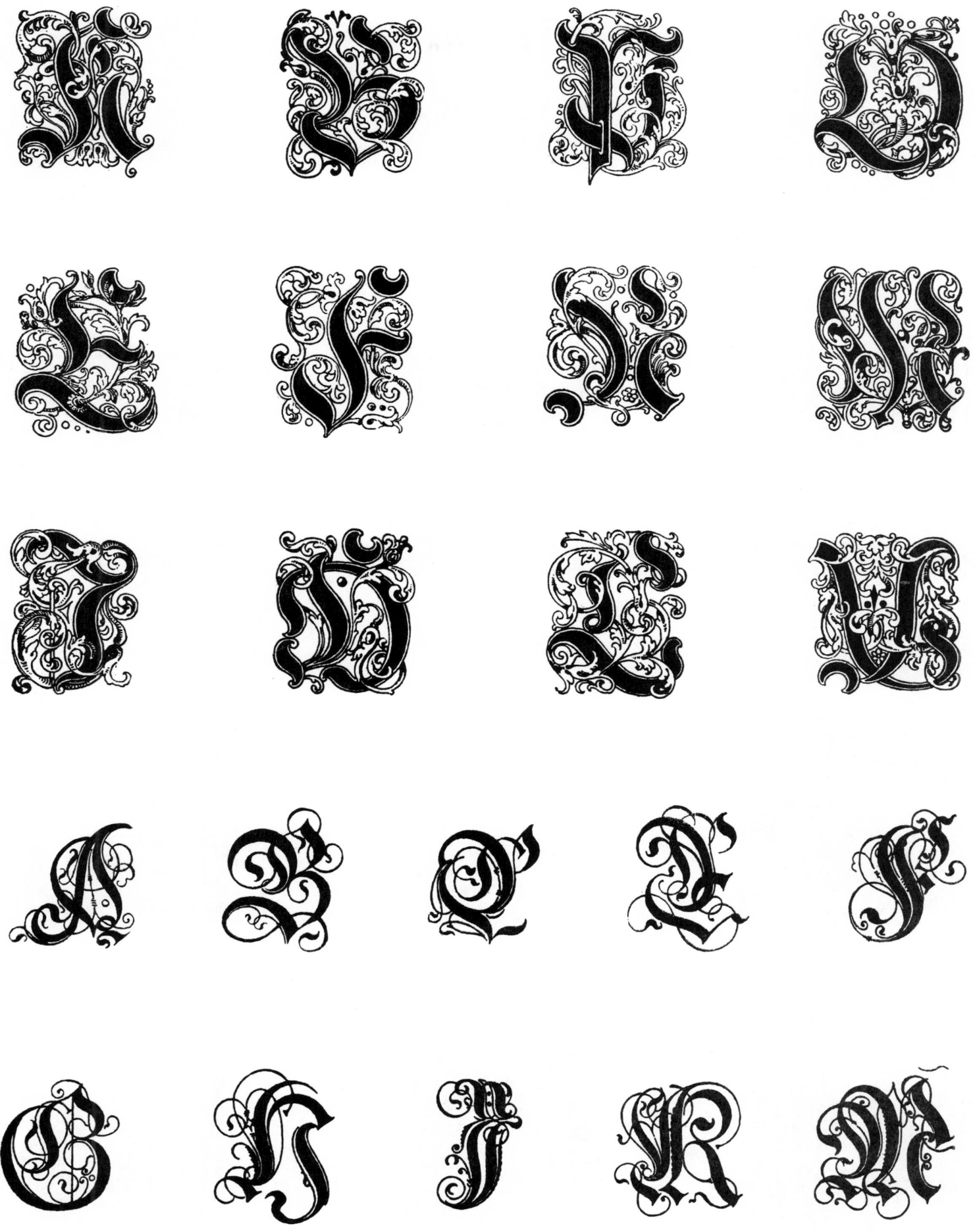

Groups of German initials of the somewhat decadent style of the 17th and 18th centuries

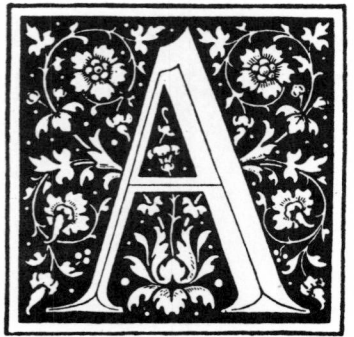

FLORENTINE INITIALS OF THE ITALIAN RENAIS-SANCE IN BRILLIANT, WELL-BALANCED WHITE ON BLACK, AFFORDING ALSO AN EXCELLENT EX-AMPLE OF A CLASSIC FORM OF IN-LINE LETTERS

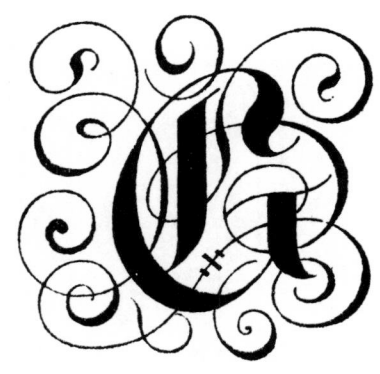

Gothic letters with flourishes particularly useful for their carrying quality when individual letter is used on a broadside or prospectus page

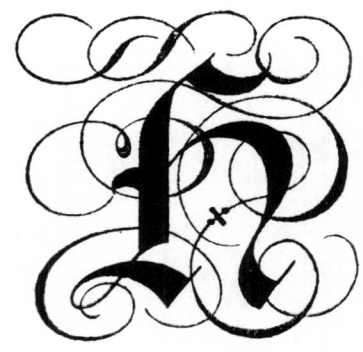

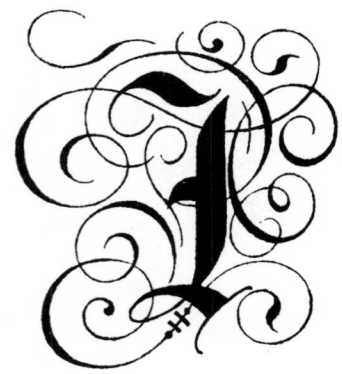
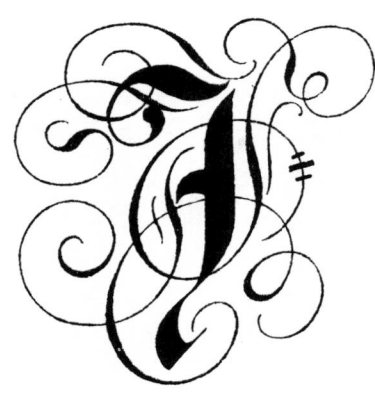
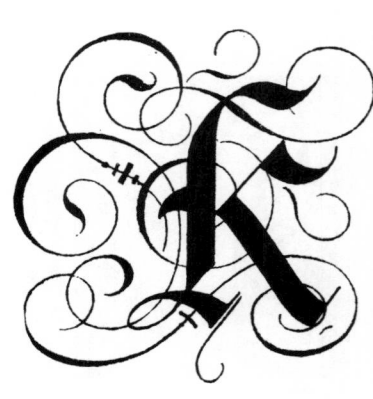

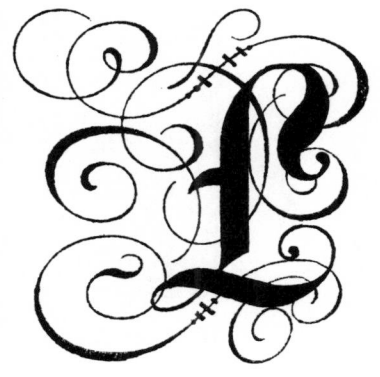 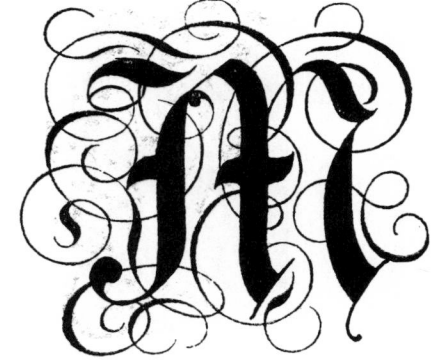 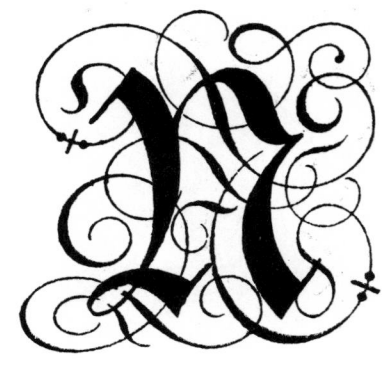

GEOFFROY TORY
PAINTER, DESIGNER, ENGRAVER, PRINTER AND BINDER
FOUNDER OF A SCHOOL OF DESIGN

Born at Bourges in 1480, he became a master craftsman, developing a finer genius than his predecessors. He is credited with having cultivated all the sciences with equal success and to him must be assigned the first place in the art of the decoration of books. He engraved portraits, designed alphabets and borders, was royal printer and made rich bindings, some of them in conjunction with Grolier. It was for Grolier that he interwove so finely his designs in compartments for bindings.

The honor of revivifying the art of engraving in France belongs to Tory alone, bestriding two centuries, the 15th and 16th.

AUGUSTE BERNARD

French Renaissance alphabet by Geoffroy Tory from Etienne's great Latin Bible, 1540

Early 16th century designs with letters of
maximum size and criblé backgrounds

O follow precedent wisely does not mean to
imitate slavishly one great exemplar, but to
study all masters faithfully, letting their great
achievements sink slowly into the mind in
order that we may patiently derive from the
richness of our acquired knowledge and organized system
an attitude of our own

LINDSAY SWIFT

Wood engraved initials of
the early 16th century

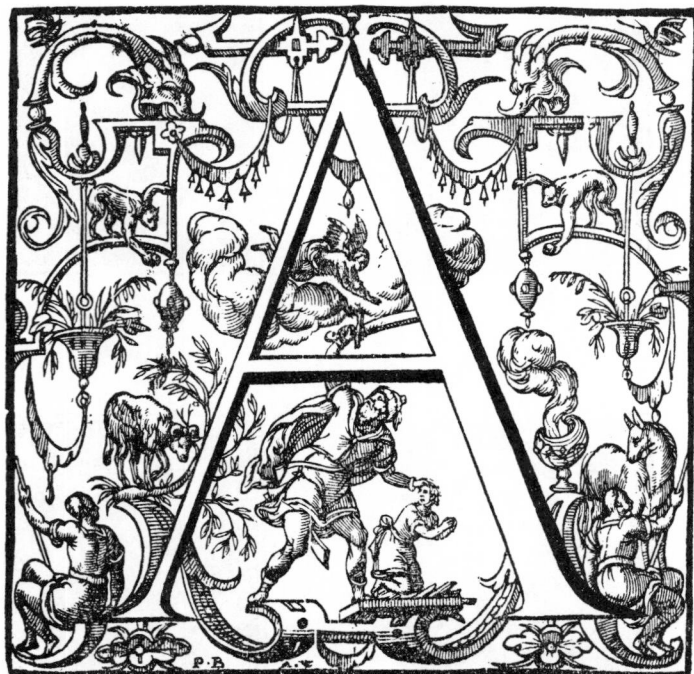
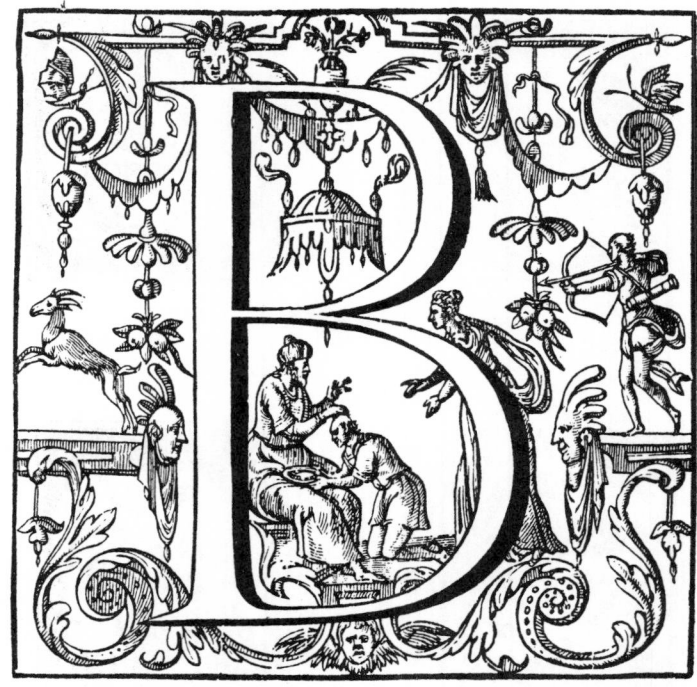

Initials of the Plantin Press, Antwerp

The collection of ornaments and initials used by Plantin exceeds those of any other early printer. His artistic taste carried itself so far that he produced many ornaments of which he was, in fact, the designer and engraver. He also employed many artists including Godefroid Ballaing of Paris, who designed for him 21 Hebrew initials in 1664. Pierre van der Borcht designed an alphabet in 1571 and this was engraved by Antoine van Leest. An alphabet of Gothic initials with white ornaments on black was also used in the Psalterium of 1571. Three alphabets of different sizes, ornamented with natural flowers, were used in the Psalterium and in the Messe de la Hèle.

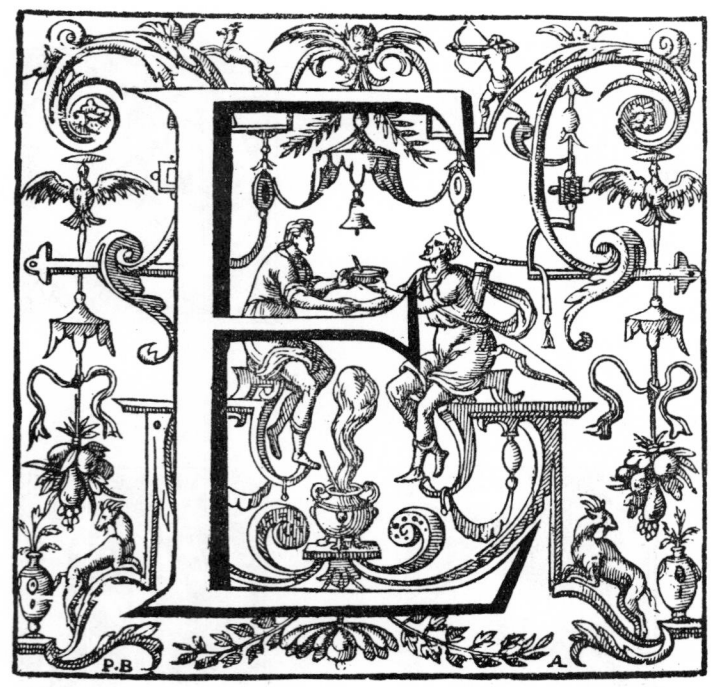
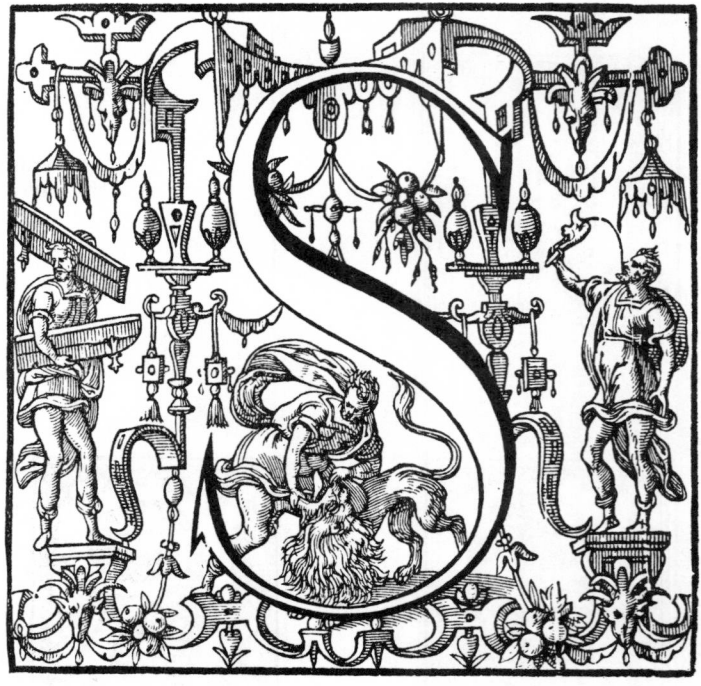

From a series of eleven Plantin initials representing subjects in the Old and New Testaments, designed by Pierre van der Borcht and engraved by Antoine van Leest. They were used in the Messe de Georges de la Hèle

Roman alphabet decorated in grotesque style with satyrs, fantastic animals and human figures,
used by Plantin in the polyglot Bible of 1570

 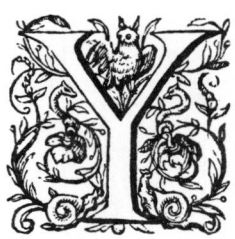

A Roman alphabet decorated in grotesque style, satyrs, fantastic animals and human figures,
dated 1570 and used in the polyglot Bible

An alphabet of interlacings used in the Psalterium of 1571

PLANTIN INITIALS

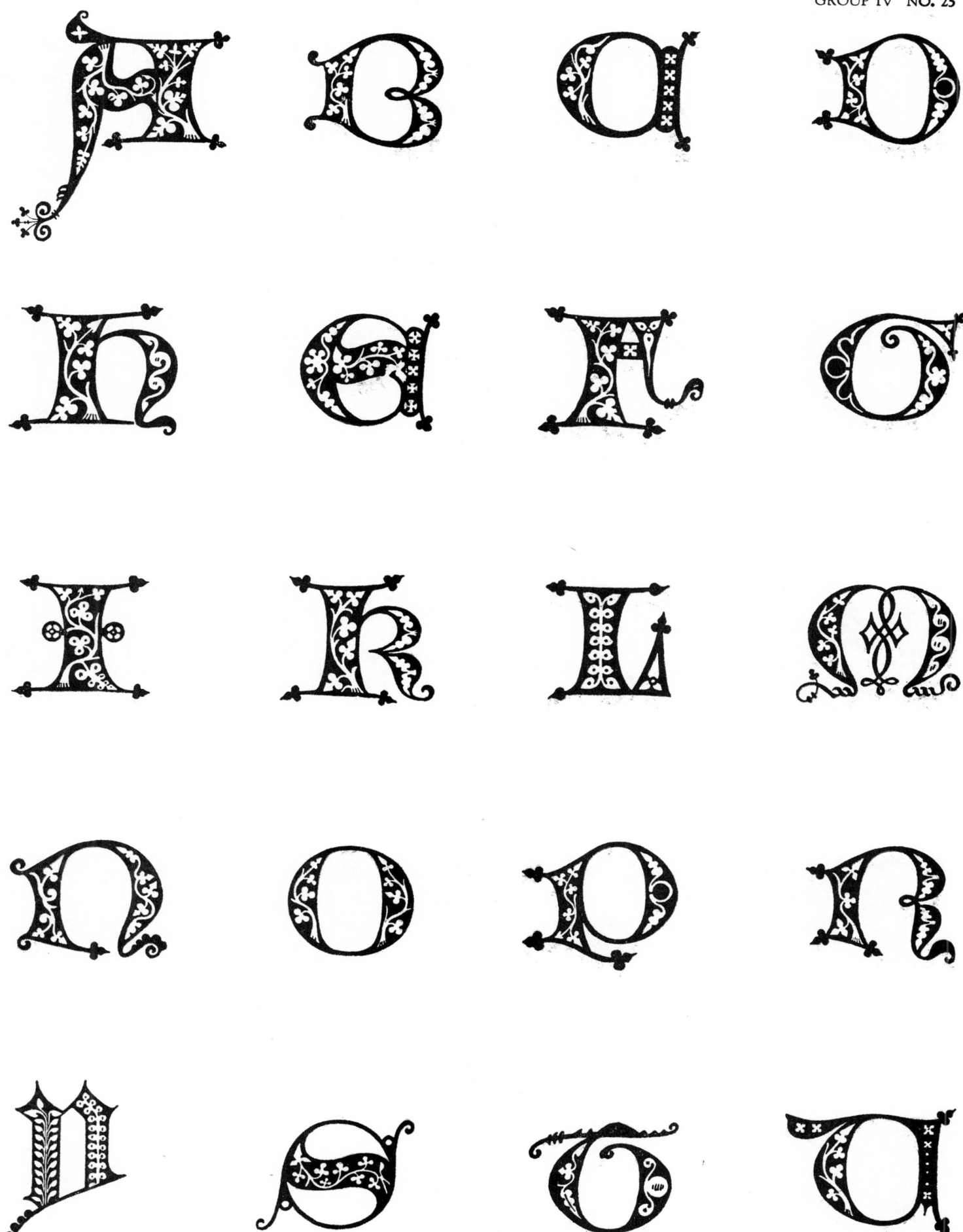

From Summa Bartholomaei Pisani Ord. Praedic. De Casibus Conscientiae, about 1475

Ribbon initials from the Missale
Traijectense, 1515

Interlacing initials with richly foliated backgrounds from The Hystorie De
Perceval Le Galloys, 1530

The Romant de la Rose contains one of the most prized series of alphabets of the early 16th century

144

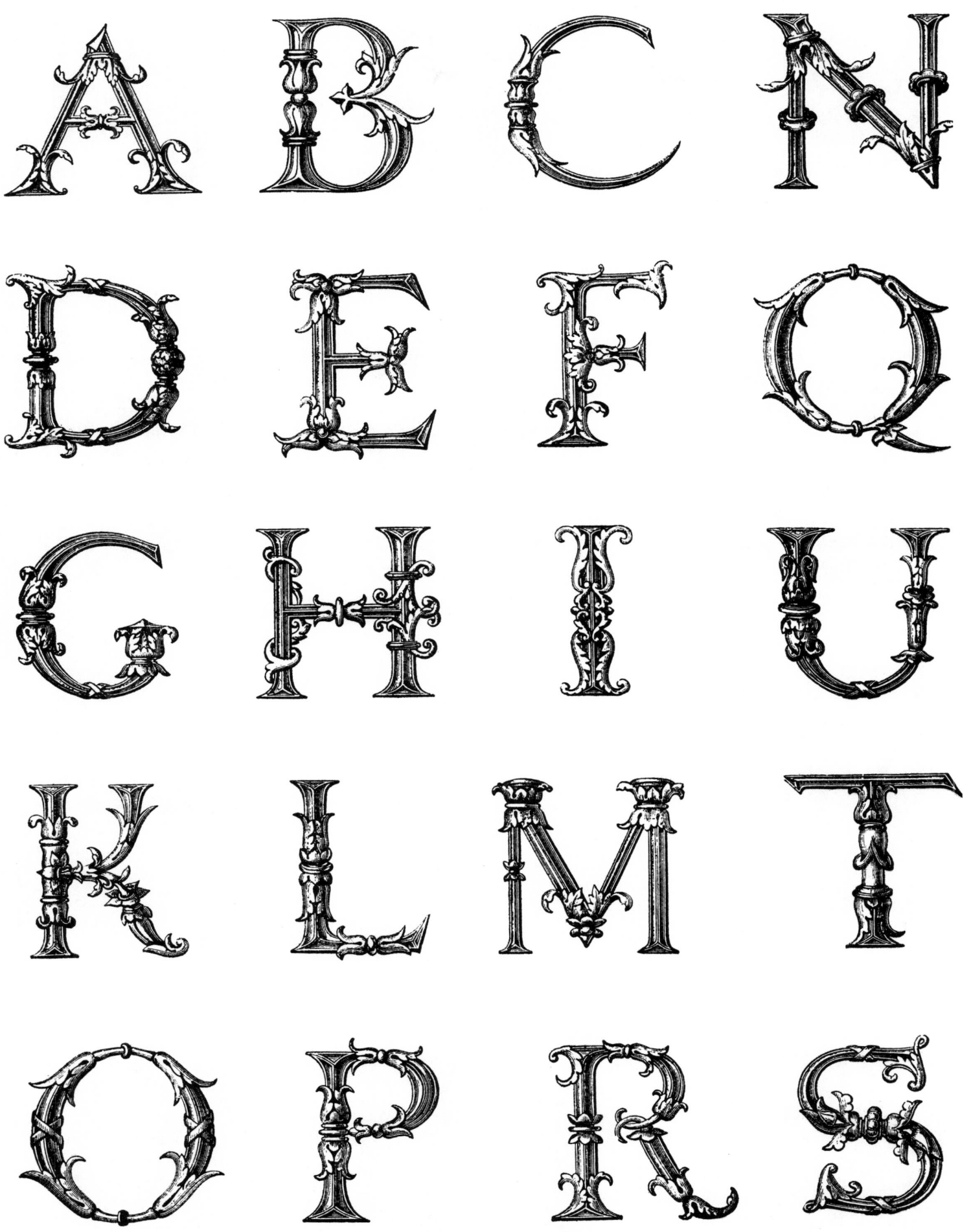

Designs based upon decorative metal work

Barock initials designed by
Georg Heinrich Paritus, 1710

Roman initials of the 16th century with light, foliated backgrounds without the usual border lines

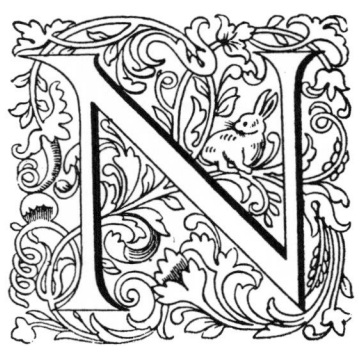
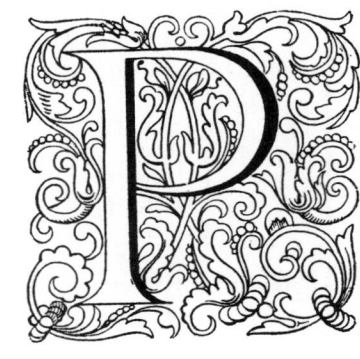

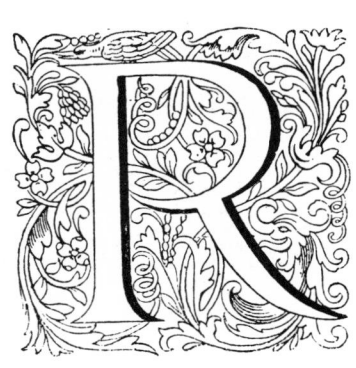
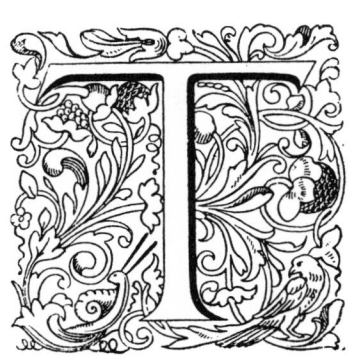

Initials of the Louis XIV period

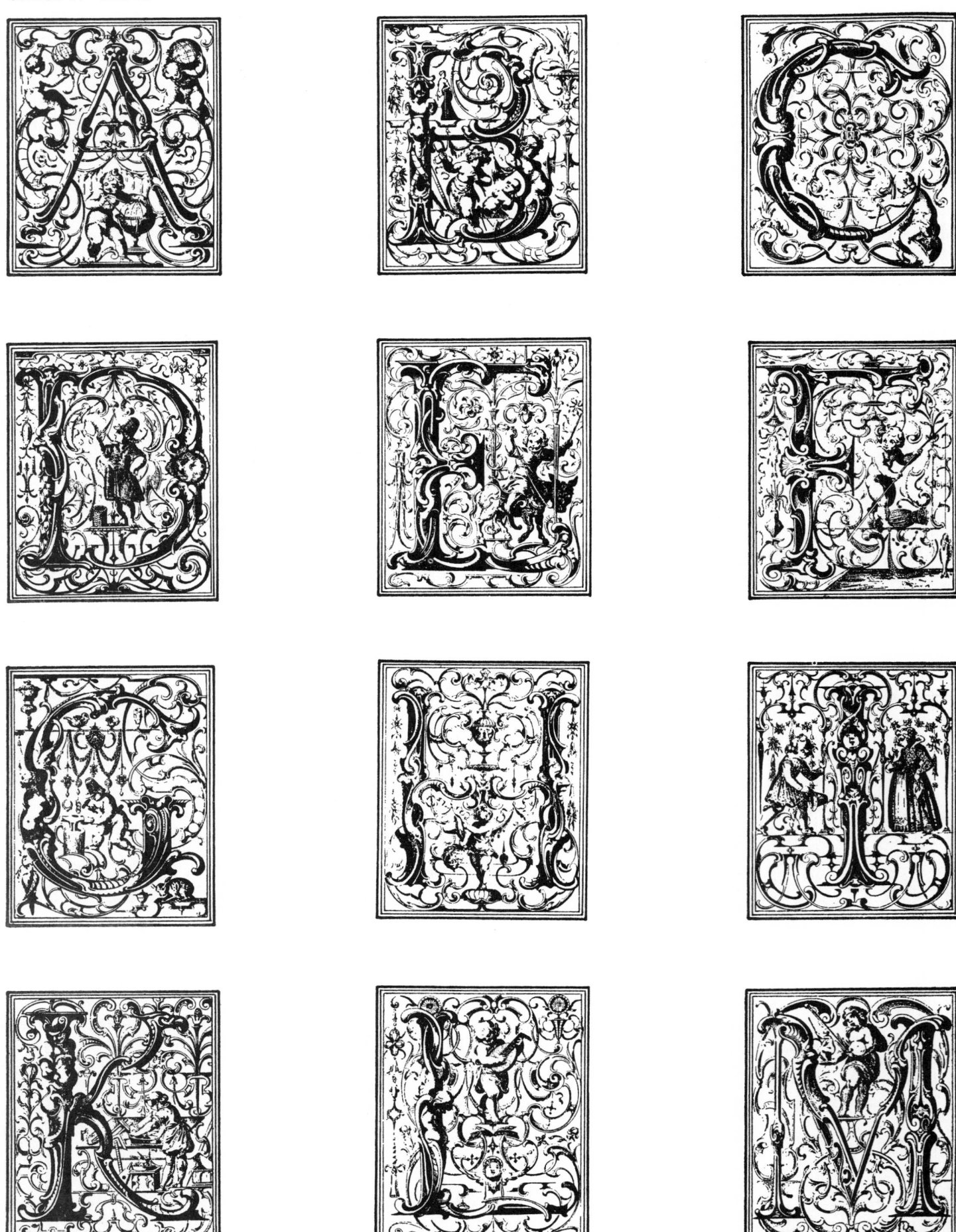

Barock initials by von Lucas Kilian, 1627

 German Renaissance designs, with in-line,
shaded Roman letters

Wood engraved initials from designs by Oronce Fine, Paris, 1532

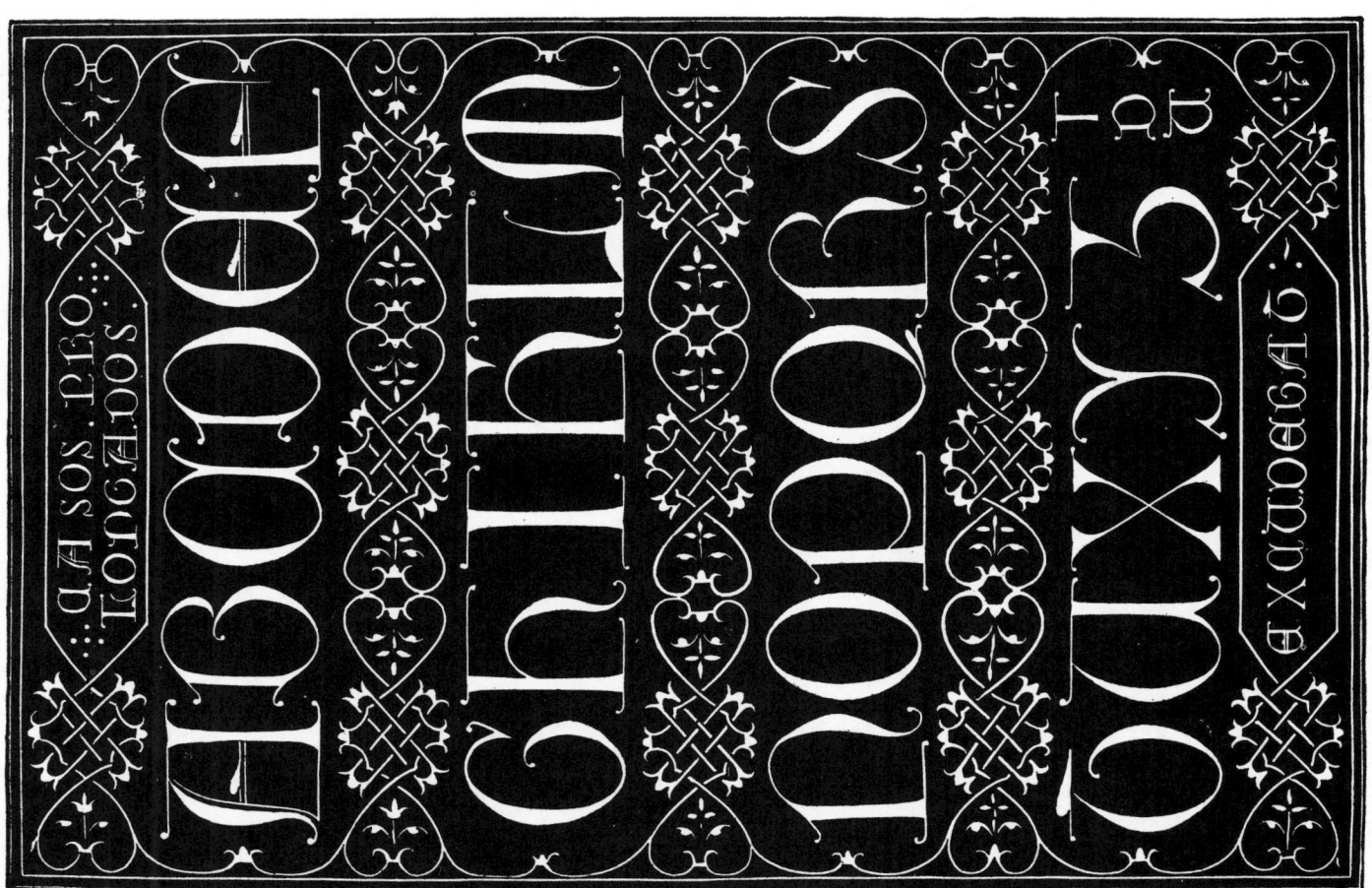

Alphabets of the 16th century, in the Spanish School, at the left designed by Juan Yciar and at the right designed by Giovano Battista Palatino

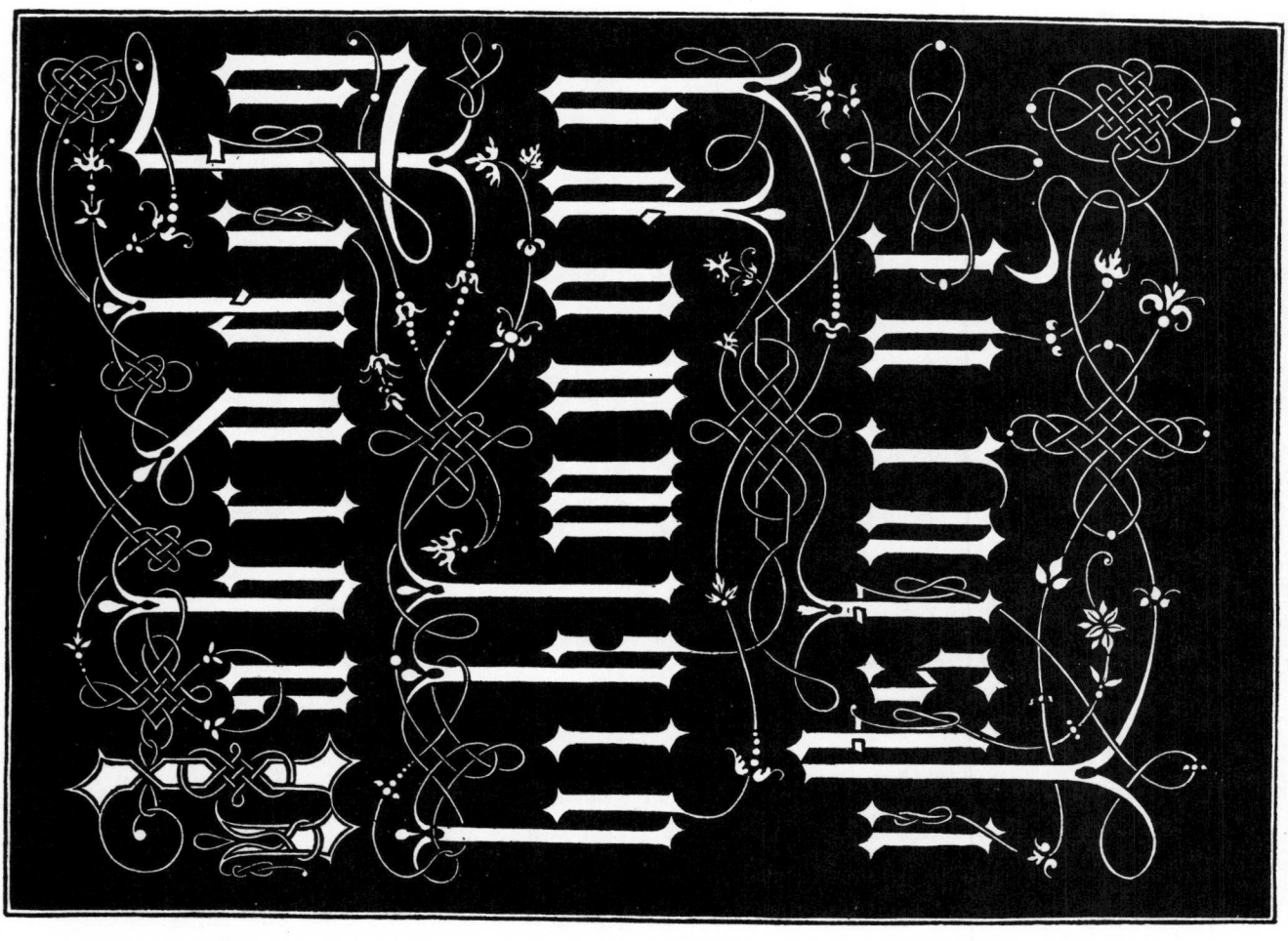

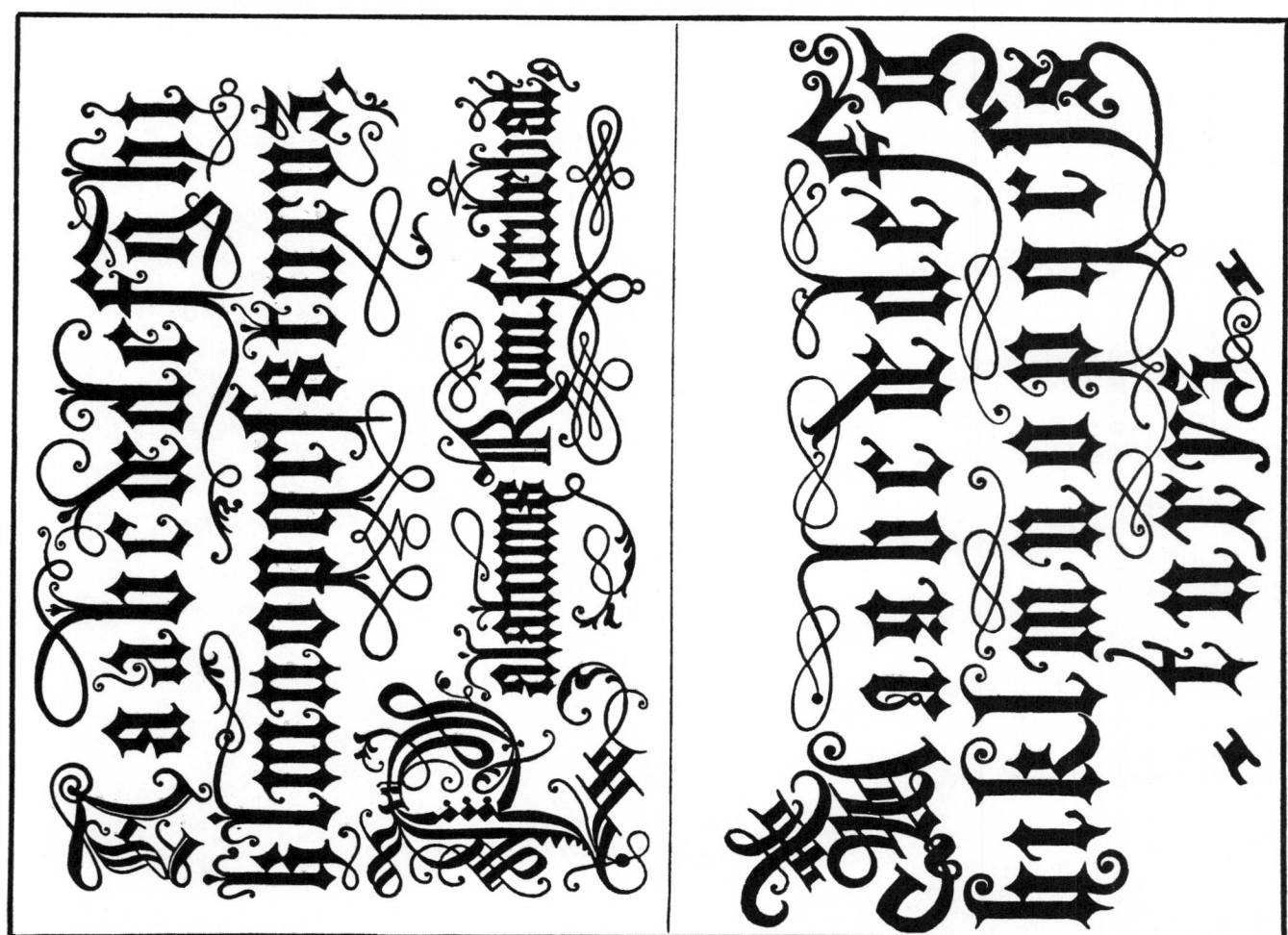

Alphabets of the 16th century, in the Italian School, designed by Giovano Battista Palatino and Tagliente

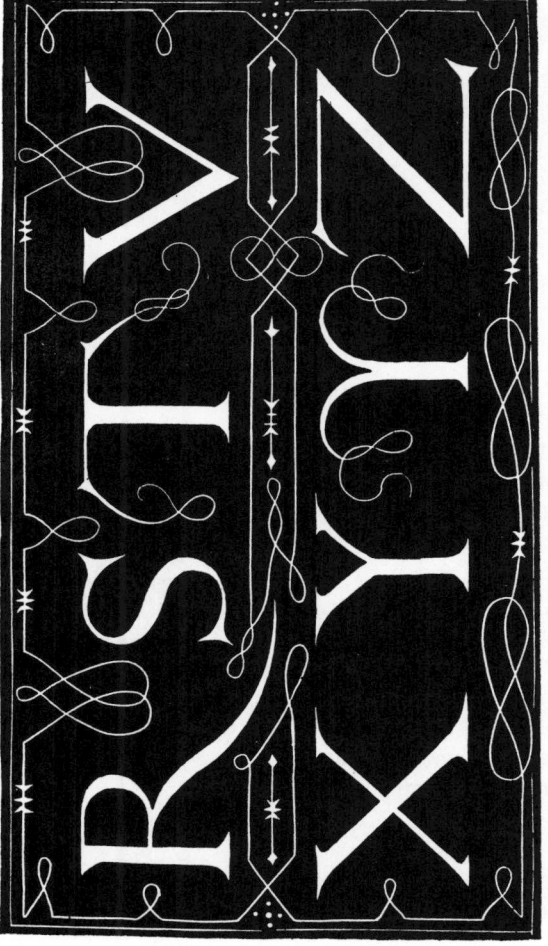

We know that the letters of the alphabet were once pictures, symbols, or abstract signs of entities and actions, and grew more and more abstract until they became arbitrary marks—the familiar characters that we know. Letters formed into words; words increased and multiplied with ideas and their interchange; ideas and words growing more and more abstract until the point is reached when the jaded intellect would fain return again to picture in writing, and welcomes the decorator and the illustrator to relieve the desert wastes of words marshalled in interminable columns on the printed page.

WALTER CRANE

Alphabet of the Italian School, 16th century, by Urbain Wyss

The story told of Giotto and his drawing for the Pope that perfect circle on paper as a proof of his artistic ability is possibly a little fiction of Vasari's; but in the mouth of the mouthpiece of all the Italian painters, it is eloquent of the prevalent belief as to what constituted art. There was no great thinking or subject or theme there. Technical skill was the only thing demonstrated, but that was sufficient not only for Vasari but for the Pope and his councillors. Given that, they thought everything else might follow as a natural sequence. Two hundred or more years later, in the same town of Florence, Andrea del Sarto, after doing some super frescos for the church of the Servi, received the popular designation of "Andrea senza errori"—Andrea without faults. It was his technical skill, not his thinking or his piety, that was without fault. That skill was the result of the insistence upon craftsmanship which had ruled in the teachings of the mediaeval guilds and had been handed down from master to pupil into the period of the Renaissance. It was the first and last requirement of the artist in any department that he should be a skilled workman.

What craftsmen were sent out of that land of Italy before, and through, and even after the Renaissance! To mention such names as Donatello, Verrocchio, Mantegna, Leonardo, Raphael, Michael Angelo, Correggio, Titian, Paolo Veronese is not only listing the great technicians, but suggesting the whole history of Italian art. Every one of them was a masterhand whether a master-mind or not. It was just so at the north. The Van Dycks and Memlings, the Dürers and Holbeins, the Rubenses and the Rembrandts, were skilled in form, color, and pattern to the last degree known to their time; they were every one of them "senza errori" in the Florentine sense. They would not be alive to-day were it not for their skill, for their subjects have practically faded out.

> "All passes—art alone
> Enduring lasts to us,
> The bust outlives the throne,
> The coin Tiberius."

JOHN C. VAN DYKE

 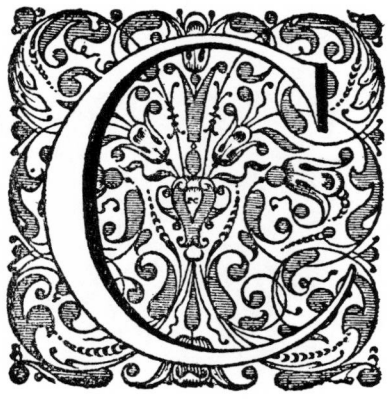

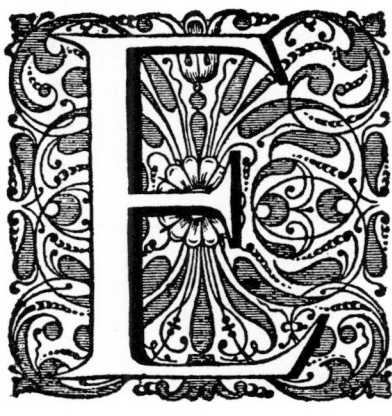

Arabesque initials with shading which colors in well with the larger sizes of type in the book page

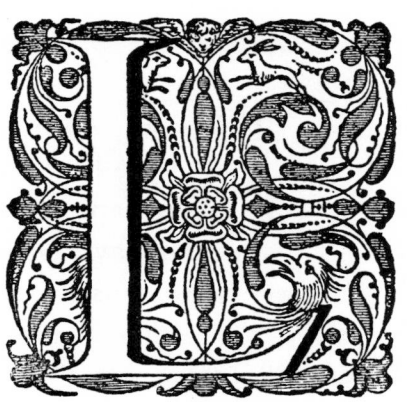

For every art is a language, and to secure power and beauty and adequacy of expression a man must command all the secrets and resources of the form of speech which he has chosen.

HAMILTON WRIGHT MABIE

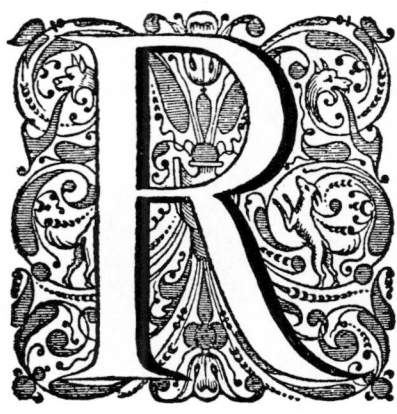

Design, which is a translation of man's thoughts and aspirations and wants into the language of form or color, must of necessity depend very largely upon impressions derived from nature, and will be controlled to a certain extent by his powers of expression. The rudeness or conventionality of barbarous art springs probably from undeveloped art powers; and repetition, creating manner, perpetuates imperfections, until, associated in regular sequences, they become accepted as styles. Processes of work, and character of material, will also control the nature of design. A great distinction, however, may be drawn between the conventionality of barbarism and the conventionality of style; the first being the result of immature art power, and the second of mature choice. The naturalistic in design is the imitation of natural forms, with most of their peculiarities to create ornamental effects; whilst the conventional treatment adheres to general forms and principles of nature as a motive, omitting unimportant details and individual peculiarities, thus producing a generalization or typeform of ornament based upon first principles.

WALTER SMITH

THE ARTS REFLECT EACH OTHER

HE highest authorities consider all the arts as one in fundamental principles, if not in aim. Phidias, Giotto, Leonardo da Vinci, Michael Angelo, and the greatest artists of all time were not specialists in one art, but students of every form of art. They were painters, architects, sculptors, musicians and poets. The arts reflect each other; the terms which are applied to the arts are borrowed from each other. We speak of the tone of a picture, and the color of a piece of music. The sculptor must have a sense of color and music, or his work will be cold. Each art may definitely require a special set of faculties to be trained, but these are co-relative and must be brought into harmony for power in any one art. Hence a certain amount of training in different arts develops the art capacities, and enables the mind to grasp the elements that are fundamental to all art.

S. S. CURRY

The field occupied by the printing arts in modern life is one of vast extent. Not only is printing with type employed to convey ideas in never ending volume through books, magazines, newspaper and numberless other ways, but graphic advertising in countless forms has become one of the striking features of modern life.

Illustration, whether concerned with imaginative work or photographic reproduction, represents an important field. Printing also enters the domain of the fine arts as in the case of etching, mezzotint and auto-lithography. In all of these fields the element of composition and design appears.

CHARLES R. RICHARDS

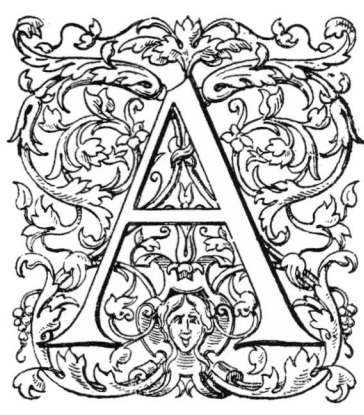RIGINALITY is a quality which is very much misunderstood. It is in truth easy enough to be original if one does not mind being ridiculous. If any man was master of Renaissance ornament it was surely Alfred Stevens; yet the number of fresh ornamental motives which he was able to produce during his lifetime can probably be counted on the fingers of one hand.

G. WOOLLISCROFT RHEAD

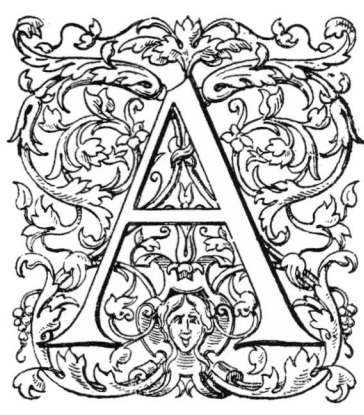 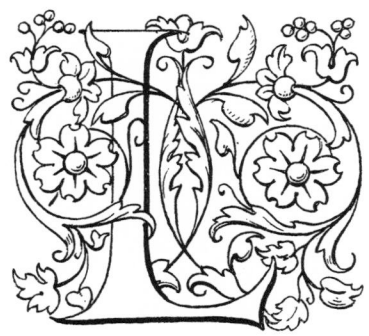 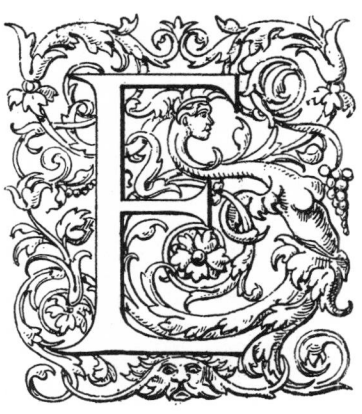

Selections from incomplete alphabets

163

Oratio ad suū pprīū angelū·

Deus ppitius esto mihi peccatori·Et sis mihi custos omībus diebus vite mee· Deus Abrahā. Deus Ysaac· Deus Jacob miserere mei·Et mitte in adiutoriū meum proprium angelū gloriosissimū: qui defendat me hodie:et ptegat ab omībus inimicis meis Sctē Mihael archangele·Defende me in plio:vt non pereā in tremendo iuditio·Archangele christi·Per gratiam quā

Rubricated page from the Prayer Book of the Emperor Maximillian. The crisp angularity of this Gothic type imitates the large black-letter of actual penmanship to a marvelous degree. It was printed in 1514 by Johann Schoensperger at Augsburg especially for the emperor, who was a munificent patron of the newly developed art of printing

HISTORIC DESIGN IN PRINTING
GROUP V—PRINTERS' MARKS AND DEVICES

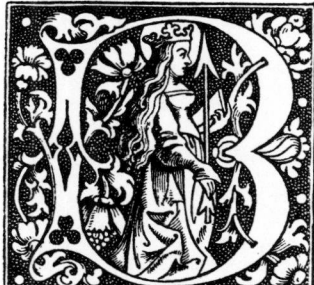

Y the end of the fifteenth century the Printer's Mark had assumed or was rapidly assuming an importance of which its original introducers had very little conception. Indeed, as early as 1539, a law, according to Dupont, in his "Histoire de l'Imprimerie," was passed by which these marks or arms of printers and booksellers were protected. Unfortunately the designs were very rarely signed, and it is now impossible to name with any degree of certainty either the artist or engraver, both offices probably in the majority of cases being performed by one man.

There is no doubt whatever that Hans Holbein designed some of the very graceful borders and title-pages of Frobert, at Basle, during the first quarter of the sixteenth century, and in doing this he included the graceful Caduceus which this famous printer employed. It does not necessarily follow that he was the original designer, although he was in intimate association with Frobert when the latter first used this device.

W. ROBERTS

The vessel of Galliot du Pre, a printer and bookseller of numerous romances and legends beginning in Paris in 1512. It bears the printer's motto: "Row on the Galley"

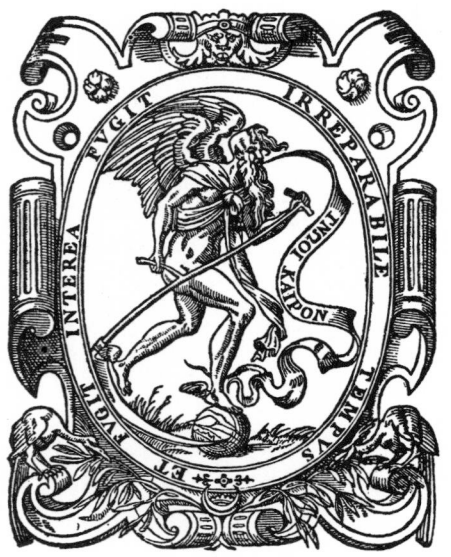

Top:
Ambroise Girault, Paris, 1525-1546
Claude Micard, Paris, 1558-1588
Pierre Le Brodeulx

Center:
Jean Temporal, Paris, 1550-1559
Jehan Guyart, Bordeaux, 1528

Bottom:
Jean Bogard, Lovain, 1556-1634
Benoist Rigaud, Lyons, 1550-1597
François Gryphe, Paris, 1532-1545

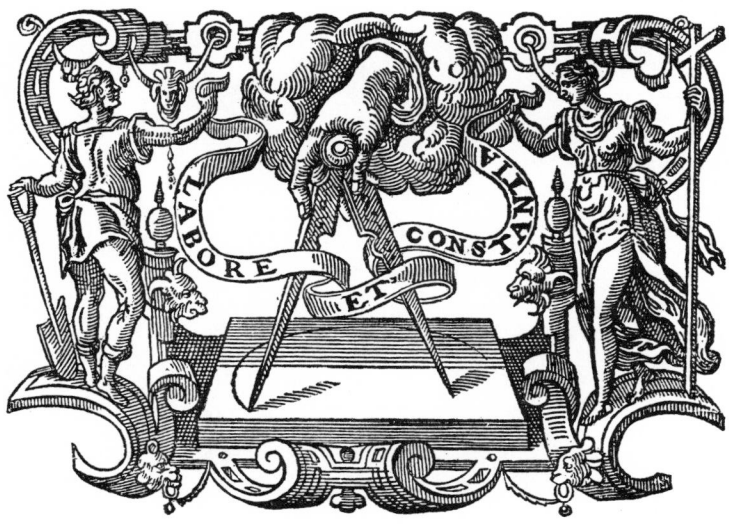

Top: Marks of Venetian Printers

Center: Plantin and a Venetian Printer's Marks

Bottom: Robert Estienne, Paris and Geneva,
1525-1559
Jean de Tournes, Lyons, 1542
Barthélemy Honorat, Lyons, 1554-1587

167

Hugues de la Porte, Lyons, 1539

Guillaume Eustace, Paris, 1493-1525

Top Left: F. Giunta, 1517
Top Right: John Schoeffler
At Right: François Regnault, Paris, 1512-1551
Lower Left: B. Rembolt
Lower Right: Anthoine Verad, 1485-1512

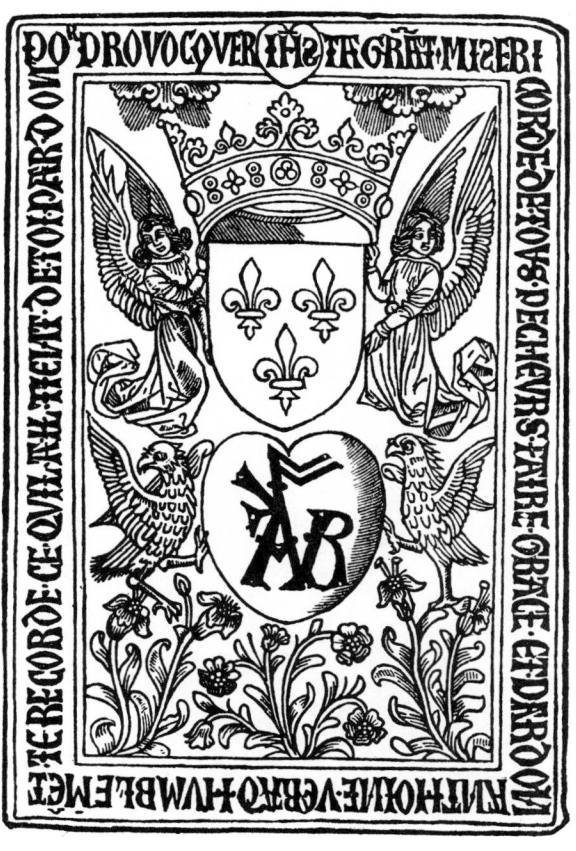

Top Left:
Ayme de la Porte, Lyons, 1498

Top Right:
Guillaume de la Rivière, 1591-
1637

Center Left:
Simon de Colines, Paris, 1520-
1546

Center Right:
Jehan la Porte, Paris, 1508-1520

Lower Left:
Gaspard Philippe, Paris, 1500-1510

Lower Right:
Anthoine Denidel, Paris, 1497-
1501

Top Left:
Guyot Marchant, Paris, 1483-1502

Top Right:
Pierre Regnault, Rouen, 1489-1520

At Center:
Jehan Bonfons, Paris, 1548-1572

Lower Left:
Denis Roce, Paris, 1490-1518

Lower Right:
Pierre Regnault, Rouen, 1489-1520

Upper Left: Cartouch with heraldic fleur de lis, Venice, 1586
Upper Center: Matthieu Chercele, Tours, 1536-1554
Upper Right: An exceptional composition, with the reviving Phoenix as the central motive, two winged chimeras sit at the base and cupids climb upon the cornucopias, crowned with a scroll, carrying the printer's motto
Center: Nicolas Petit and Hector Penet, Lyons, 1534-1545
Lower Left: Antoine Vincent, Lyons, 1537-1563
Adjoining: Jean Dallier, Paris, 1546-1574

CORNEI

Juris Utriusqz Doc.Clarissimi.Consiliox Primu volume no
uissime reuisum 7 ab infinitis errozibus expurgatu. Addiris
de nouo sumarijs:copioso vtilissimoqz Reptozio. Eiusqz ex-
cell.Auctozis vita atergo huius pagie integerrima habetis.

Rubricated title-page of a work on civil law by Petrus Phillippus, printed in
Perugia, 1477 by Johan Vydenast

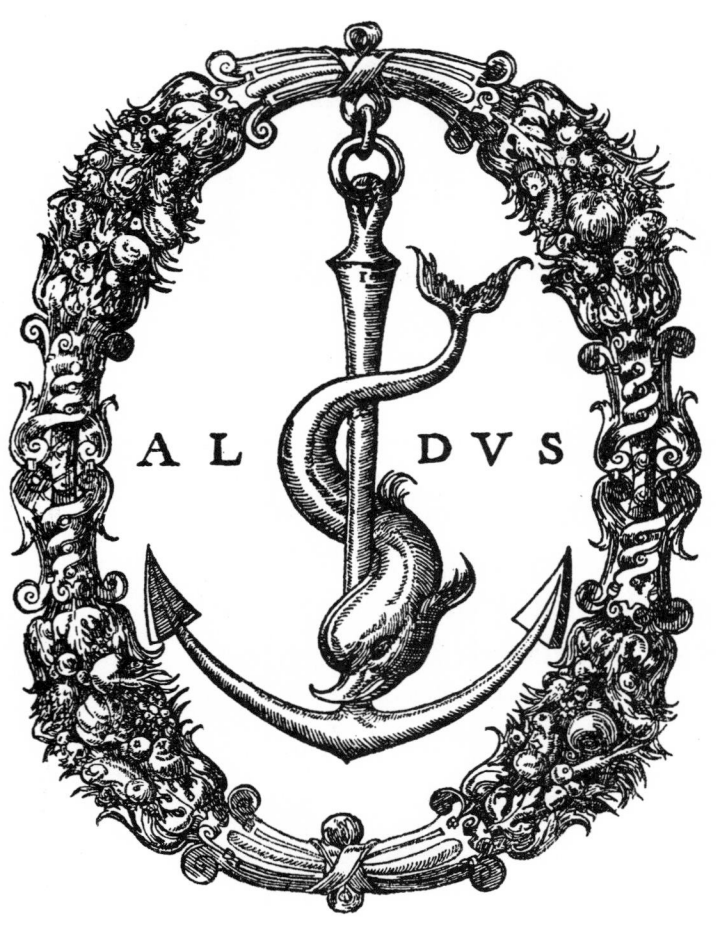

Top:
The Aldus Dolphin and Anchor were copied by many printers and in later years have been used as the mark of various English and American publishers
Right: One of the large engravings of the series of printing office interiors illustrated by Geofroy Tory for Badius

Bottom:
Left: Ulricherus of Strasburg, 1529-1539, used several adaptations of the female figure with the cornucopia
Center: Jacques Roffet, Paris, 1549 used the Seed-Sower in several of his marks
Right: Symbolic device of Robert Estienne, Paris, 1525-1559

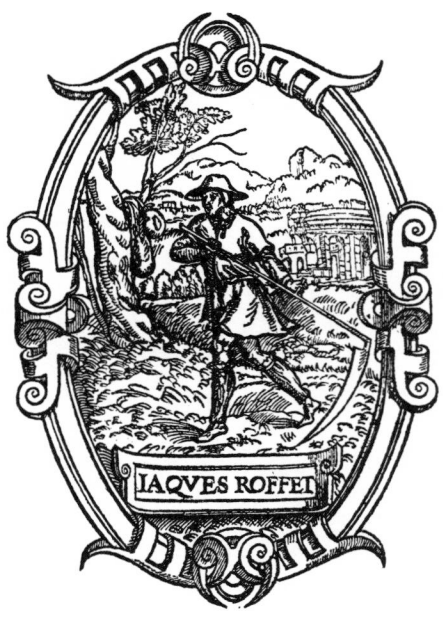

CONCORDANTIÆ
BIBLIORVM
VTRIVSQVE
TESTAMENTI,
VETERIS ET NOVI,
PERFECTÆ ET INTEGRÆ;

Quas re vera Maiores appellare possis.

Opvs facrarum literarum ftudiofis apprimè vtile, denuò, poft omnes quæ præcefferunt editiones, multis deprauatis locis commodè reftitutis & caftigatis fummo ftudio ac labore illuftratum.

ANTVERPIÆ,
Ex officina Chriftophori Plantini,
M. D. LXXXV.

One of the many different marks used by Christopher Plantin. The initial "G" is probably for Geofroy Tory, although this designer marked his work generally by the Lorraine Cross

The device at the left is commonly ascribed to Nicholas Jenson, Venice, although it was really used by him in conjunction with books printed by him and John of Cologne. This device of the cross and circle has had a most significant use and survival. In Ongania's "L'Arte Della Stampa" there are twenty-seven variations used by early printers, the one at the right being that of Octavian Scot of Monsa in the Milanese

In W. Roberts' "Printer's Mark" there are thirty variations of the use of the cross and this extra-ordinary phase of Printer's Mark is termed by Paul Delalain "la persistence de la croix." It has appeared in all forms and almost every conceivable shape, the initials of the printer usually being in the circle

The Fust and Schoeffer mark with the text of the colophon used in the first dated Bible, 1462. This is the mark now used by the Clubs of Printing House Craftsmen as significant of union and good fellowship in printing

DECISIONES
CASVVM

IVRIDICA PRAXI RECEPTORVM
totaq̃; die contingentium, ac in contra-
dictorio Iudicio deciforum.

VINCENTIO CAROCIO TVDERTINO
I. C. CLARISSIMO AVTHORE.

Nunc fecunda hac editione in ftudioforum gratiam euulgatæ.

Indice duplici, vno Titulorum, altero Rerum memoria dignarum,
vt copiofo, ita & methodicè digefto, quo facilius materiæ
omnes legenti occurrere pofsint, accedente.

CVM LICENTIA SVPERIORVM, ET PRIVILEGIIS.

VENETIIS, MDCXII.
Apud Florauantem Pratum.

Rubricated Venetian title-page with mark of printer, the three trees
surmounted by the three birds being symbolic, perhaps, of wisdom
and its messengers

AVGVSTINI
BEROII
BONONIENSIS
IVRECONSVLTI
CLARISSIMI,

QVAESTIONES
FAMILIARES PRAGMA-
TICIS PERCOMMODAE.

Hac nouiſſima omnium editione diligentia ſingulari reco-
gnitæ, & ab erroribus expurgatæ.

Eis acceſſerunt ſumma rerum capita, ac locupleſiſſimus Index.

VENETIIS,
Apud Io. Antonium Bertanum. MDLXXIIII.

SECONDA PARTE
DE LE COSE MORALI DI PLV-
TARCO; RECATE IN QVE-
ſta noſtra lingua, da M. Giouanni
Tarbagnota. Nuouamente
riſtampata, et corretta.
CON VNA GIONTA D'VNA TAVOLA
delle ſentenze piu notabili che in
quella ſi contengono.

IN VENETIA
Appreſſo P. Gironimo Giglio, e compagni.
M. D. LIX.

Two Venetian title-pages with carefully balanced display lines. These pages have excellent cartouch designs and introduce heraldry, a motto and symbolism, the storks being the emblems of filial piety, defined by Confucius: "Carrying on the aims of our forefathers"

D. Mathiæ Coleri Iurifcon-
fulti in Academia Ienenfi

TRACTATVS

DE PROCESSIBVS

EXECVTIVIS, IN CAVSIS CIVILI-
BVS ET PECVNIARIIS, ACCOMMODA-
TVS PASSIM AD PRACTICAM
FORI SAXONICI.

Cui in fine adiectus eft index verborum & rerum,
quæ in hoc opere continentur, copiofus.

CVM GRATIA ET PRIVILEGIO ROMANAE
CAESAREAE MAIESTATIS AD DECENNIVM.

Ienæ,

EXCVDEBAT TOBIAS STEINMAN.

Anno M. D. LXXXVI.

A title-page of 1586 in which the larger sizes of lettering are engraved, indicating the limitation
in cast types. The printer's mark has an elaborate inscription and an unusually
pictorial center. Printed by Tobias Steinman, Jena, 1586

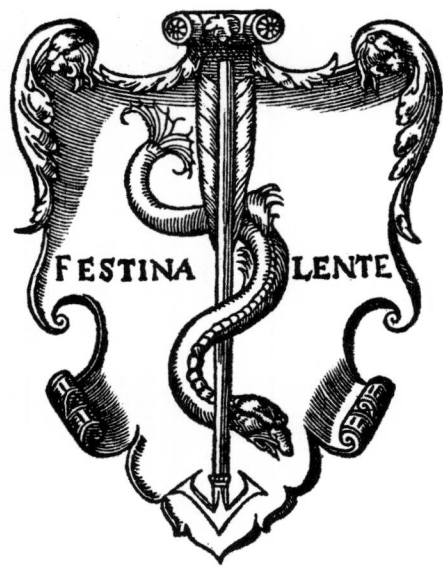

It is interesting to note that the Printer's Mark preceded the introduction of the title-page by nearly twenty years, and that the first ornamental title known appeared in the "Calendar" of Regiomontanus, printed at Venice by Pictor, Loeslein and Ratdolt in 1476, in folio. Neither the simple nor the ornate title-page secured an immediate or general popularity, and not for many years was it regarded as an essential feature of the printed volume. Its history is intimately associated with that of the Printer's Mark, and the progress of the one synchronizes up to a certain point with that of the other. In beauty of design and engraving, the Printer's Mark, like the Title-Page, attained its highest point of artistic excellence in the early part of the sixteeth century. This perhaps is not altogether surprising when it is remembered that during the first twenty years of that period we have title-pages from the hands of Dürer, Holbein, Wechtlin, Urse Graff, Schauffelein and Cranach.

W. ROBERTS

Top:

Left: Design by Hans Holbein for John Bebel, Palma

Center: One of the series of Badius' printing office interiors

Right: Shield with motto and device used by Heinrich Von Neuss, Cologne

Bottom:

Left: Poncet Le Preux, Paris, 1508-1551

Right: One of the smaller devices used by Christopher Plantin with the compass and Plantin motto, "Work and Constancy"

GLOSSARY OF TERMS
USED IN DECORATIVE DESIGN
IN PRINTING

NEARLY *every problem of design involves discussion, and the naming of styles, construction or details. It is difficult for those who have not taken a course of instruction in design to know all the terms. As this work on Historic Design in Printing will be used for reference purposes and discussion by many who will want some general terminology and description, a limited Glossary is presented. There are several comprehensive histories, dictionaries of art and finely printed books of reproductions. A few titles are included in the list of reference books in two of the succeeding pages.*

Acanthus. A plant, the foliage of which has served as decorative motive in classic design from its use in Greek ornament down to modern times. Its beautiful serrated leaves and graceful growth give acanthus special value to the ornamental designer.

Aesthetics. A theory of perception and of the science of the beautiful.

Alignment. A term used in typography for trueness to marginal, top or bottom lines and applied commonly to the even relation of initial letters or other decorations of the type page.

Anchor. In religious use it is the symbol of hope and is one of the great motives used in devices.

Anthemion. In Greek art a flat decorative group of flower or leaf; some have the general character of radiating cluster of blossoms of the plant and hence often called honeysuckle.

Arabesque. A piece of decorative scroll work or other ornament more or less intricate, composed of foliage, leaves, fruits, scrolls of fantastic animals and human figures. Arabesque won its highest triumph in the Loggia of the Vatican as shown in the designs of Raphael.

Balance. Synonym for equilibrium. A composition may be well balanced in both grouping and in lights and shades.

Caduceus. The staff carried by Mercury or Hermes. Around it two serpents were coiled and it was winged at the top. It is the symbol of peace.

Capital. The uppermost and ornamented part of a column, pillar, or pilaster, which serves as the crown of the shaft.

Cartouch. 1. An elliptical tablet or scroll like some containing the names of the Pharaohs. 2. Sculpture or back ornament in form of a scroll enrolled, used as field for inscription, etc.

Cinquecento. Literally 500 but it is used as an abbreviation for mille cinquecento that is, 1,500 and is applied as a general term to the art of Italy of the 16th century. During this brilliant period the classical art was at its height.

Classical. In the strict sense it is the term applied to the best period of ancient Greek art. By analogy, the name is given to schools which take the monuments of Greek art as their models.

Congruity. A general consistency in the relation of each part of an object or between the completed work and its surroundings. The incongruous in ornament was perhaps most apparent following the break up of the Renaissance the latter part of the 16th century.

Cornice. The large molding which forms the coping of a façade or surmounts the door or window.

Cornucopia. An ornament consisting of a horn in which are flowers, fruits and other natural objects. It symbolizes peace and prosperity.

Criblé. Minute punctures or depressions in surfaces of metal or wood. It occurs in earliest backgrounds for printed borders and initials. De Vinne describes the process as being intended to offset in a measure the impossibility of obtaining a solid background because of the imperfections of early press work. Its modern equivalent is the stippled background used in illustrations and advertisements for rapid printing processes to obviate offset. Criblé backgrounds also lighten borders and decorations so that they harmonize better with type pages than if solid blacks are used.

Cross. Used in expression of religious sentiment, in heraldry and in processionals.

Decoration. Derived from the Latin word decorus, a root that also supplies us with an English word decorum. Decorative art is therefore primarily what may be used in a certain position with propriety; that which is seemly, becoming and fitting. Hulme.

Diaper. As a symbol of ornament it consists of a repetition, covering surfaces as in bookcover designs and in decorative end leaves.

Dolphins. A favorite fish which heralds used as the armorial ensign of the Dauphin, the eldest son and heir apparent of the kings of France. In Christian archaeology, the dolphin is a symbol of swiftness, diligence and love. It is often entwined with an anchor. The first Christians wore these two symbols united in a ring which was known as a nautical anchor. The dolphin anchor was made most famous as a printers' device by Aldus. The dolphin appears more than any other significant feature in the borders included in this book.

Eagle. In ancient art the eagle often figured on medals and coins. It also symbolizes victory, authority and power.

Egg-and-Dart. A decorative motive consisting of a pointed arrow separating two eggs. Sometimes the darts are slightly ornamented. The Egg-and-Dart is one of the most used motives in conventionalized borders and frames.

Encarpa. A festoon of fruit and flowers commonly used to decorate friezes and other flat spaces.

Entablature. In Grecian, Greco-Roman and neo-classic architecture, the ordinary horizontal forms of material carried upon the columns and extending upward as far as and including the first decidedly projecting course of material.

Escutcheon. Name applied to a shield upon which coat of arms and other devices are emblazoned. Escutcheons are abundantly used in Gothic architecture. The term is always applied to metal plates on doors for keyholes, etc. It is now a common form of frame for devices and trade-marks.

Façade. The outside surface of a building, especially the front which is more richly decorated than the rest of the edifice. Illustrations of façades in classical architecture are a source of many useful forms and details for the designer.

Festoon. It generally consists of foliage, flowers or branches entwined or bound together. Festoons were employed by architects of the Renaissance and are now common in headbands and other forms of decorative design in printing.

Fleur-de-Lis. The flower found in many coats of arms as the symbol of nobility and sovereignty. It is pre-eminently the royal insignia of France. It assumes different forms in different epochs.

Fleuron. The name given to a small rose-like flower surrounded by leaves employed as an ornament in classic art.

Foliage. Nearly every style of architecture has made use of foliage for purposes of ornamentation. In antiquity, the leaves of the acanthus, palm, olive and ivy were thus employed; the Byzantine and other styles utilized for the same purpose the vine, oak, parsley, mullein and thistle. Foliage has been applied to the decoration of capitals, bands and friezes. The work thus enriched is said to be foliated and the ornament itself is called foliation.

Fret. A kind of ornament much employed in Grecian art, formed of bands or fillets variously combined; a piece of perforated ornamental work. Frets are in meander patterns, also crenelated, triangular and undulating. Many of the best type foundry borders are frets and they are used frequently in decorative design.

Frieze. In architecture it is the entablature between the architrave and cornice. The term frieze is applied to the broad border which sometimes runs around the top of a room between the wallpaper and the cornice. By analogy, the frieze may also be a design the length of which is considerably greater than its height.

Frontispiece. The term applied to the reproduction of a drawing or painting obtained either by engraving or some mechanical process and placed as the illustration next the first page of a book or manuscript.

Garland. An architectural ornament representing foliage, flowers or fruits plaited and tied together with ribbons.

Goffering. The impressing by means of a hot plate an ornament either sunk or in relief upon leather, paper, etc. as shown by the border plate of this book.

Gothic. A term applied to mediaeval architecture and to lettering of an angular form in general use in the middle ages. Mediaeval manuscripts were executed in Gothic characters of extraordinary beauty. The Gutenberg Bible and other early books were in Gothic type.

Grotesque. A symbol of ornament representing fantastic subjects or forming arabesques in which extravagant figures and fanciful animals are interlaced. The taste for this method of decoration continued during the period of the Renaissance.

Hours, Books of. Prayer books of which there are many in existence in manuscripts and in early printed books. Among the early printed books of this kind are many with pages which are bordered with woodcuts of extraordinary delicacy. These books are keenly sought by collectors especially those printed by Simon de Colines, Hardouin, Simon Vostre and Kerver.

Imbrications. Ornaments which take the form of fishes' scales or the segemented edge on tiles which overlap. Ornaments have undulating portions which overlap each other.

Incunabula. The term applied to volumes printed before the 16th century. Many libraries have collections under this head and the library of the Ann Mary Brown Memorial at Providence, Rhode Island consists entirely of Incunabula.

Intaglio. A design or illustration made by cutting into the surface of the material. The name was originally given to engraved gems but now more commonly applied to printing from incised plates.

Lapis Lazuli. An opaque blue stone — the shade of blue used principally in illuminated manuscripts.

Lorraine Cross. A cross with two projecting arms on each side. One of the most persistent elements in printers' devices. It is shown in Group V, No. 12.

Lotus. The beautiful lily of the Nile is one of the most characteristic forms of Egyptian ornament. It was dedicated to Isis and Osiris and was also an emblem of fertility from its association with the great river that, by its annual overflow, brought plenty to the land and made Egypt the granary of the ancient world. Hulme.

Louis Quatorze. A style of ornament developed towards the close of the 17th century (1643–1715). It is described as "essentially an ornamental style, its chief aim being effect by a brilliant play of light and shade; color, mere beauty of form in detail having no part in it. This style arose in Italy, and the Chiesa del Gesù at Rome is mentioned as its type or model. The great medium of the Louis Quatorze was gilt stucco-work, which, for a while seems to have almost wholly superseded decorative painting; and this absence of color in the principal decorations of the period seems to have led to its more striking characteristic,— infinite play of light and shade." (Wornum, Analysis of Ornament.)

Louis Quinze. This style (1715–74) is the exaggeration of the Louis Quatorze, rejecting all symmetry, and introducing the elongation of the foliations of the scroll, mixed up with a species of crimped conventional coquillage or shell-work. The style found its culmination in the bizarre absurdities of the Rococo.

Meander. To wind, turn or twist. A labyrinth; a kind of ornamental design having a labyrinthine character.

Molding. A projection, square, convex, or concave in profile, ornamenting a wall. Moldings are frequently decorated with foliage and geometric forms. They form an important part of decorative design in borders and frames.

Mythology. Early design was largely influenced by the fabulous history of gods, goddesses and heroes. Mediaeval and modern artists have ever sought their inspiration in classical mythology. It is an especially important source for the designer seeking classical motives.

Olive. The foliage of the olive tree, a native of Asia, is frequently used in decorative art. The olive is the symbol of peace.

Ovolo. A continuous ornament in the form of an egg which generally decorates the molding called the quarter-round. Eggs are usually separated from one another by pointed darts.

Palm. The leaf of the palm tree is a frequent motive in decorative art. It is particularly appropriate to the construction of trophies as it is the symbol of victory.

Parchment. The skin of a sheep or goat prepared and polished with pumice stone and used for several artistic purposes. Old manuscripts were executed on parchment and expensive works are now sometimes printed on it as it is admirably adapted for taking proofs of line engravings.

Passe-Partout. An engraving made of two movable parts. The term may be applied to engraved ornament or illustrations. The frame of it always remains the same while the center is movable.

Pediment. The triangular mass resembling a gable at the end of a building in the Greek style; a small gable or triangular decoration like a gable over a window. Pediments are shown in several of the title-pages and small frames in the preceding pages.

Pilaster. A square pillar on a wall partly embedded in it, one-fourth or one-fifth of its thickness projecting. Pilaster forms of ornamentation are much used in border design.

Pompeiian. Essentially Roman, with freedom, lightness of touch and delicacy of treatment. While primarily architectural, Pompeiian ornament in entablatures is a source of many beautiful motives and colorings for design in printing.

Proportion. Harmonizing relation of the different parts of a composition.

Renaissance. A period during which there was a general revival of art throughout Europe. This movement began in Italy during the 15th century and continued with little abatement of vigor throughout the 16th. It is further defined by various authors in the display pages of this book.

Scrolls. The decorative ornament in use from the earliest period and prototype of the arabesque, tangential junction or growth based on natural forms is the decorative principle involved.

Radiation. The spreading out or divergence of lines or forms from a common origin. It is a principle which is almost universal in nature and is common in vertical and pendant forms of design.

Repose. The result of fitness, proportion and harmony — the opposite of unrest and movement.

Rubricated. Printed in red. Rubrica was red ochre, the edicts of the civil law being written originally in it. Rubrics was a term applied to manuscripts in which the initial letters were illuminated in red. The example shown in Group IV, No. 48, is an excellent rubricated page, although the same term applies to the one immediately following and many others.

Spacing. A harmonizing distribution of forms in a given space. In typography, it relates both to the distance between letters and between lines.

Strap-Work. A form of ornament which consists of a narrow band in convolutions similar to those that a leather strap thrown down at hazard would form. Very common in late Renaissance.

Subordination. To make one part of a work subservient to another with the object of emphasizing the principal motive and also enriching it by the process.

Superposition. Imposing one ornamental motive, inscription or device over another less important element.

Symmetry. A harmony produced by repetition and doubling over of any form on its axis.

Symbolism. A symbol is a visible sign of an idea, anything which suggests an idea or thing as by resemblance or by convention. Symbolism is the greatest field for the designer in printing, giving significance to the elements as well as beauty to the form. The great galaxy of symbolism imparting attributes to the sun, moon and stars and to nearly all vegetable and animal life enables the designer to give a meaning to his ornamentation.

Tailpiece. An engraving usually merely ornamental and placed at the end of chapters or on short pages of display printing.

Technique. In painting and sculpture the term technique denotes manipulative skill, mastery of material and all those qualities of hand and eye which contribute to the executive excellence of a work of art. It has been the fashion of late years to decry technique and to attach too great a value to certain gifts of literary invention. But as it is an artist's business to be articulate in his own medium, whether it be paint or clay, it is quite certain that technique is of far greater importance, and is dependent on far higher qualities of mind than any knack of finding subjects or portraying sentiment. Adeline.

Tertiary. Colors variable in number which enter into the composition of another color.

Vellum. The skin of a calf used in illuminated books of the middle ages. It is also used for proofs of engravings and etchings and sometimes for bookbindings.

Vignette. It means strictly a little vine. Used originally to denote an ornament in Gothic architecture, it was also applied to initial letters in manuscripts which were decorated with the tendrils of a vine. The meaning of the word has been extended to cuts forming head and tailpieces in a book whether they are decorative or illustrative. Vignette commonly applies to any cut or engraving which is not enclosed in rigid lines but is included in the text.

The latter part of the fifteenth century was prolific in artistic genius. Truly, "there were giants in those days." Albrecht Dürer, the father of the German School, was born in 1471; that sublime genius Michael Angelo, in 1474; Titian, the great Venetian colorist, in 1477; Raphael, "the prince of painters," in 1483. Rubens was born more than three hundred years ago; Rembrandt, "the inspired Dutchman," in 1606. Those great masters fully understood the value of that art which could multiply their designs.

FREDERICK KEPPEL

BOOK REFERENCE LIST

*T*HERE are many books about books and seemingly there should be no difficulties in the accessibility of all the works dealing with the history, styles and standards of printing. The subject of Historic Design in Printing is, however, so largely buried in general books that only a few can be specified as relating directly to design.

The most useful books for those interested in this subject are to be found under library headings such as History of Printing, Incunabula, Bookbinding and general books relating to the arts of the fifteenth and sixteenth centuries. The brief list of authors and titles following will be found to contain much of the best material.

Bagley, Harold. The lost language of Symbolism, an inquiry into the origin of Certain Letters, Words, Names, Fairy Tales, Folklore and Mythology. This deals historically with the earliest water marks and printers' devices, defining the various elements of symbolism entering into them.

Bernard, Auguste. Geofroy Tory, Painter and Engraver: First Royal Printer: Reformer of Orthography and Typography under Frances I. An account of his life and works by Auguste Bernard, translated by George B. Ives and illustrated under the direction of Bruce Rogers. Boston, The Riverside Press, 1909.

Blades, William. A list of medals, jettons, tokens, in connection with printers and the art of printing. London, 1869.

Butsch, A. F. Die Bücher-Ornamentik der Renaissance. A collection of initials, title-pages, borders and bindings. Vol. 1 contains 100 plates and Vol. 2, 111 plates.

De Vinne, Theodore Low. Christopher Plantin and the Plantin-Moretus Museum at Antwerp with illustrations by Joseph Pennell and others. New York, The Grolier Club, 1888.

Notable printers of Italy during the fifteenth century. Illustrated with facsimiles from early editions and with remarks on early and recent printing. New York, The Grolier Club, 1910.

Duff, Edward Gordon and others. Hand lists of English printers, 1501–1554.

Gerlach, Martin. Das alte Buch. A collection of printing ornamentation and binding from the fifteenth to the nineteenth centuries.

Goudy, Frederic W. The Alphabet. Fifteen interpretative designs drawn and arranged with explanatory text and illustrations.

Hamlin, A. D. F. The History of Ornament, Ancient and Medieval with 400 illustrations. New York, Century Company, 1916.

Humphreys, Henry Noel. Masterpieces of the early printers and engravers. A series of facsimiles from rare and curious books. London, Sotheran & Co. 1870.

Jones, Owen. The Grammar of Ornament. Illustrated by examples from various styles of Ornament. 112 plates.

Lippman, Fr. Engraving and Etching, a handbook for the use of students and print collectors, with 131 illustrations. New York, Charles Scribner's Sons, 1906.

McKerrow, Ronald B. Printers' and Publishers' Devices in England and Scotland 1485–1640. Printed at the Chiswick Press for the Bibliographic Society, London, 1913.

Neidling, A. Bücher Ornamentik in Miniaturen, Initialen, Alphabeten des IX. bis XVIII. Jahrhundert. This contains many ornaments and initials and has many book decorations by Hans Holbein.

Ongania, Ferdinando. L'Arte della Stampa nel Rinascimento Italiano, Venezia, 1894. This book contains the largest collection of borders, initials and other designs used in printing. Unfortunately it is not well arranged nor well printed. Copies are still obtainable through booksellers.

Petzendorfer, Ludwig. This contains many excellent examples of both early and modern initials. Stuttgart, Julius Hoffman, 1894.

Plantin, Index Characterum Architypographiae Plantinianae: Specimen des Caractères Employés dans L'Imprimerie Plantinienne. Editions du Musée Plantin-Moretus, Antwerp, 1905.

Pollard, Alfred William. Early illustrated books. A history of the decoration and illustration of books in the fifteenth and sixteenth centuries. London, 1893.

Last words in the history of the title-page, with notes on some colophons and 27 facsimiles of title-pages.

Quaritch, Bernard. A collection of Facsimiles from Examples of Historic or Artistic Book-binding, illustrating the History of Binding as a branch of the decorative arts. London, 1889.

Monuments of the early printers in all countries. London, 1886–87.

Roberts, William. Printer's Marks. A chapter in the history of typography. London, Bell, 1893.

Shaw, Henry. A Handbook of Medieval Alphabets and Devices, with 36 plates. London, Bernard Quaritch, 1853.

Silvestre, L. C. Marques typographiques. There are over 1,000 marks and designs, well reproduced with the name and date but with no descriptive text. Paris, 1867.

Wornum, Ralph N. Analysis of Ornament and Characteristics of Styles, with introduction to the study of the history of ornamental art. London, Chapman and Hall, Ltd., 1884.

In several of the large libraries of the United States particular provision has been made for books about printing. In 1906, in connection with the 200th Anniversary of the Birth of Benjamin Franklin, a catalogue of books on the History and Art of Printing was issued by the Boston Public Library, listing the books of this library and of the libraries of Harvard University and the Boston Atheneum. These three libraries have much material for the designer and a considerable portion of the examples in this book are from the original works and collections in them.

The American Typographic Library and Museum, Jersey City, N. J. has many books on printers' marks and historic design from which much material was obtained for this work.

The New York Public Library, the Library of Congress, Washington, the Chicago Public Library and other large libraries have many examples of early printing and reference works.

The Boston Museum of Fine Arts, the Metropolitan Museum of Arts, New York, and other museums of fine arts throughout the United States have libraries and collections of prints. State, university and historical libraries have many books dealing with the history of printing, engraving, paper making and the allied arts.

The higher achievement of the individual and of printing as an art is true to the adage, "He who would advance in the arts or professions must look backward at least one-half of the time."

To those who are acquiring books and prints relating to printing, Goodspeed's Bookshop, 9A Ashburton Place, Boston, offers books on printing, old printed books, books of design and lettering, prints of all kinds, ancient and modern, also portraits of printers, old title-pages and other samples of early printing.

Some of the publishers and dealers in architectural books in New York and other cities also have books of design and examples of early printing which are desirable as reference material.